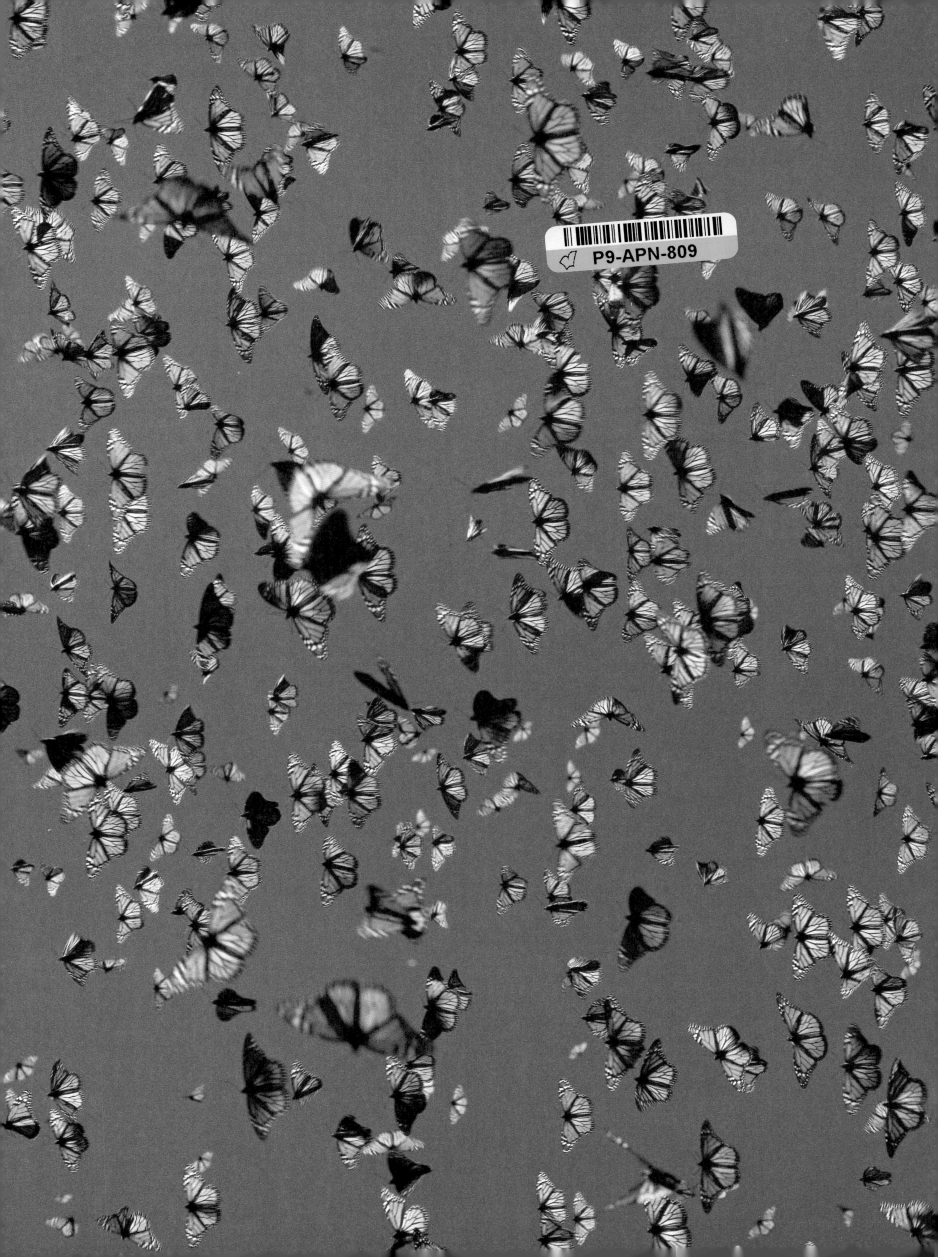

P9-APN-809

The
WONDERS
of LIFE

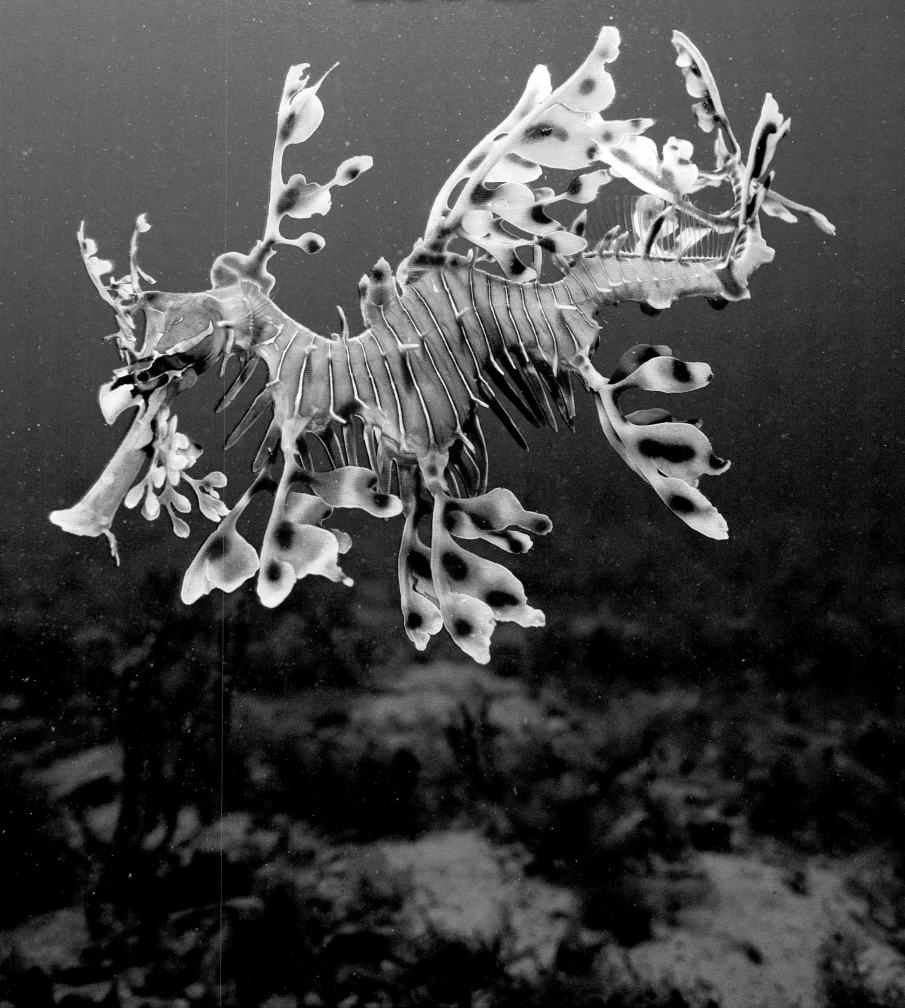

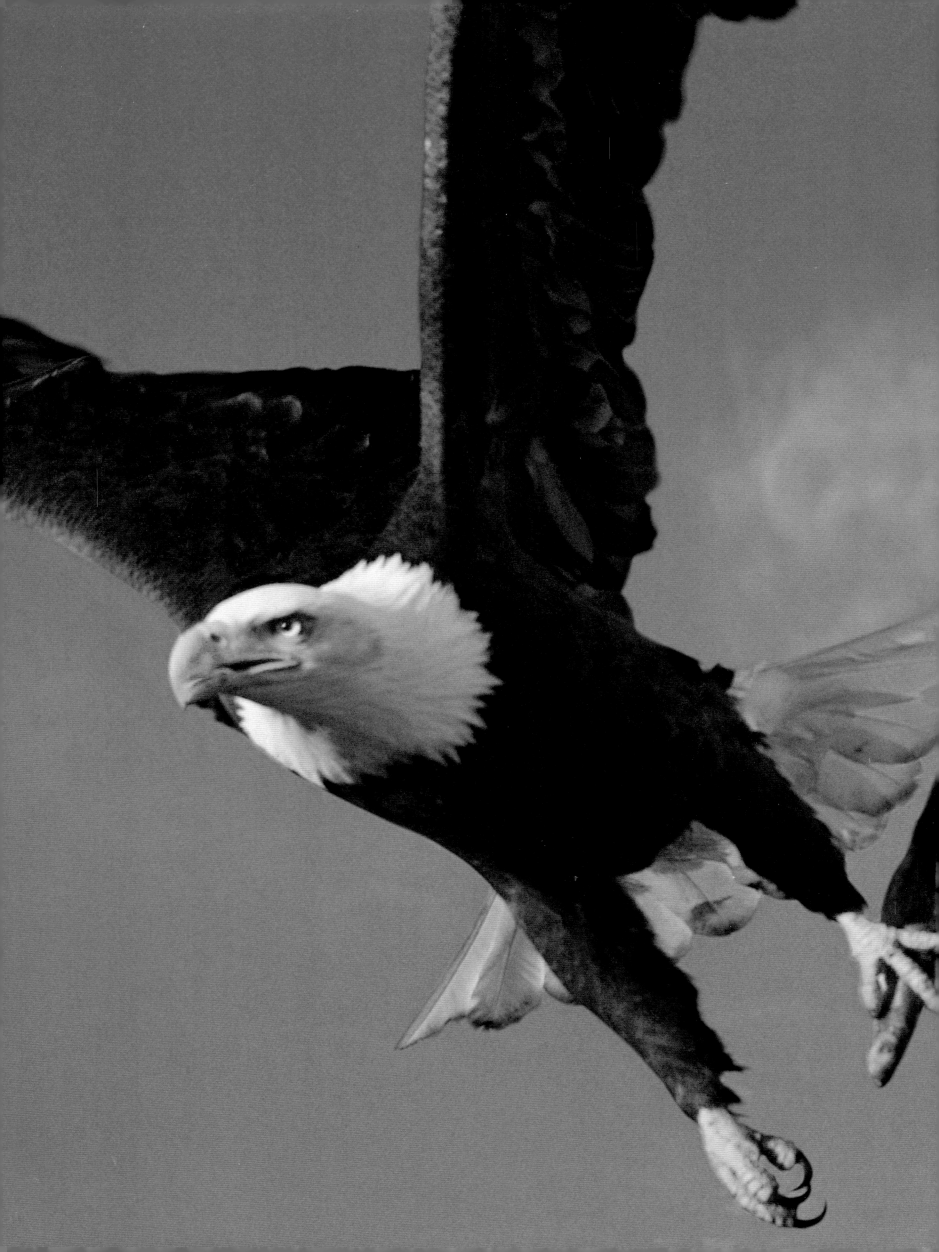

The
WONDERS
of LIFE

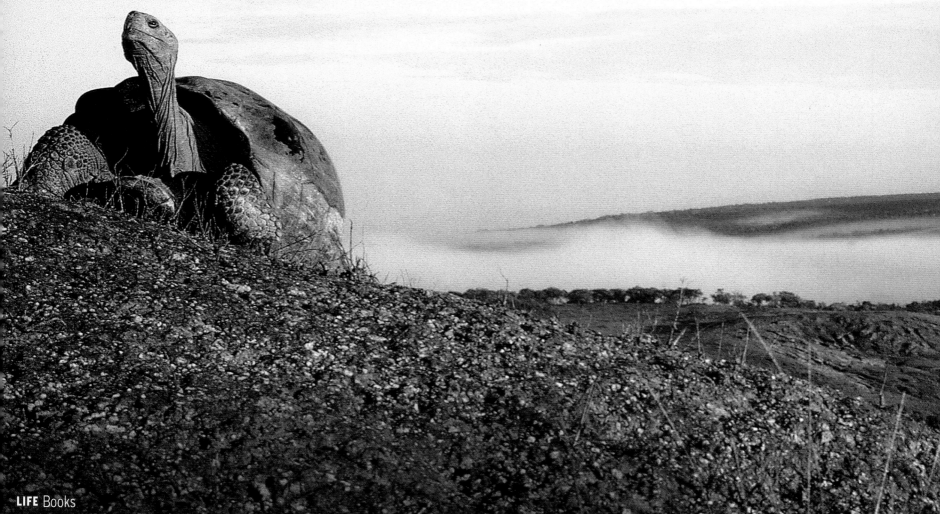

LIFE Books

MANAGING EDITOR Robert Sullivan
DIRECTOR OF PHOTOGRAPHY
Barbara Baker Burrows
ART DIRECTOR Mimi Park
DEPUTY PICTURE EDITOR Christina Lieberman
WRITER-REPORTER Hildegard Anderson
COPY EDITORS Barbara Gogan, Parlan McGaw
CONSULTING PICTURE EDITORS Mimi Murphy
(Rome), Tala Skari (Paris)

PRESIDENT Andrew Blau
BUSINESS MANAGER Roger Adler
BUSINESS DEVELOPMENT MANAGER Jeff Burak

TIME HOME ENTERTAINMENT

PUBLISHER Richard Fraiman
GENERAL MANAGER Steven Sandonato
EXECUTIVE DIRECTOR, MARKETING SERVICES
Carol Pittard
DIRECTOR, RETAIL & SPECIAL SALES Tom Mifsud
DIRECTOR, NEW PRODUCT DEVELOPMENT
Peter Harper
DIRECTOR, BOOKAZINE DEVELOPMENT & MARKETING
Laura Adam

PUBLISHING DIRECTOR, BRAND MARKETING
Joy Butts
ASSISTANT GENERAL COUNSEL Helen Wan
BOOK PRODUCTION MANAGER Suzanne Janso
DESIGN & PREPRESS MANAGER
Anne-Michelle Gallero
BRAND MANAGER Roshni Patel
EDITORIAL OPERATIONS Richard K. Prue
(Director), Brian Fellows (Manager),
Keith Aurelio, Charlotte Coco, Tracey Eure,
Kevin Hart, Mert Kerimoglu, Rosalie Khan,
Patricia Koh, Marco Lau, Brian Mai, Po Fung Ng,
Rudi Papiri, Robert Pizaro, Barry Pribula,
Clara Renauro, Hia Tan, Vaune Trachtman

SPECIAL THANKS TO Christine Austin,
Jeremy Biloon, Glenn Buonocore, Jim Childs,
Susan Chodakiewicz, Rose Cirrincione,
Jacqueline Fitzgerald, Carrie Frazier,
Lauren Hall, Jennifer Jacobs,
Brynn Joyce, Mona Li, Robert Marasco,
Amy Migliaccio, Kimberly Posa,
Brooke Reger, Dave Rozzelle, Ilene Schreider,
Adriana Tierno, Alex Voznesenskiy,
Sydney Webber, Jonathan White

ISBN 10: 1-60320-141-6
ISBN 13: 978-1-60320-141-4
Library of Congress Control Number:
2010927612

"LIFE" is a trademark of Time Inc.

We welcome your comments and suggestions about
LIFE Books. Please write to us at: LIFE Books.
Attention: Book Editors
PO Box 11016,
Des Moines, IA 50336-1016

If you would like to order any of our hardcover Collector's
Edition books, please call us at 1-800-327-6388.
(Monday through Friday, 7:00 a.m.—8:00 p.m. or Saturday,
7:00 a.m.—6:00 p.m. Central Time).

ENDPAPERS: Those masters of migration, monarch butterflies,
swarm in Michoacan, Mexico. **INGO ARNDT/MINDEN**

PAGE 1: Hiding in plain sight, a leafy sea dragon displays its
camouflage in Rapid Bay, South Australia.
MARK SPENCER/AUSCAPE/MINDEN

PAGE 2–3: Bald eagles, one having caught lunch, soar in the
blue sky over Alaska. **STEVE BLOOM**

THESE PAGES: A Galápagos tortoise sees a new day dawn on
Isabella Island in his eponymous South Pacific chain.
TUI DE ROY/MINDEN

CONTENTS

What a Wonderful World!

This is a wild book. In its pages we have animals as big as trucks and plants as big as small towns. We have flowers that dance for our pleasure and flowers that shyly hide underground, flowers that can kill animals and flowers that can heal animals. We have a teeny tiny bird that is directly descended from T Rex and a truly enormous bird that can't fly but can run 45 miles an hour. We have a lizard king that could rip you apart (and would, gladly) and a lizard princeling that walks on water. This is a wild, wild book.

It is a book that includes an abundance of what are called "exotics." Our editors felt that by focusing on life at the far fringes—the biggest, smallest, toughest, gentlest, rarest, plain old weirdest species of plants and animals—we could paint a picture of the constantly amazing world around us. The results of our researches routinely startled us, even when we were fully expecting to come across uncommon beauty or one more amazing fact. The adaptability and resiliency of many of our selected subjects is truly astounding. We found that any number of plant species that have successfully evolved to the present day seem to possess an innate natural intelligence. If water is scarce, they find ways to horde what little there is; if there is a poor supply of available nutrients, they start trapping bugs to supplement their diet. As for the animals: They, too, have learned to cope—by becoming faster or more sly, by climbing higher or diving deeper.

Since we are dealing with survivors in these pages, their refined abilities comment on the endlessly fascinating evolutionary process. In a presumption, we feel that Charles Darwin might have enjoyed this book; he certainly would have relished the vibrant pictures of species that he encountered during his voyages on the *Beagle.* Whether he would have approved of our somewhat wide-eyed narrative descriptions of these plants and animals, well, that we cannot say. But the fact is: We *were* left wide-eyed by what we learned, and we wanted to share our excitement with you.

We learned what was true and what was not. There are no unicorns in these pages, except the one that adorns this introduction. Without wanting to burst any bubbles: Unicorns are mythical, and so are dragons and phoenixes and Whomping Willows and apple-throwing trees in Oz and man-eating trees in Madagascar. All mythical. The lotus tree that induced somnolence in the ancient Greeks never existed either, although an actual plant of another name, possessed of abnormally potent fruit, may have been called the lotus by storytellers, just as the island of Santorini may have been the model for Plato's Atlantis. Be that as it may, there never was and isn't today a lotus tree.

But we're sure you'll agree after diving into this book: There is no need to go the extra mile into the unreal to find life on earth sensational. The unicorn isn't here, but the narwhal, an oceangoer with a tusk every bit as fine, is. The lotus tree is absent, but even if we had a picture of one it wouldn't rival those herein of the giant sequoias, bizarre baobabs, miraculous mangroves or ancient oaks. A verity that we became dedicated to in compiling this volume is: Truth really is stranger than fiction. Look at these pictures, read these words, and see if you don't agree.

As this is the third book that LIFE's editors have produced in our Classic Collection series, it includes a bonus feature we have become known for: photographic prints from the famed LIFE archive that can be extracted and framed. We chose pictures that we thought you might like to put on your wall; we gave a miss to the wildebeest and all weedlike plants, fascinating though they might be. As in our previous two volumes, when the print is extracted, the exact picture is still there on the page beneath, so your deluxe coffee-table book remains intact. It's an elegant trick worthy of the dancing flower, and one that our readers have come to expect—and greatly enjoy.

Unicorn: Not real.

Fruit-throwing trees in Oz: Not real.

Oak tree and pines in Yosemite National Park: Real.

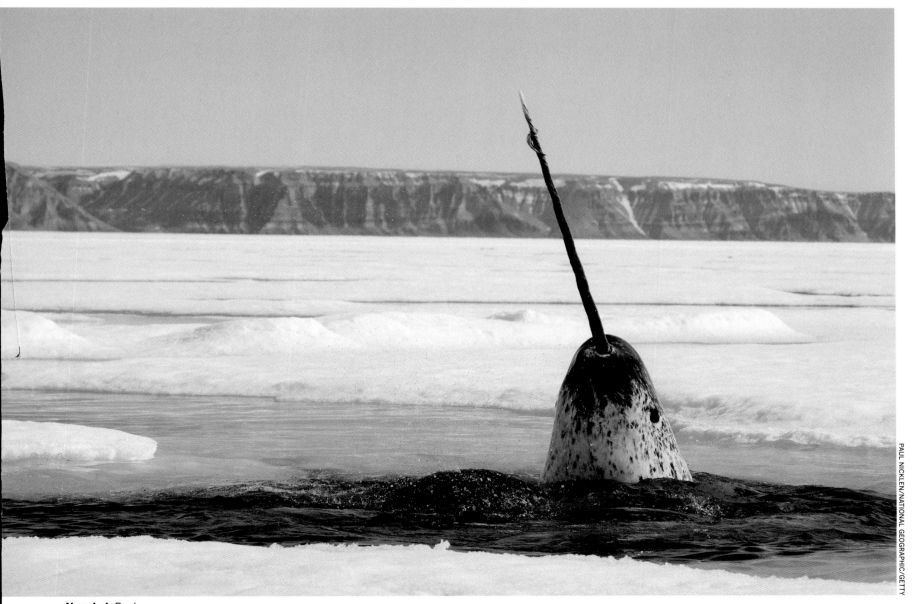

Narwhal: Real.

7

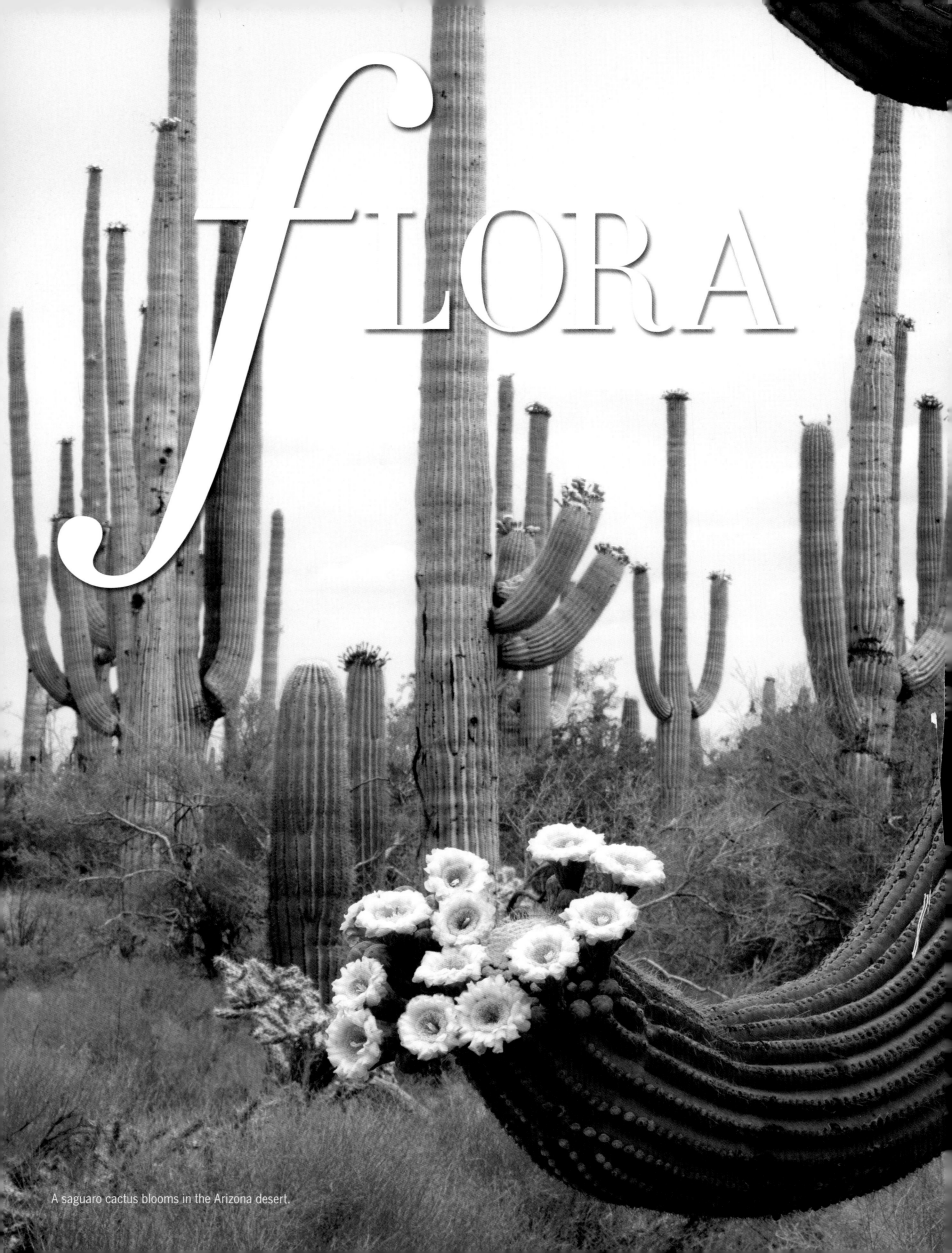

fLORA

A saguaro cactus blooms in the Arizona desert.

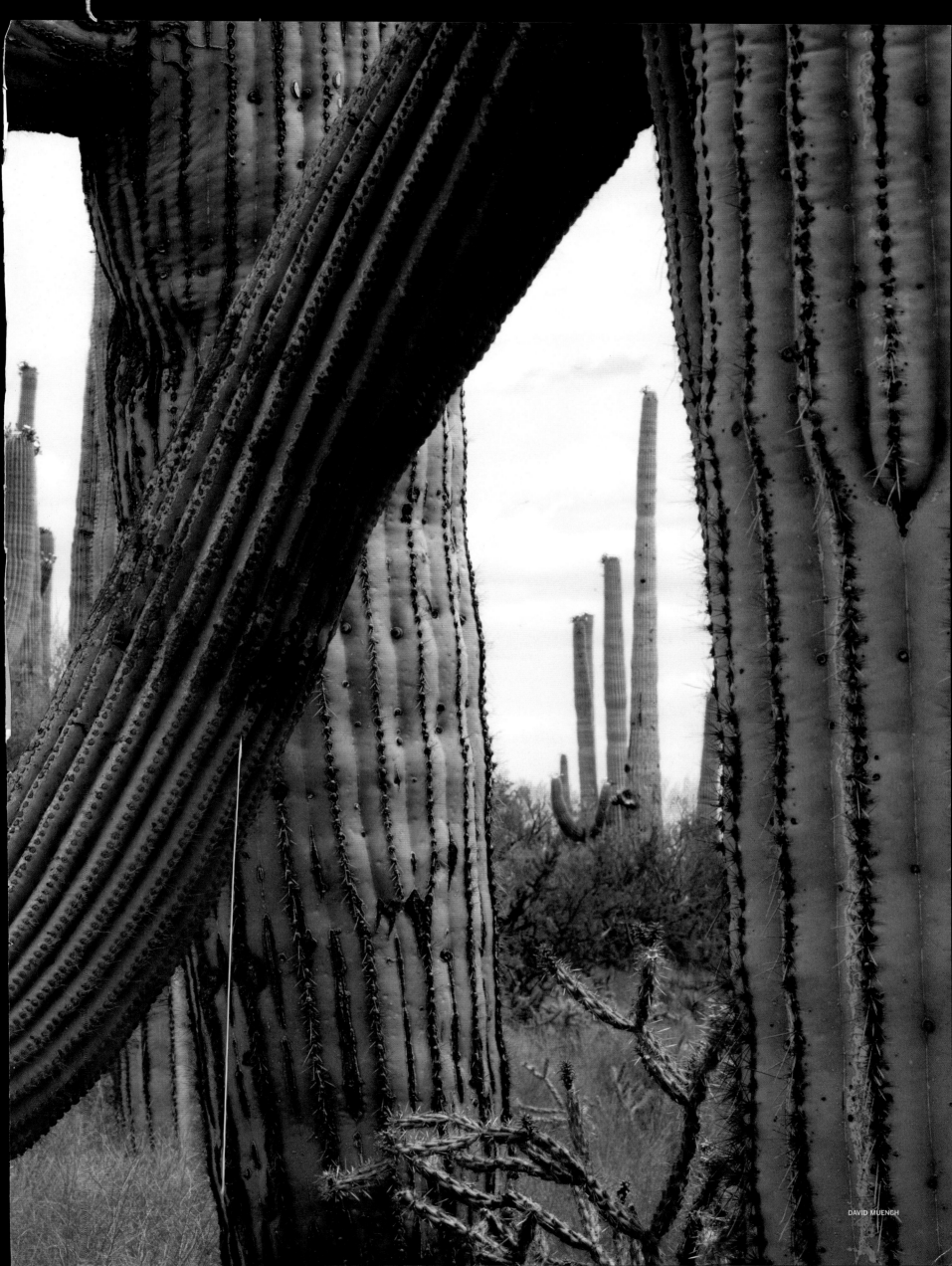

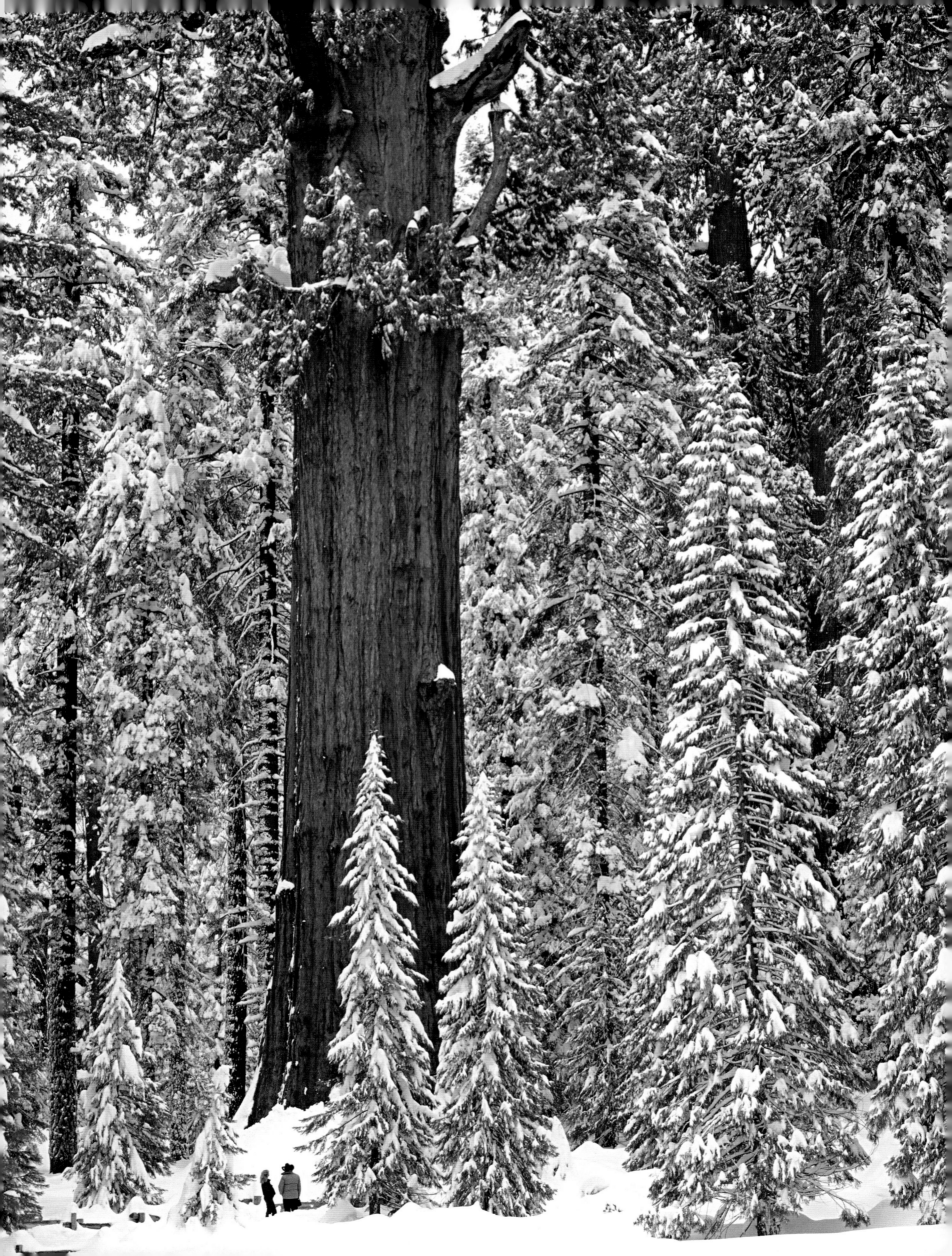

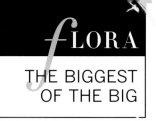

LOUIE PSIHOYOS/CORBIS

SEAN ARBABI/AURORA

Saluting the General and Genevieve

Whether or not lions are the animal kings of the jungle, giant redwoods and sequoias are, without challenge, the plant kings of the forest. Their size is positively staggering; as we gaze skyward (note the two tiny people, opposite), trying in vain to visually grasp the upper reaches, we literally stagger backward in reverence—an awesome experience with an awesome tree. Redwoods exist elsewhere than in California, but the Golden State is a famous haven for these gigantic trees, which have been harvested in considerable quantity in the past but today are protected in national, state and regional parks on the West Coast. We see on the opposite page the General Sherman tree, a giant sequoia 275 feet high but, as important, with a base measuring 36.5 feet in diameter—a combination that, once you do the math and

figure in the amount of wood, makes this the largest non-clonal tree by volume on the planet. (What's meant by "clonal" is explained on page 22, where we look at the likely candidate for the weightiest clonal colony of plant life: seeming fully sized trees that are in fact mere stems of a humongous, largely subterranean living organism.) Yes, this sequoia was named after the equally prodigious Civil War general William Tecumseh Sherman—named, interestingly, by the naturalist James Wolverton, who was a lieutenant in Sherman's 9th Indiana Cavalry. High tribute for the boss, indeed. Redwoods, attractive in so many ways, can be appreciated simply as a scenic delight or as a playground: Above, we see Genevieve Summers, not looking up but straight ahead while climbing a giant near Springville, also in California.

AURORA

Reaching
for the Heavens

This is photographer James Balog's remarkable rendering of the Stratosphere Giant, a coast redwood in Humboldt Redwoods State Park that, at 370 feet in height (and still growing), was for years considered the tallest tree on earth; recently, three trees in Redwoods National Park have been placed some feet higher on the list, and the jockeying for the top spot continues. Balog executed many chapters in his telling of the Humboldt story while suspended from on high and shooting directly ahead, then assembled the whole quite like a child assembles a Lego tree.

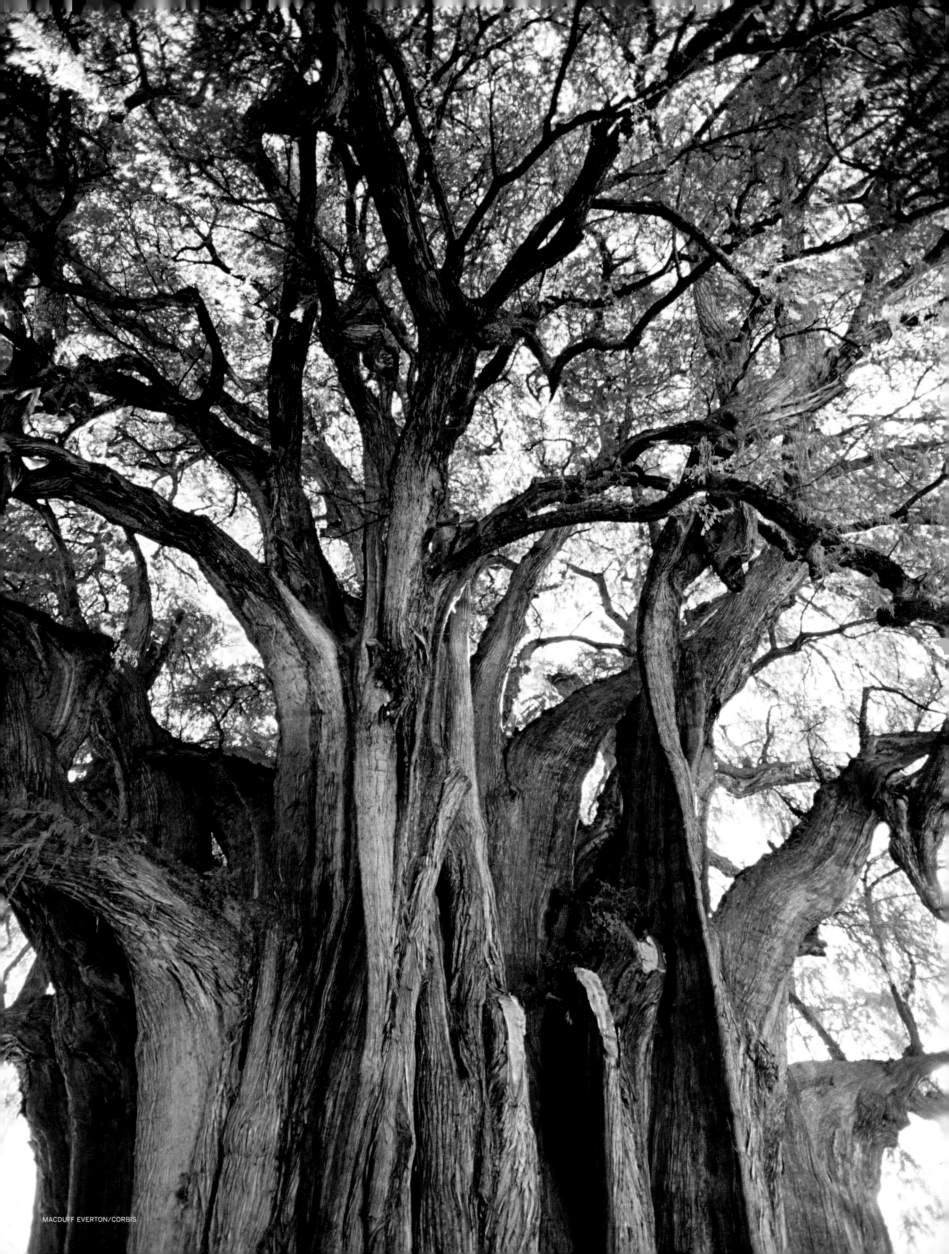

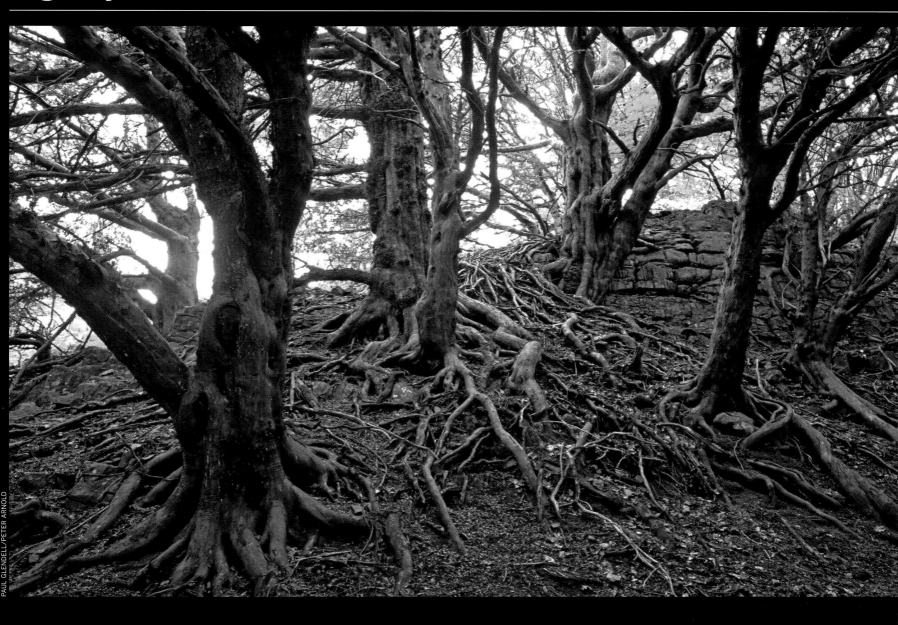

n Not only in California, and not only among redwoods, do giant trees dwell. This wide guy (opposite) is a living fossil. Really, that's not an oxymoron: Much of the tree is dead and already fossilized. It was and is the species called bald cypress, and stoically resides near the city of Oaxaca in Mexico. It is at least 2,000 years old, perhaps as much as 3,000, and is famous as the Tule Tree. It has a height of (only!) about 130 feet. But its diameter is 150 feet and its circumference is nearly 200 feet. Its volume is something like 900 cubic yards and its weight is estimated at, gulp, 636 tons. That's a hunka, hunka tree. And so

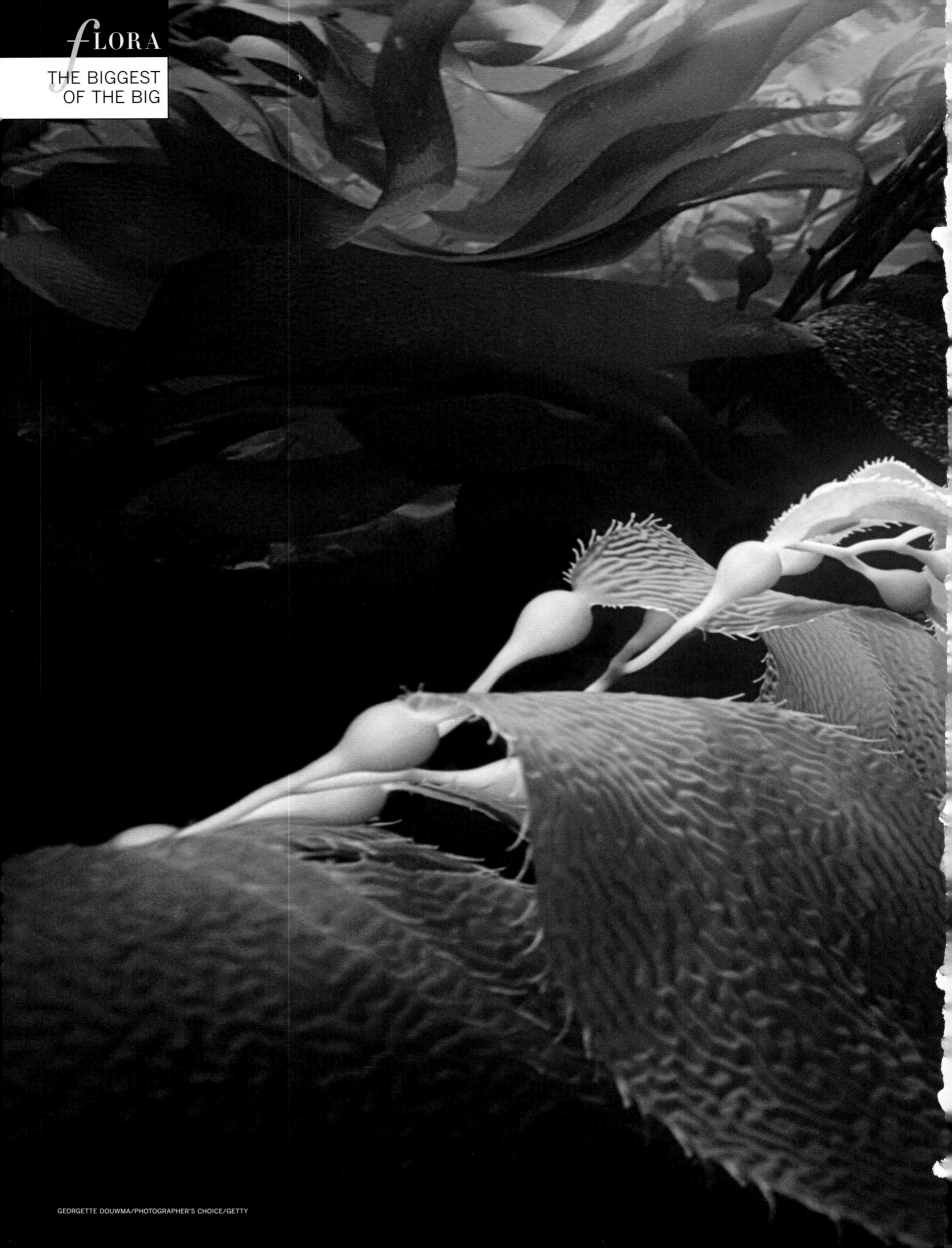

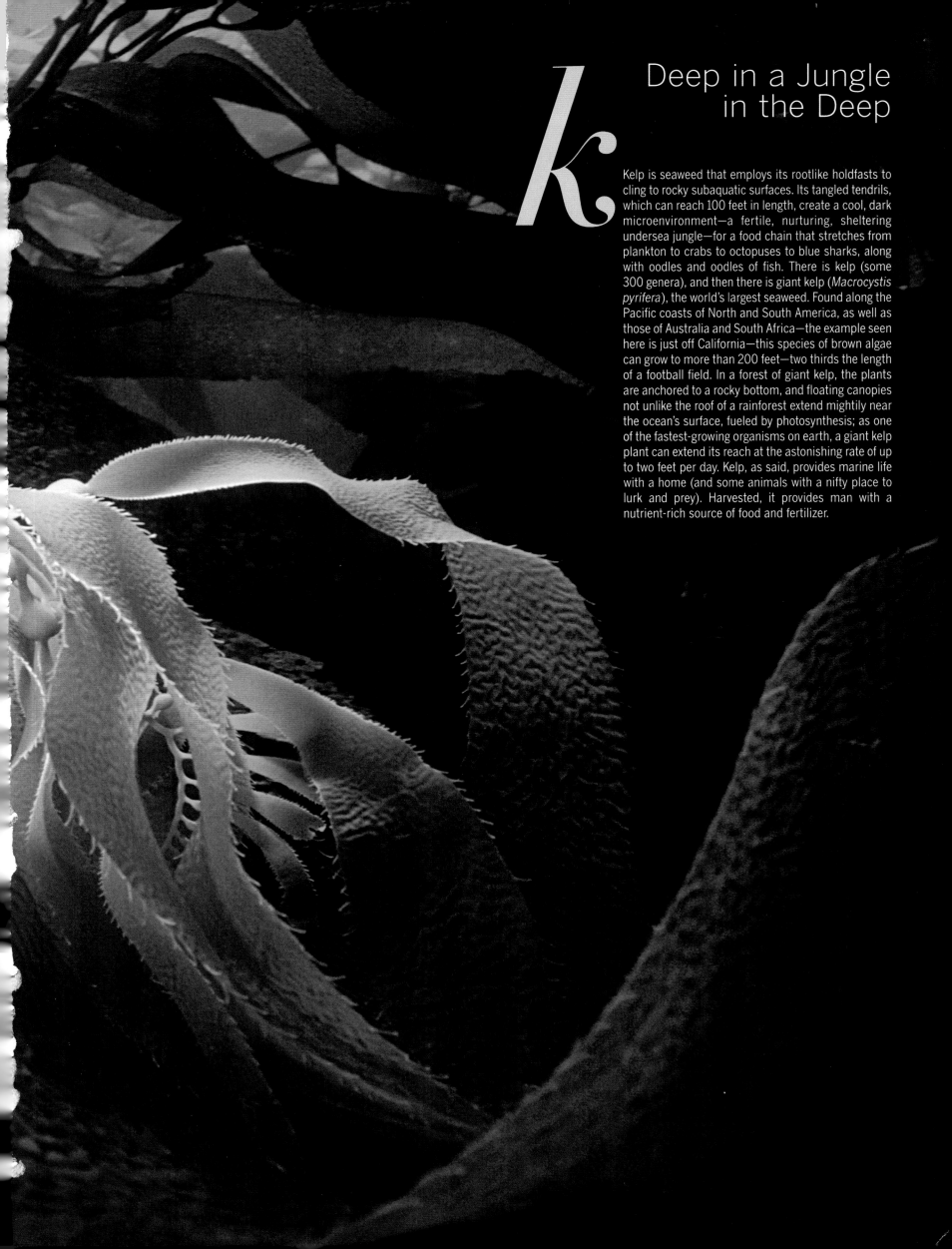

Deep in a Jungle in the Deep

k

Kelp is seaweed that employs its rootlike holdfasts to cling to rocky subaquatic surfaces. Its tangled tendrils, which can reach 100 feet in length, create a cool, dark microenvironment—a fertile, nurturing, sheltering undersea jungle—for a food chain that stretches from plankton to crabs to octopuses to blue sharks, along with oodles and oodles of fish. There is kelp (some 300 genera), and then there is giant kelp (*Macrocystis pyrifera*), the world's largest seaweed. Found along the Pacific coasts of North and South America, as well as those of Australia and South Africa—the example seen here is just off California—this species of brown algae can grow to more than 200 feet—two thirds the length of a football field. In a forest of giant kelp, the plants are anchored to a rocky bottom, and floating canopies not unlike the roof of a rainforest extend mightily near the ocean's surface, fueled by photosynthesis; as one of the fastest-growing organisms on earth, a giant kelp plant can extend its reach at the astonishing rate of up to two feet per day. Kelp, as said, provides marine life with a home (and some animals with a nifty place to lurk and prey). Harvested, it provides man with a nutrient-rich source of food and fertilizer.

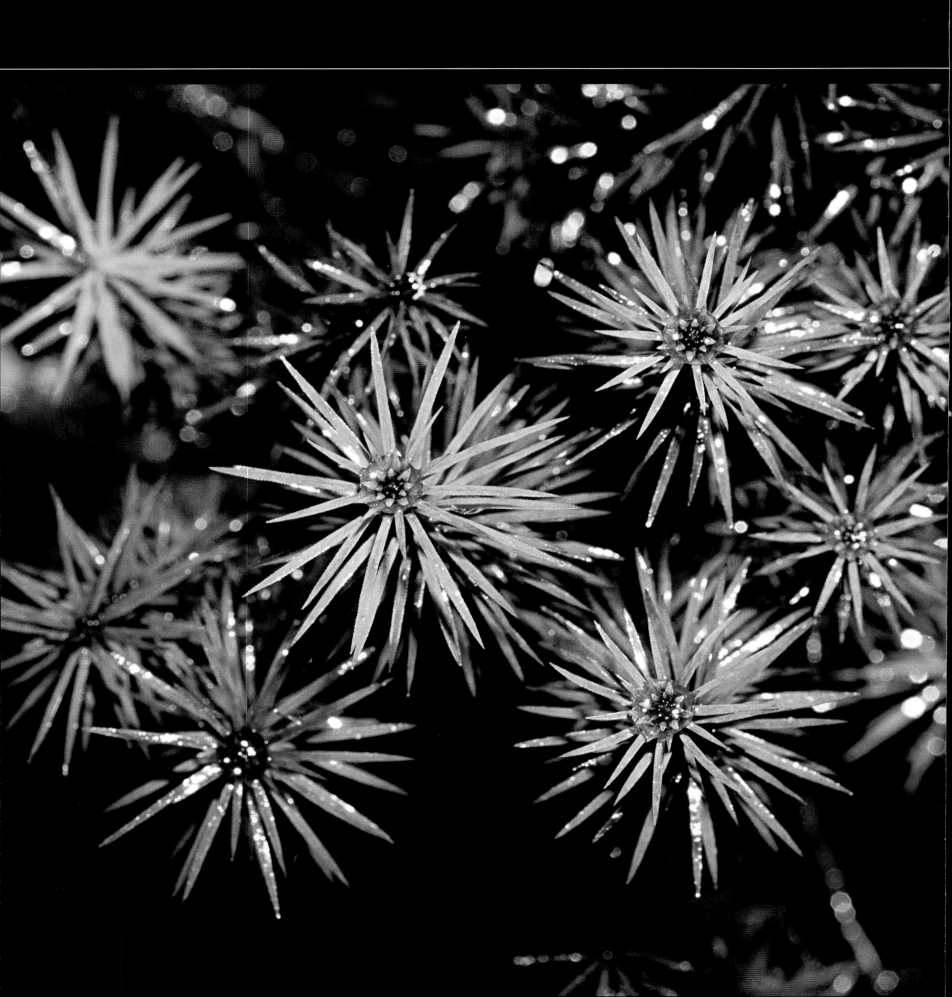

Wonders Down Under

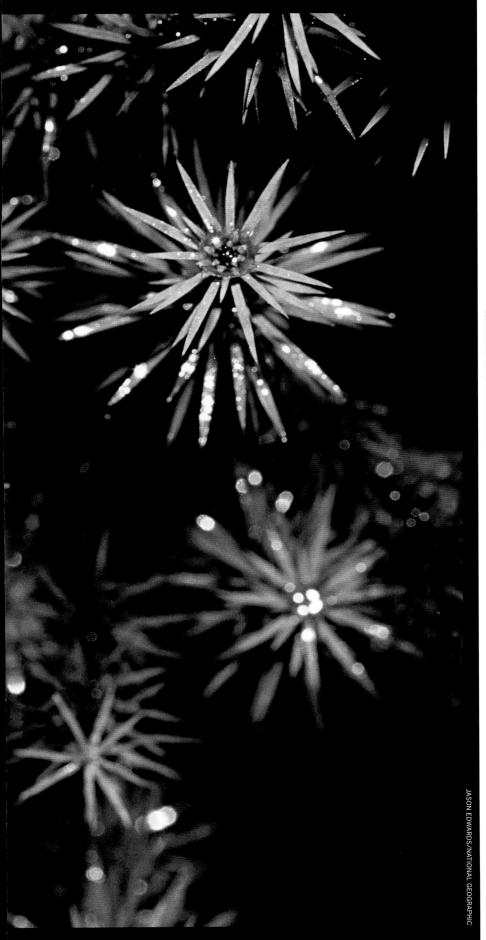

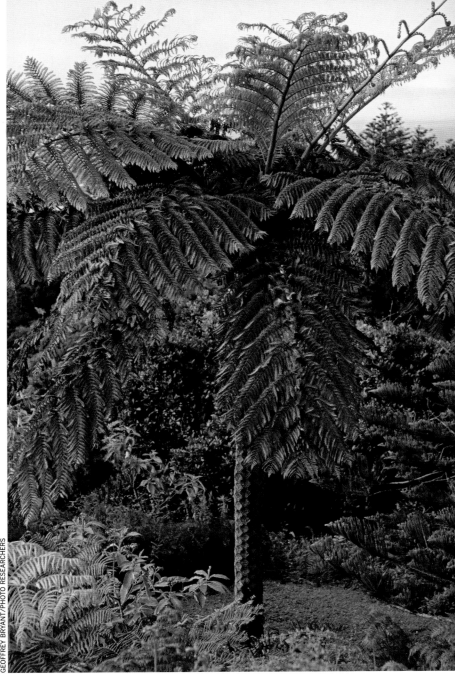

Later in these pages we will learn of the extreme, well, *funkiness* of animals that call the lands of the southeastern Pacific home. Australia, Tasmania and New Zealand, along with other islands in the region, floated off on their own scores of millions of years ago when the Southern Hemisphere supercontinent Gondwana ruptured. Isolated and adrift—and devoid of certain predatory species that defined the food chains of Asia or Africa—these realms gradually became possessed of rigorously individual climates and collections of singular life-forms. Most famous among their unique holdings are the kangaroos and the wallabies, the koalas and the wombats. But there are fun plants to look at Down Under as well. At left, we have a close view of *Dawsonia superba* moss. Perhaps the tallest of the world's 12,000 species of bryophyta (nonvascular plants), this native of New Zealand, Australia and elsewhere in the region (this particular example thrives in the Yarra Ranges National Park in Australia) can grow to 18 inches in height. That's one mighty moss, and the Norfolk Island tree fern (*Cyathea brownii,* seen above) is one fantastic fern—among the planet's very largest. A robust tree endemic in the islands for which it is named, and found in Australia as well, it can grow to 60 feet or more in height and boasts leaves up to nearly 20 feet long. Western tourists visiting Oz and environs often describe a wonderland, and this has nearly as much to do with the extraordinary flora as with the fauna.

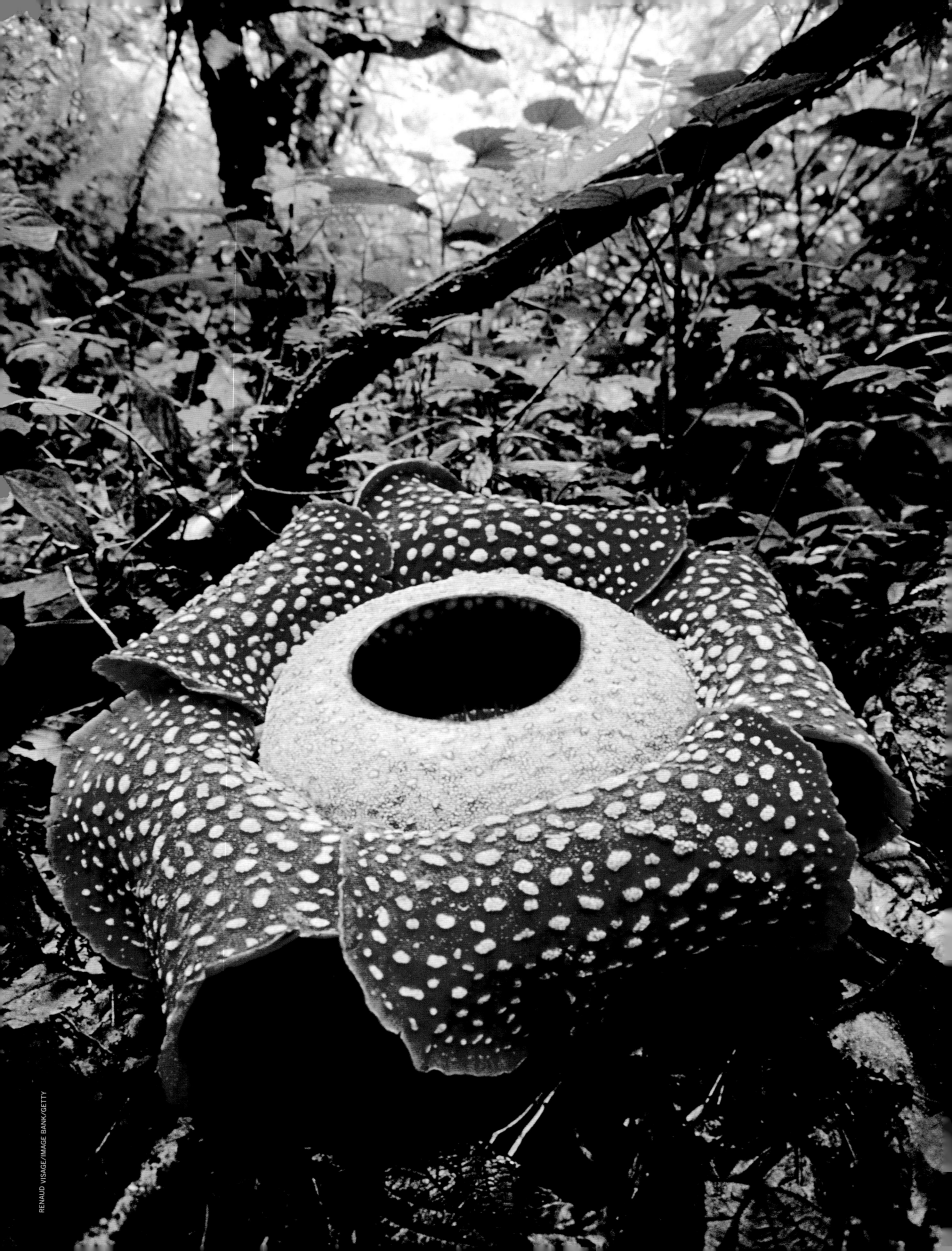

The Wow and the *Whew!*

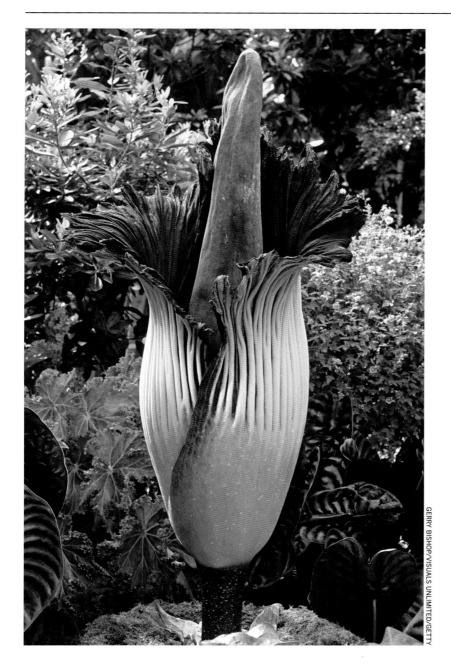

GERRY BISHOP/VISUALS UNLIMITED/GETTY

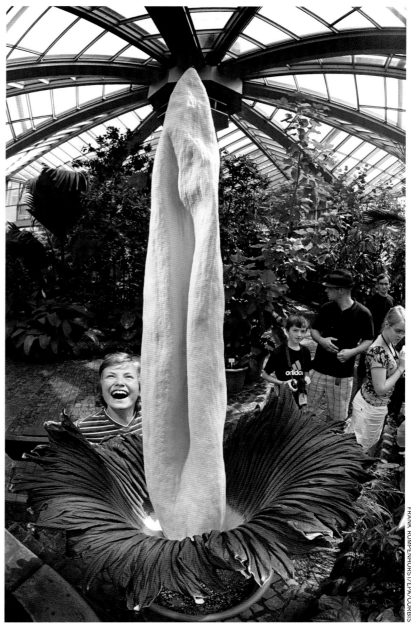

FRANK RUMPENHORST/EPA/CORBIS

*t*There are plants enormous in their size, in their beauty and, at times, in their stink. The *Rafflesia arnoldii* (opposite), found in the rainforest of Indonesia, is a rarity with a beautiful bloom that is the world's very largest, at three feet across and weighing as much as 24 pounds. You could put six or seven quarts of water into the hold in the center of the flower, not that you'd want to get that close. When in flower, the *Rafflesia arnoldii* gives off an awful smell, like that of rotting flesh. (The odor attracts insects to pollinate the plant.) The scent is what has earned the *Rafflesia* its nickname: the "corpse flower." A kind of partner plant, which also originated in Indonesia (in Sumatra) and which also exudes an odor of carrion to attract pollenizing bugs, is the *Amorphophallus gigas* (also titan arum). This flower has the world's most vigorous inflorescence and can grow to about five feet tall (two examples, above). Some insist that this is the "corpse flower," and the fierce and smelly battle for proprietary rights to a moniker continues.

A Trembling Giant

This photograph of a bucolic scene at Utah's Fish Lake features a deception. In it can be seen a part—a very small part—of what might be the largest and one of the oldest single living organisms on earth, a plant dating back perhaps 80,000 years with one root system and 47,000 stems covering more than 100 acres and weighing in—if one *could* weigh it—at more than 6,600 tons. What you think you're seeing extending upwards from the lakeshore is part of a lovely grove of trembling aspen (*Populus tremuloides*), so named because the leaves of this species shiver in the lightest breeze. But in fact these thin trees all share a common DNA and root; beneath the surface of the soil, they are part of a massive, intertwined monster. Aspen colonies are common throughout the United States—in 2006, the U.S. Postal Service commemorated the aspen as one of the 40 "Wonders of America"— but all others pale before the clonal colony in Utah called the Pando, named for the Latin word meaning "I spread."

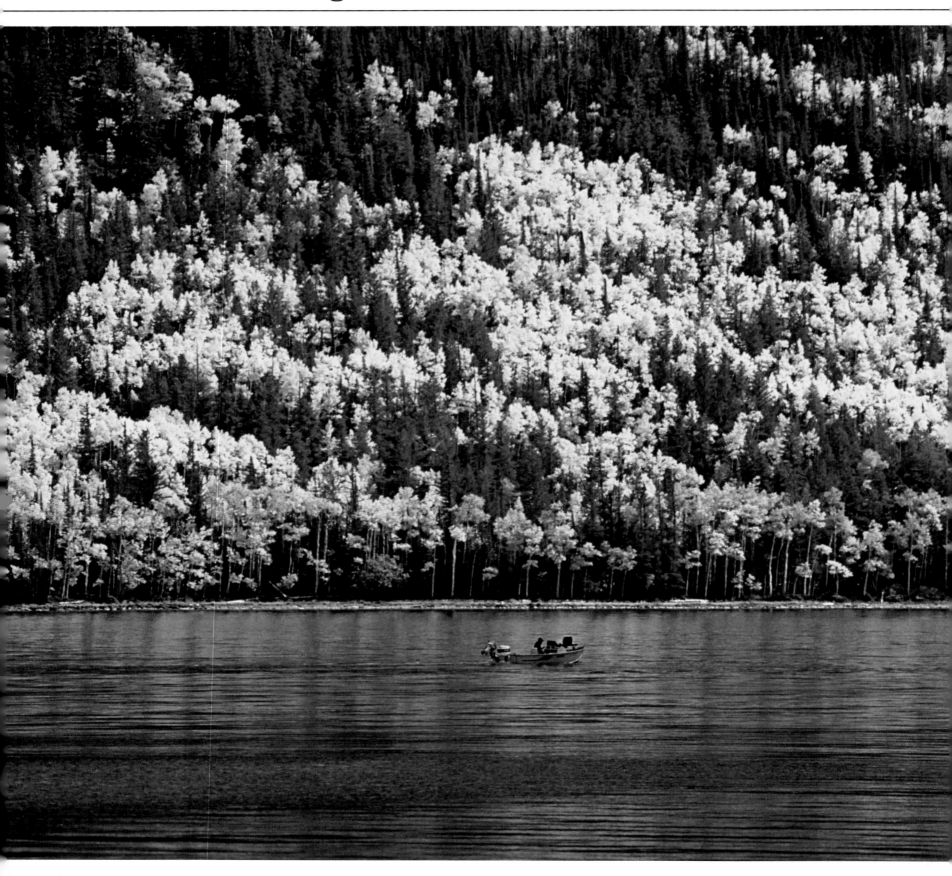

There's a Fungus Among Us

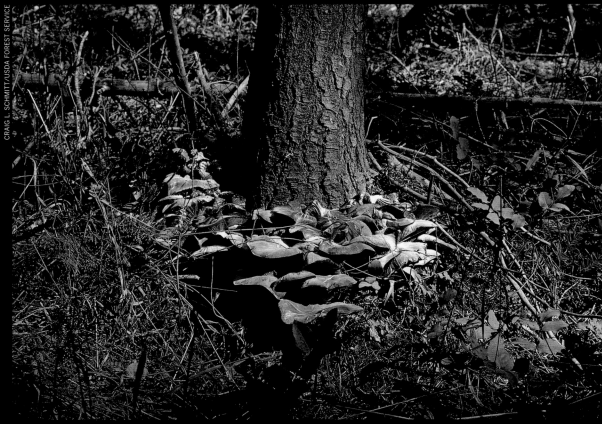

*h*oney fungus can be, as with the Pando and other aspen colonies, both disarmingly unassuming and alarmingly outsize, and for the same reason—it travels, like an effective spy, underground. There are 10 or more species of parasitic fungi among the so-called honeys, and certain of them are responsible for some of the largest and longest lived organisms in the world: In the Malheur National Forest in eastern Oregon, a single colony covers nearly 3.5 square miles and has claimed the ground for thousands of years. It also claims trees and forest shrubs throughout the world as it is, as said, a parasite. It kills by girdling a tree; it takes its time as it murders, traveling barely more than a yard per year. Unlike many other parasitic organisms, it then continues to feed off an already dead plant. When it shows itself, as in this picture, it is usually at the base of a tree, hugging the stump while, unobserved by human eye, feeding off it. A last, totally cool *Wonders of Life* fact: Some species of this fungus (which, as seen, has a fruit that presents as a mushroom) are bioluminescent, and the eerie nocturnal light called fox fire is traceable to honey fungus.

Eyes on the Prize

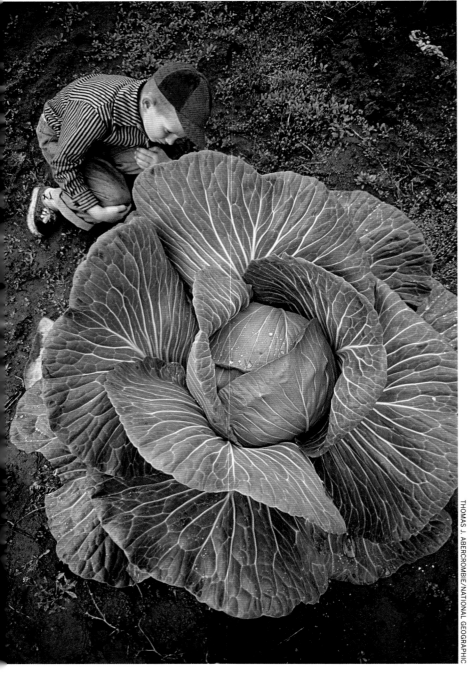

THOMAS J. ABERCROMBIE/NATIONAL GEOGRAPHIC

GUS CHAN/THE PLAIN DEALER/AP

*a*Annually at state fairs throughout the United States and harvest festivals around the world, agriculture becomes sport, a celebration of our ability to create not only sustenance but abundance, which talent we as a species have cultivated and improved upon through the ages. We brag of our advanced abilities via symbolic giant pumpkins and pineapples, cucumbers and cabbages. This prodigious produce does indeed boggle the mind, which is its declared intent; an ancillary aspiration is, in many instances, to win a trophy or blue ribbon. Pictured on these pages are a wee boy dwarfed by a super-size cabbage in Alaska's Matanuska Valley (opposite) and another lad, Jerry Rose III, aged three in October 2005, climbing on his dad's triumphant 1,344.5-pound pumpkin in Huntsburg, Ohio (below). Just for the record—which is, after all, what such extraordinary examples of vegetation are all about—it is thought that a 1,725-pound behemoth lovingly nurtured in 2009 by Christy Harp of Jackson Township, Ohio, is the largest pumpkin ever grown.

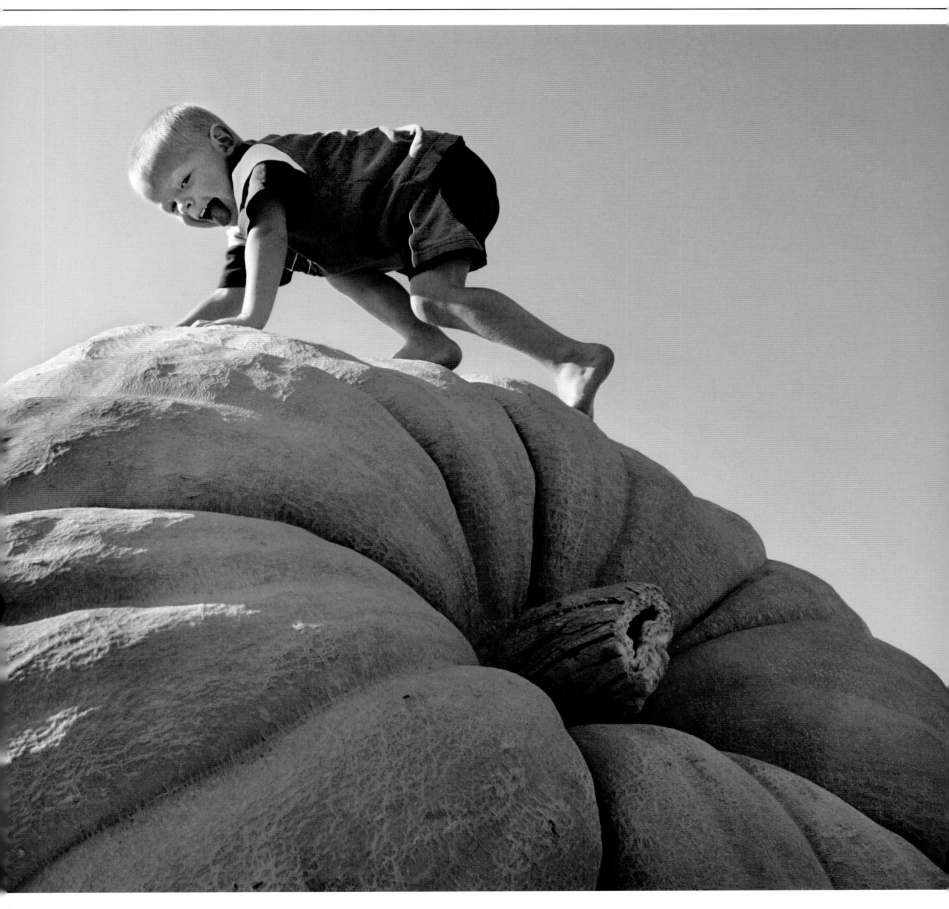

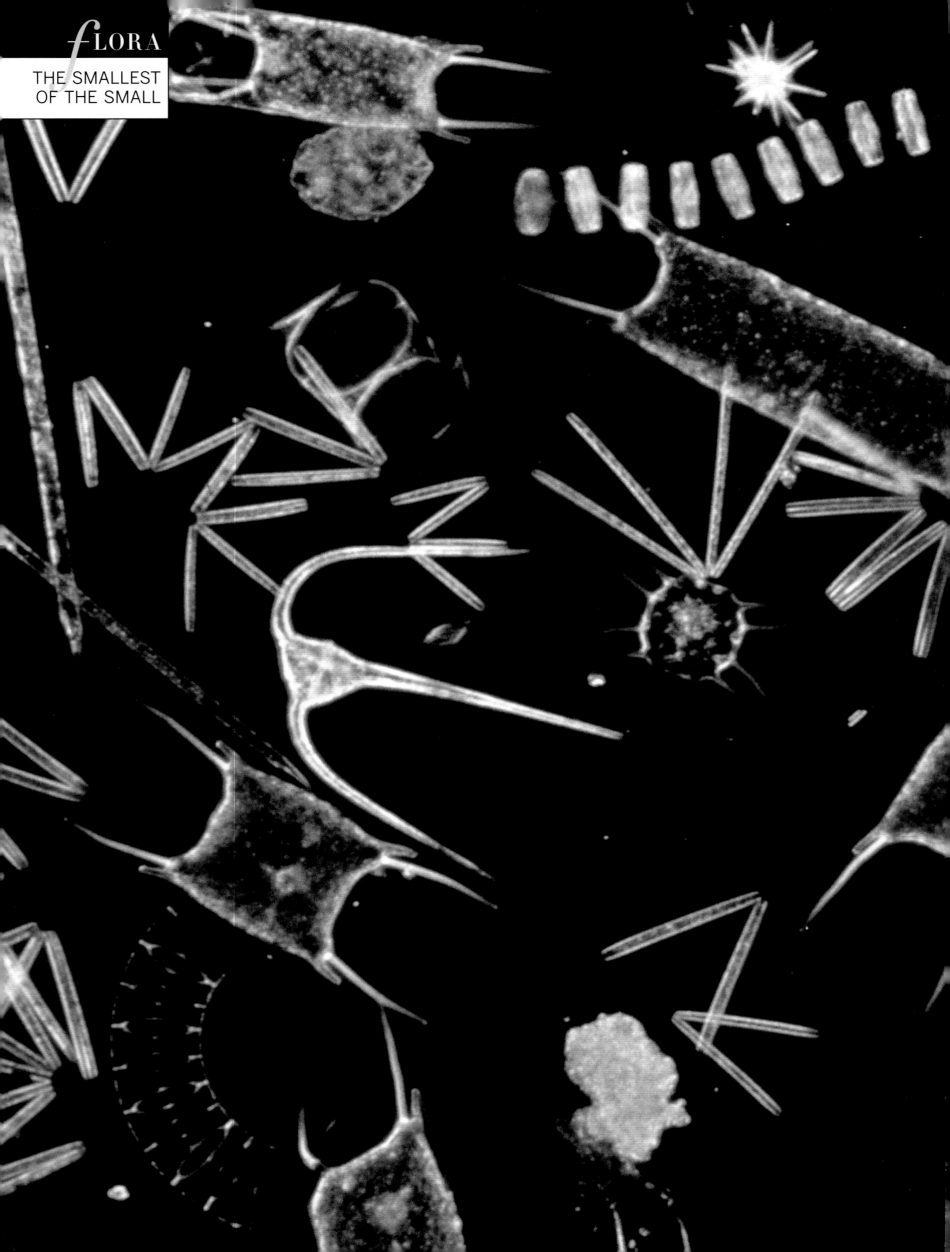

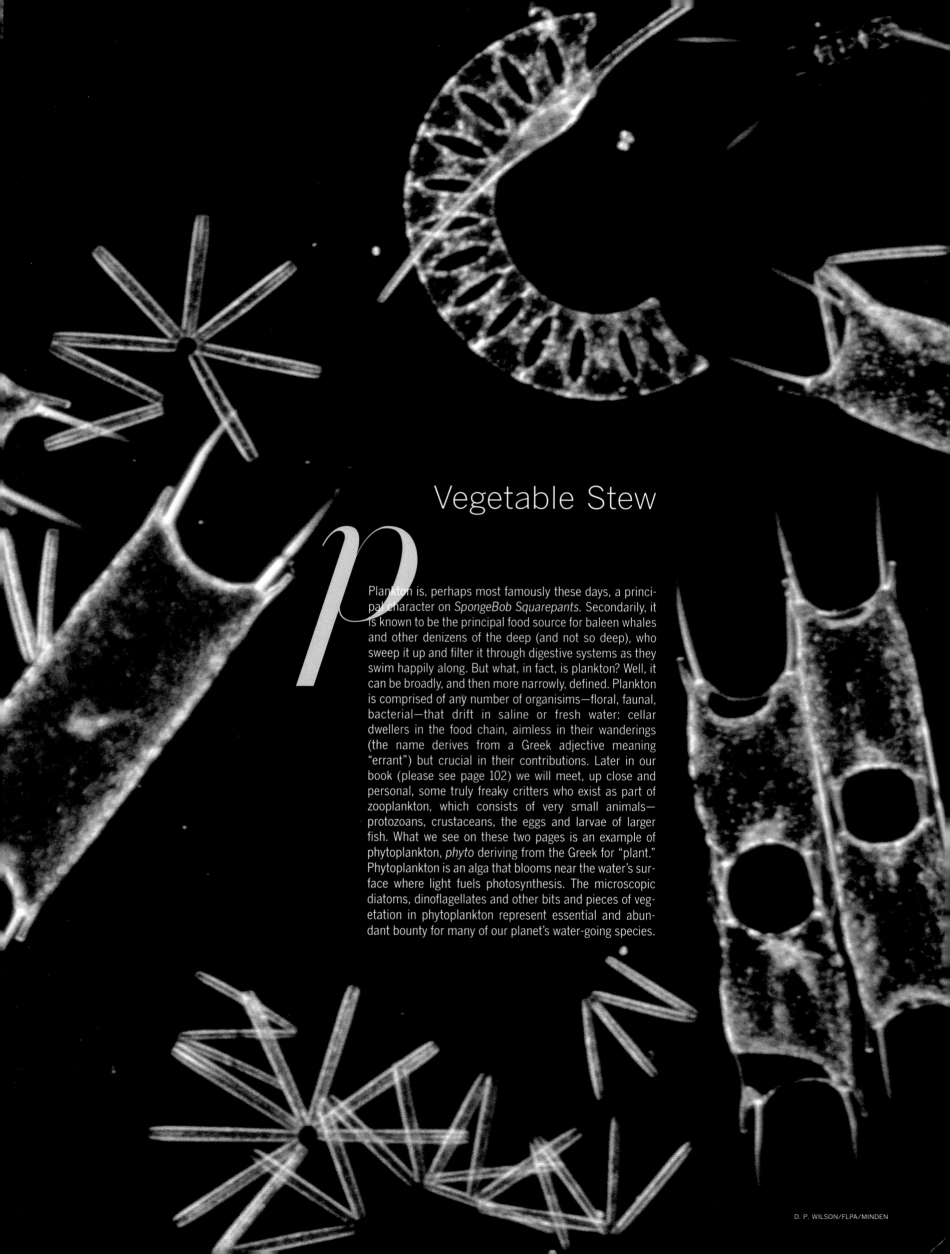

Vegetable Stew

*P*lankton is, perhaps most famously these days, a principal character on *SpongeBob Squarepants*. Secondarily, it is known to be the principal food source for baleen whales and other denizens of the deep (and not so deep), who sweep it up and filter it through digestive systems as they swim happily along. But what, in fact, is plankton? Well, it can be broadly, and then more narrowly, defined. Plankton is comprised of any number of organisims—floral, faunal, bacterial—that drift in saline or fresh water: cellar dwellers in the food chain, aimless in their wanderings (the name derives from a Greek adjective meaning "errant") but crucial in their contributions. Later in our book (please see page 102) we will meet, up close and personal, some truly freaky critters who exist as part of zooplankton, which consists of very small animals— protozoans, crustaceans, the eggs and larvae of larger fish. What we see on these two pages is an example of phytoplankton, *phyto* deriving from the Greek for "plant." Phytoplankton is an alga that blooms near the water's surface where light fuels photosynthesis. The microscopic diatoms, dinoflagellates and other bits and pieces of vegetation in phytoplankton represent essential and abundant bounty for many of our planet's water-going species.

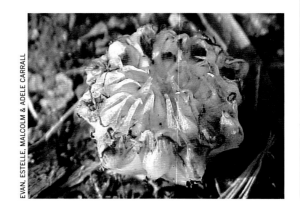

EVAN, ESTELLE, MALCOLM & ADELE CARRALL

In the Wild . . .

There are weird plants everywhere, but the "underground orchid," of which there are only two known species in the world (one native to western Australia and one native to the east of the island continent) is said to be "so unique that it is considered a scientific wonder." To fully appreciate the flower's rarity even in its own family, consider that there are more than 35,000 species of orchids, the largest group of flowering plants on the planet—one of every seven such plants is an orchid— and yet the underground orchid was completely unknown in horticultural circles before 1928, when farmer Jack Trott saw a tiny crack in the ground and detected a sweet odor emitting from it. He removed a bit of dirt and found a pretty white flower about a half-inch in diameter. This leafless plant, the western version of the orchid, had devised a way to grow and flower entirely underground (thus conserving water) in a harsh, desert environment. Between 1928 and 1959 the western orchid was found only six more times, in each instance purely by chance. Twenty years went by before it was seen again in 1979, and no new populations have been discovered since 1989. Meantime, the eastern underground orchid (left) was first seen in 1931 and has since been found in perhaps 10 places, most recently in 2002 by a 13-year-old boy. As it is still unknown what species of vegetation the orchid depends on for survival, the plants cannot be successfully transplanted or cultivated. The same is hardly true of the mountain pine, seen below in one of its many native locales, in the high country above Abruzzo, Italy. It has been thoroughly domesticated, and as with the plants we will meet immediately following, it is today a decorative staple worldwide.

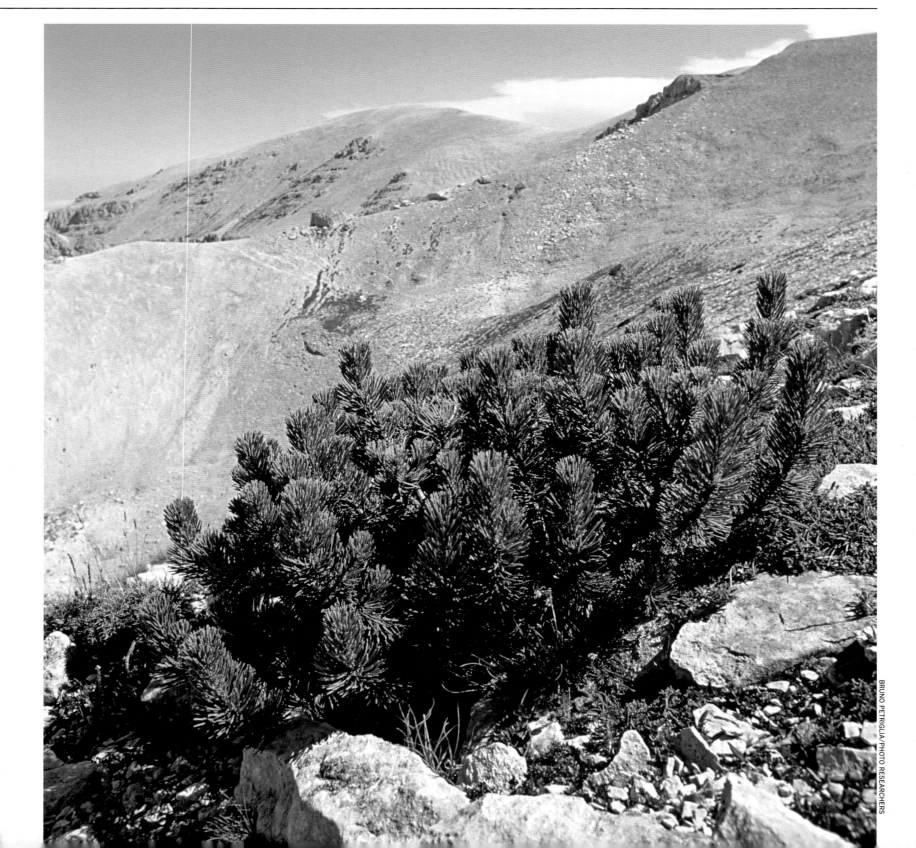

BRUNO PETRIGLIA/PHOTO RESEARCHERS

f For reasons of practicality and aesthetics, many human beings enjoy smaller versions of things: dinky dogs, little rodents and all manner of dwarf plants. The mountain pine opposite is a mini version of a taller tree, because in the high country, it must hunker down in the face of wind and weather to survive. But in gardens and along public and private walkways worldwide, it is an adornment bred to delight passersby. The pine and many other trees are genetically engineered in smaller editions, but the most famous and widely misunderstood of tiny trees is the bonsai. The term refers to a process rather than a species: growing trees from a variety of stocks—perhaps a juniper, perhaps something else that might behave appropriately—and then pruning and potting to the individual's satisfaction. Bonsai, in other words, is all about craft; it's about art more than agriculture. Worldwide, the term *bonsai* and the trees associated with it are considered Asian, and this is just: The word represents a Japanese pronunciation of an earlier Chinese term for the cultivation and display of miniature trees; the Chinese practice of *pentsai* dates from the Chin Dynasty, circa A.D. 256 to 420. Today, bonsai-shaped trees like this one from a Japanese garden are grown in homes from Australia to Alaska, South Africa to Sweden.

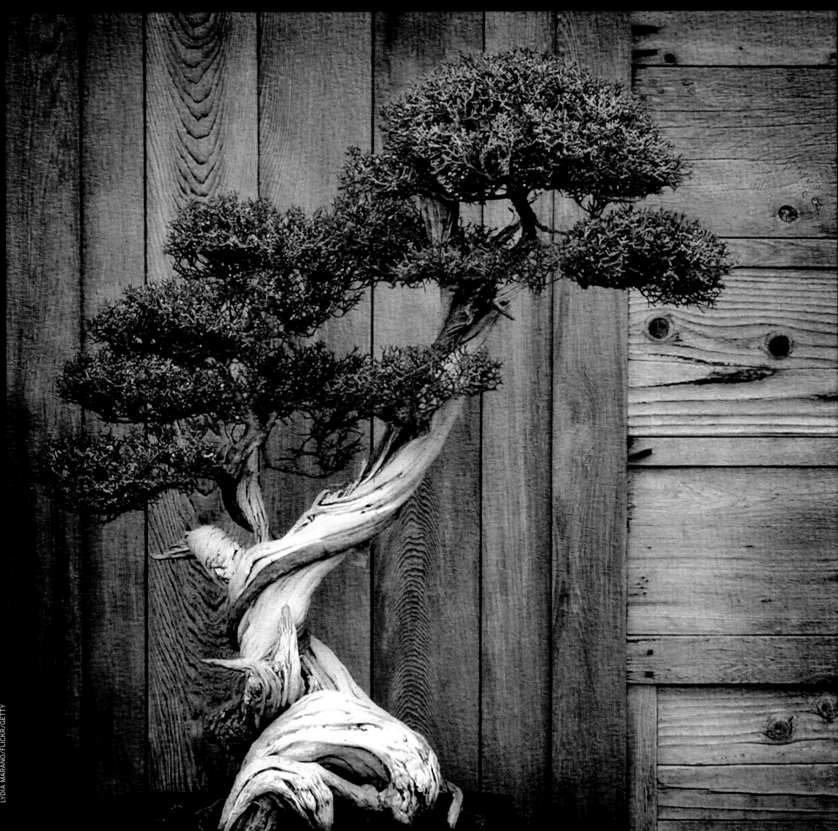

LEE ANNE WHITE/AURORA

Nasty Customers

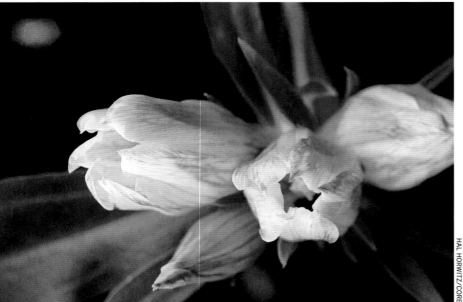

HAL HORWITZ/CORBIS

PARAMESWARAN PILLAI KARUNAKARAN/FLPA/MINDEN

Venomous snakes and spiders are feared by all, not least because many of them can move and strike with stealth and alacrity. But the world is rife with poisonous plants, some more notorious than others, that pose a threat simply by sitting there in the noonday sun. In this first grouping we have species whose names or reputations clearly shout: *Danger!* Clockwise on these two pages, from top left: The castor bean in the dark-leafed plant lurking amid the ornamental grasses contains the deadliest plant poison on earth; the bushman's poison plant has historically supplied a toxin that renders the arrows of southern African natives quickly lethal; the seeds of moonseed can cause paralysis or death in humans but are harmless to birds; nightshade, also known as the devil's cherry or belladonna, has toxins throughout that can cause convulsions and death in humans but that have no effect on birds, horses and other animals; the water hemlock is the "most violently toxic plant . . . in North America," according to the USDA; it is the stalks and leaves, not the dark berries, of the ominously named chokecherry that can cause asphyxiation; the berries of a strychnine tree can be lethal, as Queen Cleopatra's servants, forced to ingest them, learned to their painful dismay; and when cows ingest snakeroot blooms (above), their produce can cause milk sickness in humans.

DAVID CAVAGNARO/VISIONS UNLIMITED/GETTY

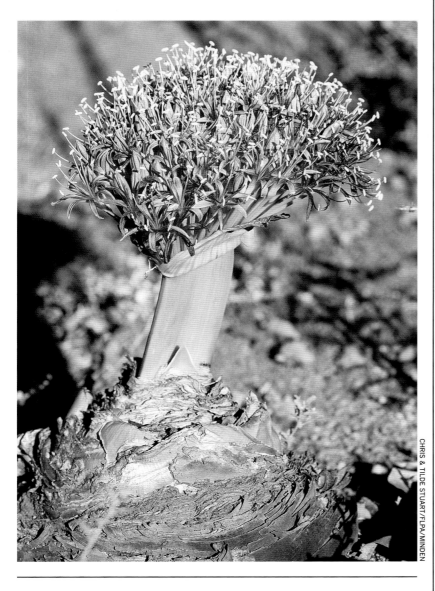

Frenemies

The plants on the pages immediately previous come with warning signs, usually in the form of ominous names; the ones seen here do not. Some are among our favorite flowers yet threaten us with grave dangers. Below: Narcissus, better known and beloved as the daffodil, has bulbs that can cause illness if consumed (the flower and stem are nontoxic to humans). Opposite, clockwise from top left: Daphne, a popular ornamental shrub, contains the toxin mezerein, which causes vomiting and diarrhea; the rosary pea, this specimen of which is in south Florida, is anything but holy, containing in its seed toxic abrin, which can cause hemorrhaging and seizures; a flower with a similarly religious name, the angel's trumpet is related to petunias and potatoes but contains a hallucinogen that can prove lethal; the baseball plant has become a ubiquitous lawn ornament despite its inherent toxicity; the rhododendron and its cousin the shrub azalea are both poisonous as they contain andromedatoxin in their leaves and berries; and, finally, oleander, another favorite as a decorative shrub, has leaves, twigs, blooms and berries that can kill horses, livestock and humans.

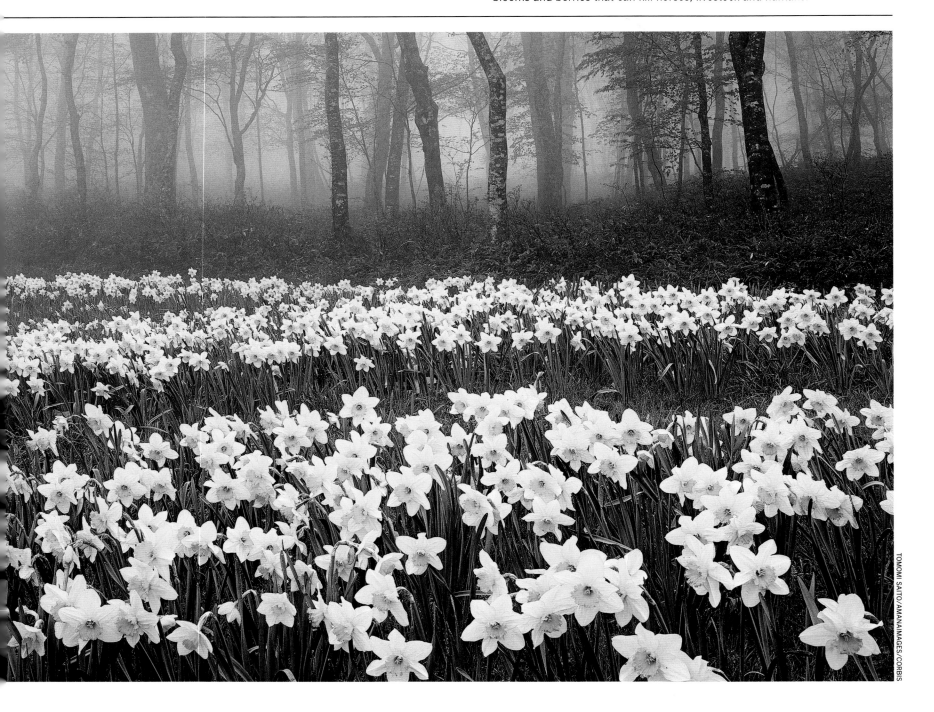

TOMOMI SAITO/AMANAIMAGES/CORBIS

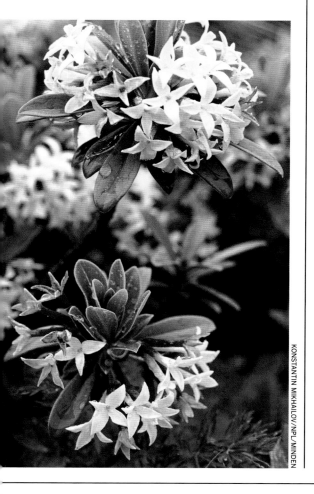

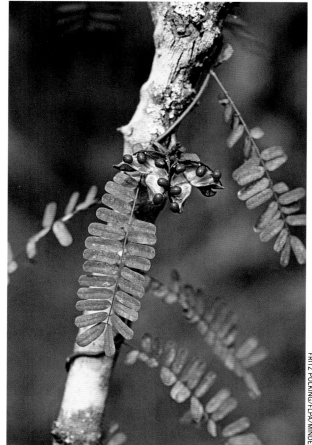

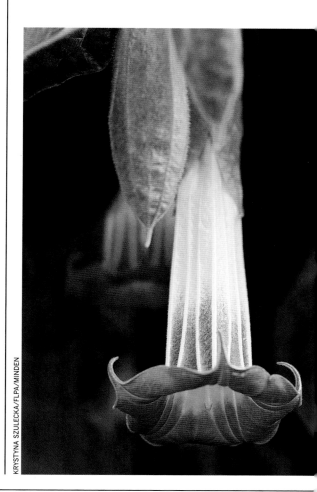

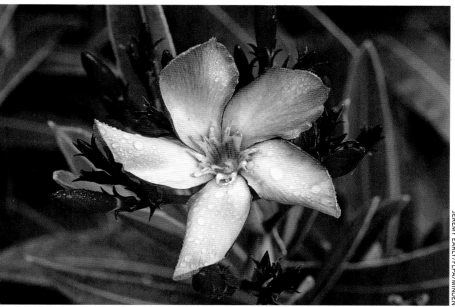

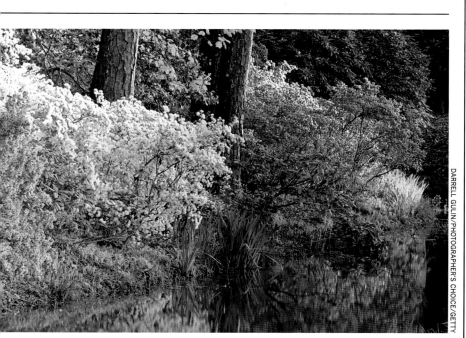

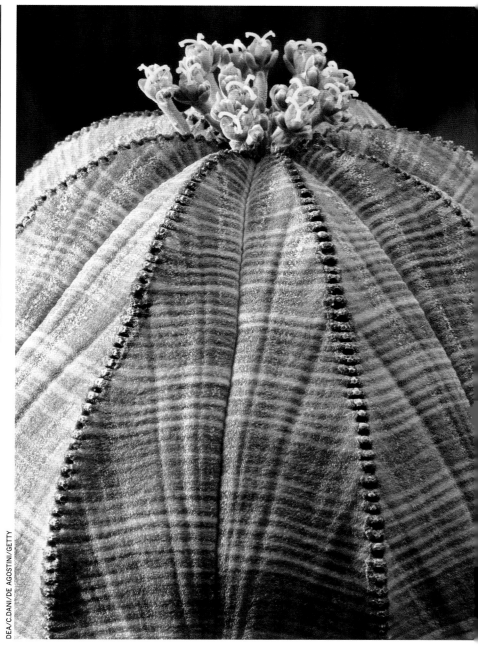

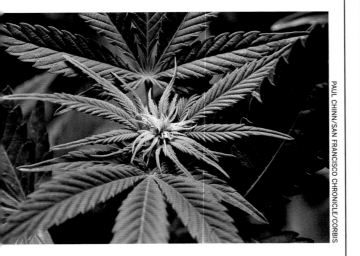

PAUL CHINN/SAN FRANCISCO CHRONICLE/CORBIS

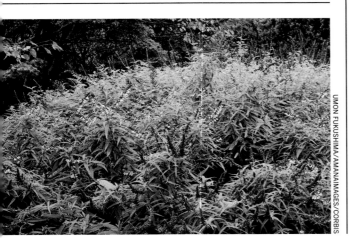

UMON FUKUSHIMA/AMANAIMAGES/CORBIS

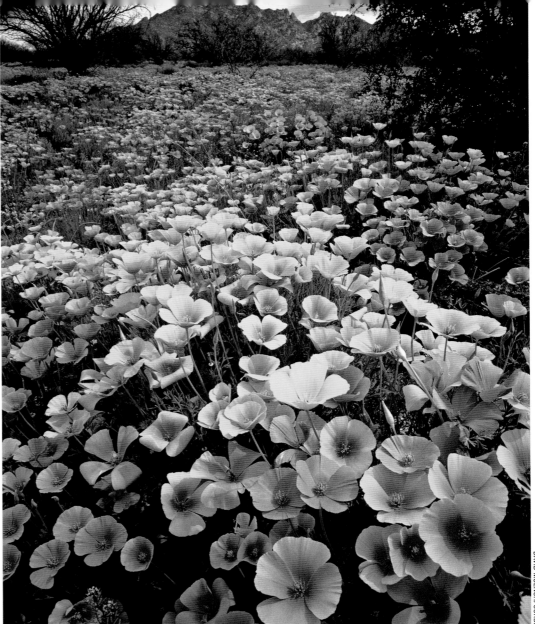

DAVID MUENCH/CORBIS

BLICKWINKEL/AURORA

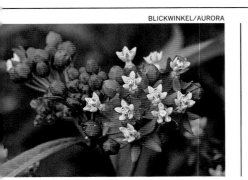

THAD SAMUELS ABELL II/NATIONAL GEOGRAPHIC/GETTY

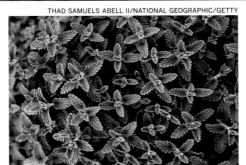

SAM ABELL/NATIONAL GEOGRAPHIC/GETTY

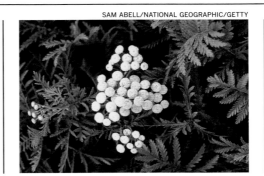

WILDLIFE/PETER ARNOLD

The Straight Dope on Medicinal Plants

Since the time of the ancients man has known that there existed hundreds of flowers, herbs and other plants that could be used to cure an itch or quell a fever. On these two pages and on those immediately following we look at some of the planet's most potent and proliferative medicinals. Clockwise from top left, we have marijuana, widely abused recreationally but of professional use (and legal for such in more than a dozen states) in treating everything from depression and anxiety to cancer pain; a carpet of California poppies that would make Dorothy swoon and that could alleviate nervous tension or pain in others; an unfurling frond of lady fern, one of the world's oldest plants, whose juices have an astringent property useful in easing the pain of cuts, bee stings and minor burns; alfalfa, once a character in the *The Little Rascals,* and for much longer an important hay crop of the legume family, rich in minerals and vitamins (C, D, E and K) and, say some, a help in reducing cholesterol; tansy, a member of the aster family with a strong scent, also known as Stinking Willie, of use today as an insect repellent and in Merrie Olde England during Lent in tansy cakes, whose bitter taste reminded the partaker of Christ's suffering; catnip or catmint, whose secreted oils have properties that relieve menstrual cramps and insomnia in humans and cause freaky delight in felines; blood flower, whose sap is an emetic, inducing vomiting (which can be a good thing) and can also help as a heart stimulant or (get this!) worm expellant; and sage, which derives from the Latin *salvera,* meaning "to heal," and whose properties can relieve gas pains. Sage can be useful, but it is hardly as potent as John Evelyn claimed in the 1600s: "'Tis a plant indeed with so many and wonderful properties, as that the assiduous use of it is said to render men immortal." That particular cure-all has yet to be found.

FRITZ POLKING/FLPA/MINDEN

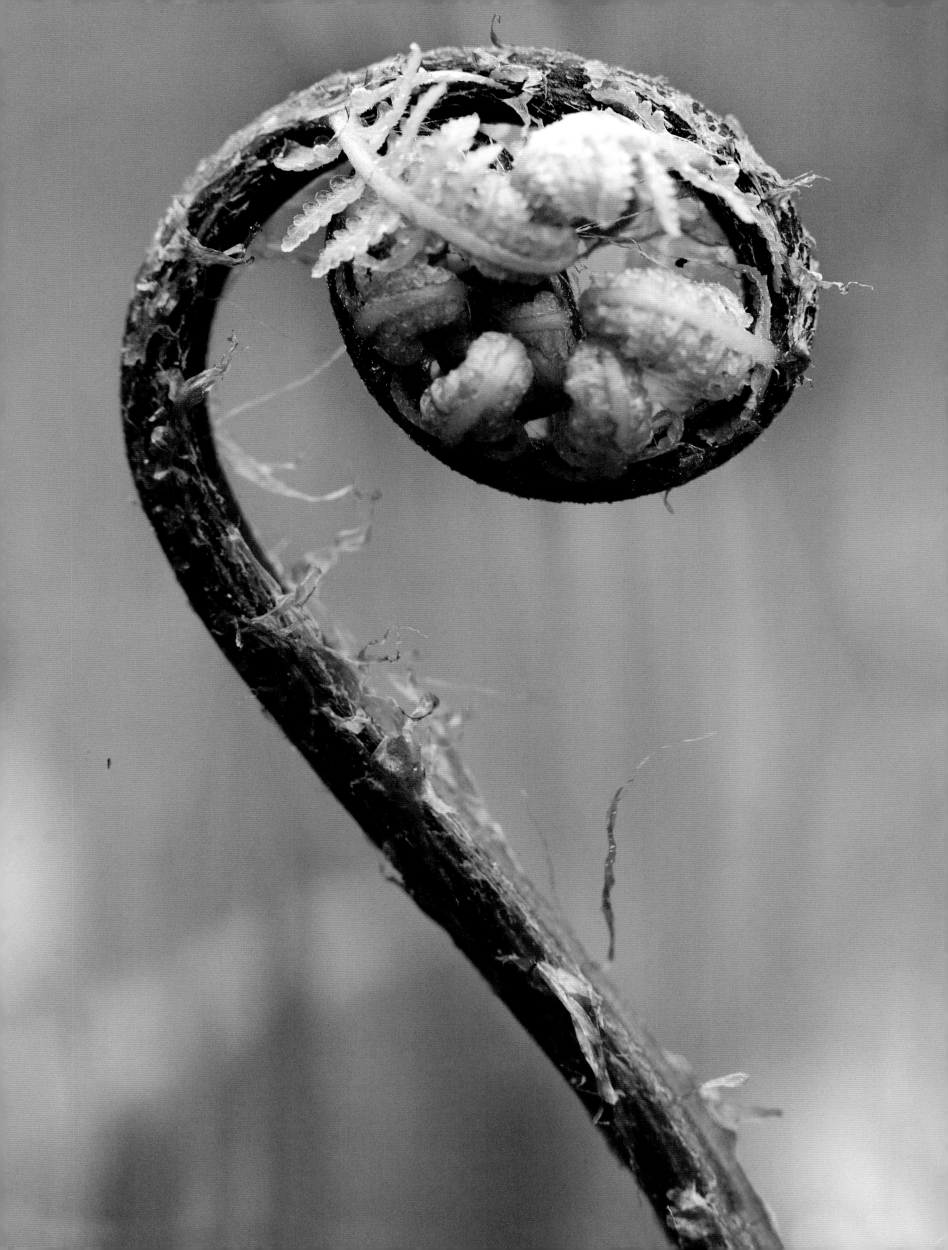

Good for
What Ails You

TOM TILL/AURORA

PAUL TAYLOR/STONE/GETTY

ROLF NUSSBAUMER/NPL/MINDEN

GEOFF SIMPSON/NPL/MINDEN

Today by-products of plants are found in anti-inflammatory sprays, anti-fungal ointments, insect repellents, antiseptic solutions, fever-reducing agents, antihistamines, painkillers, expectorants, antibacterials and detox drugs; the garden is indeed well represented in the pharmacy. Beginning clockwise from top left, we see red clover, among the largest clovers and the most famous as a healer, which was once used to alleviate coughs and even longer ago to ward off evil spirits, and today is thought by many herbalists to be an effective sedative and detoxifier; roots of the burdock herb which, when boiled, have traditionally been used to treat rheumatism, gout and, when applied externally, dandruff; luscious blackberries, which contain health-promoting vitamins and antioxidants in their berries, but also anti-inflammatory and dysentery-fighting medicines in the plant's roots and leaves; wild marjoram, which can aid in human digestive processes; wild quinine, which was used historically by various American Indian tribes in treating burns and illness in humans and animals, and has been employed as a fever-reducer in treating malaria, though its dangers as a medicine have been noted by the FDA; sweet violet, thought by some to be effective in fighting colds and flu, and thought by some physicians to be an effective diuretic; feverfew, which provides balm to soothe insect bites and tea to soothe the soul; and Navajo tea (intermingling with prickly pear cacti), used since time immemorial to treat urinary tract infections.

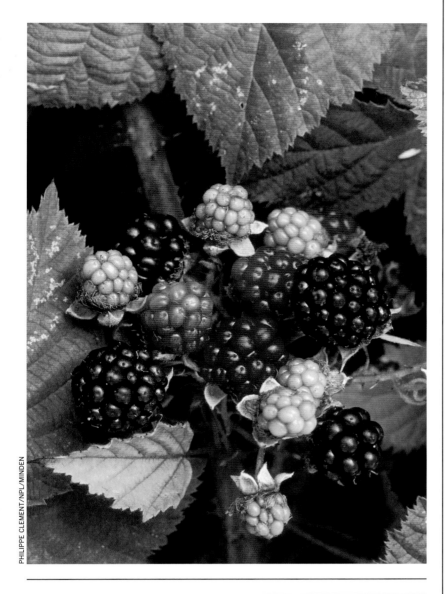

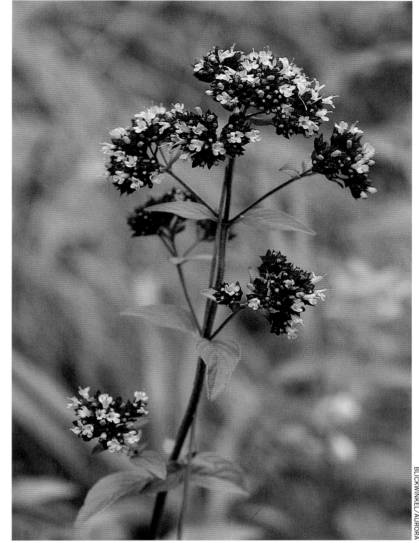

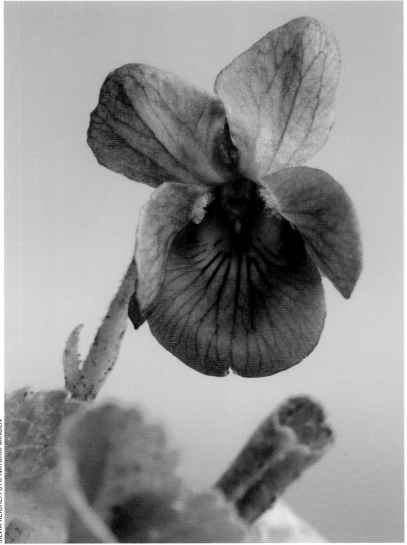

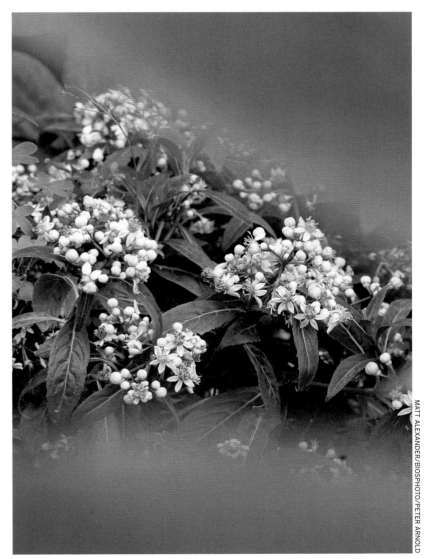

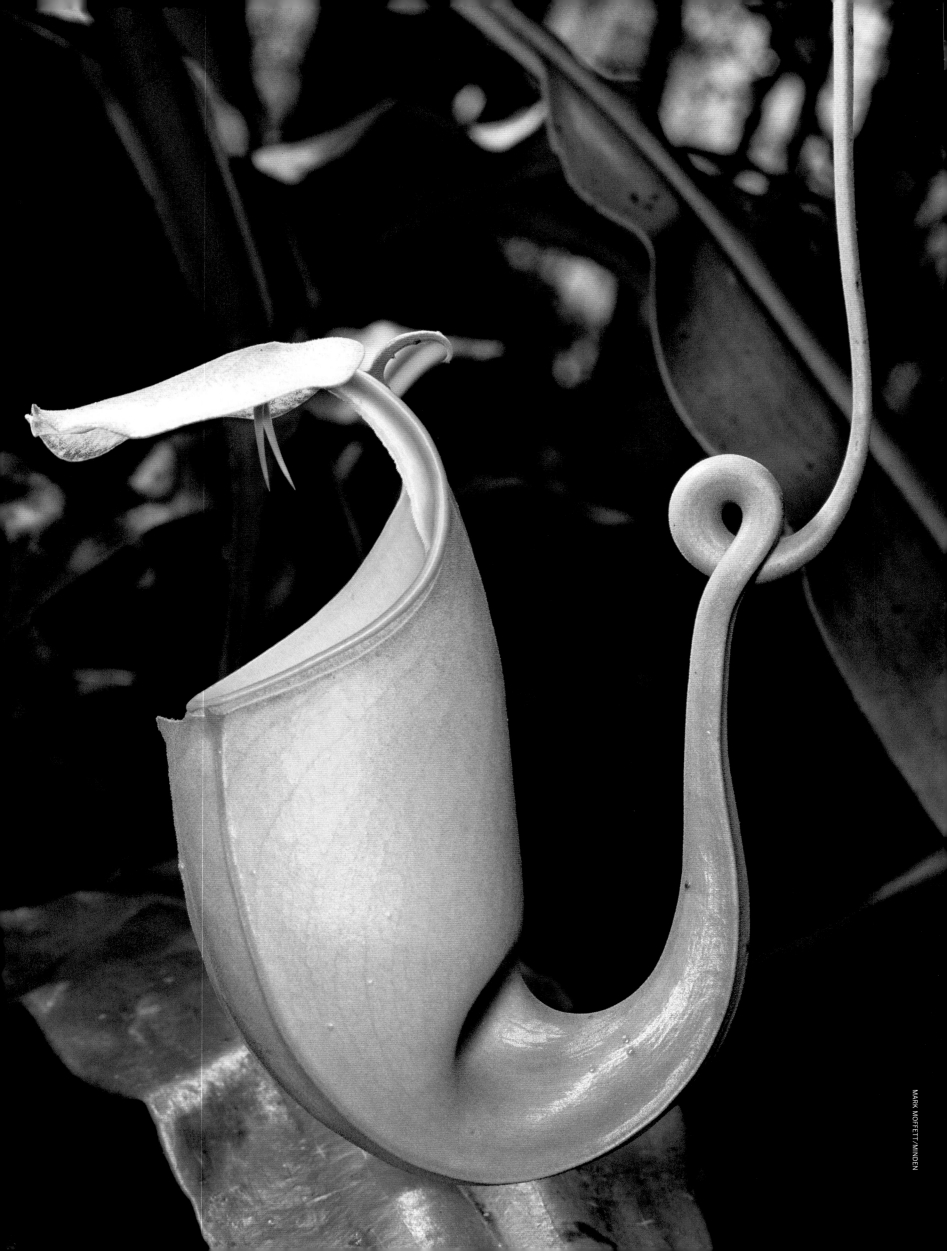

*O*n these pages we see three different pitcher plants, each as lethal as the next to insects and other arthropods, the primary food source of all terrestrial carnivorous plants. There are perhaps 630 species of bug-eating plants in the world, luring and trapping their prey in a variety of ways. Some of them feature, as we shall see, bladder traps, flypaper traps or snap traps. Pitcher plants use a mechanism known as a pitfall trap. These killers have no moving parts but typically attract insects with a nectarlike substance secreted near the rim of their, well, pitcher. The victim ventures further, then slides in to its doom—drowned and then digested in the belly of the beast. Opposite is a Villose pitcher plant in Borneo, and below, right, is an Albany pitcher about to dine on an ant in western Australia. In North America we have up to 11 species of *Sarracenia,* and this is one (below, left) being visited in its eastern United States habitat by a gray tree frog, who hopes to steal the pitcher's meal.

All-Star Pitchers

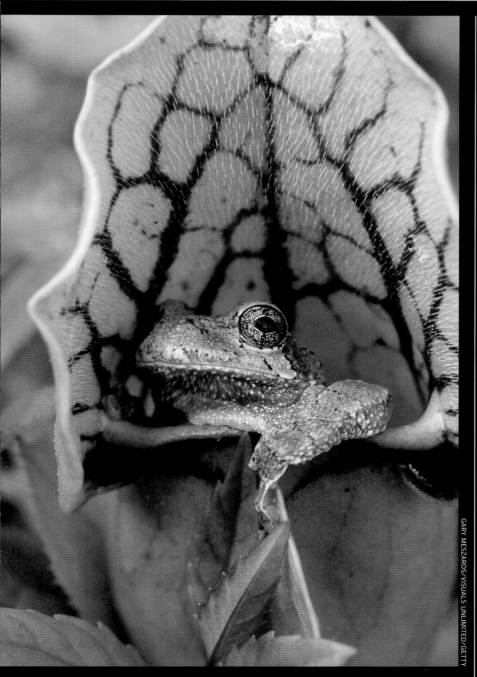

GARY MESZAROS/VISUALS UNLIMITED/GETTY

MICHAEL DURHAM/MINDEN

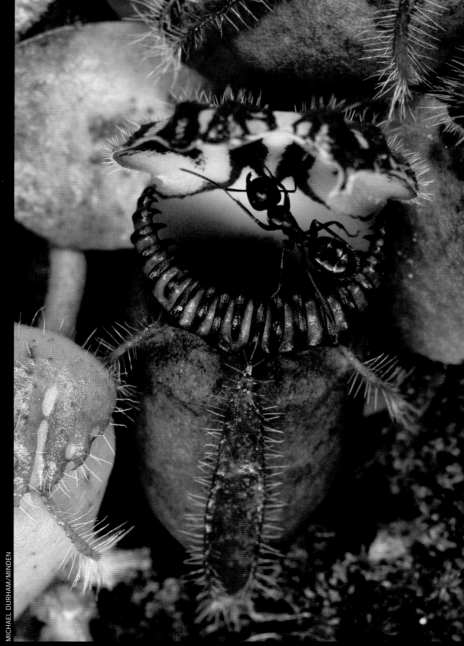

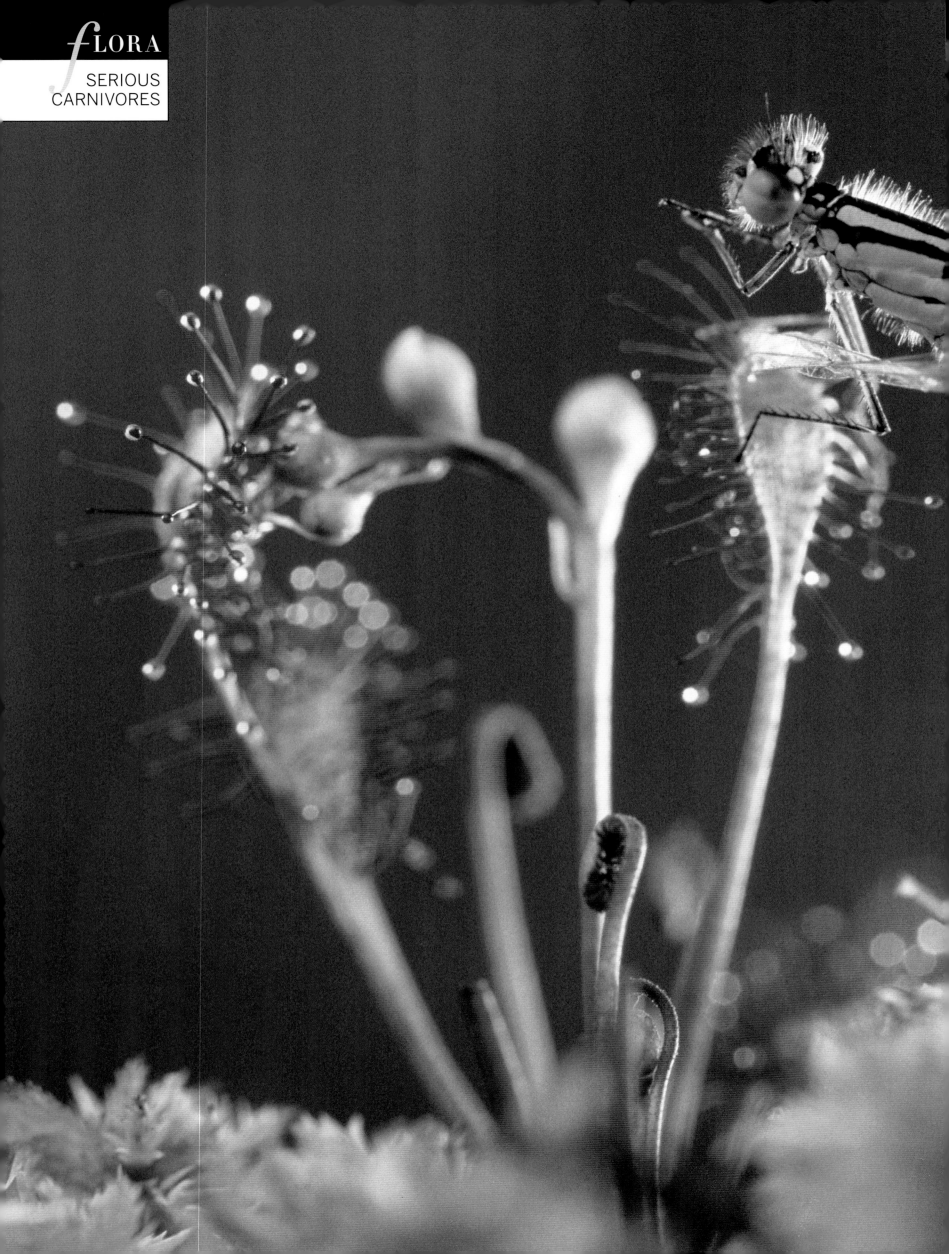

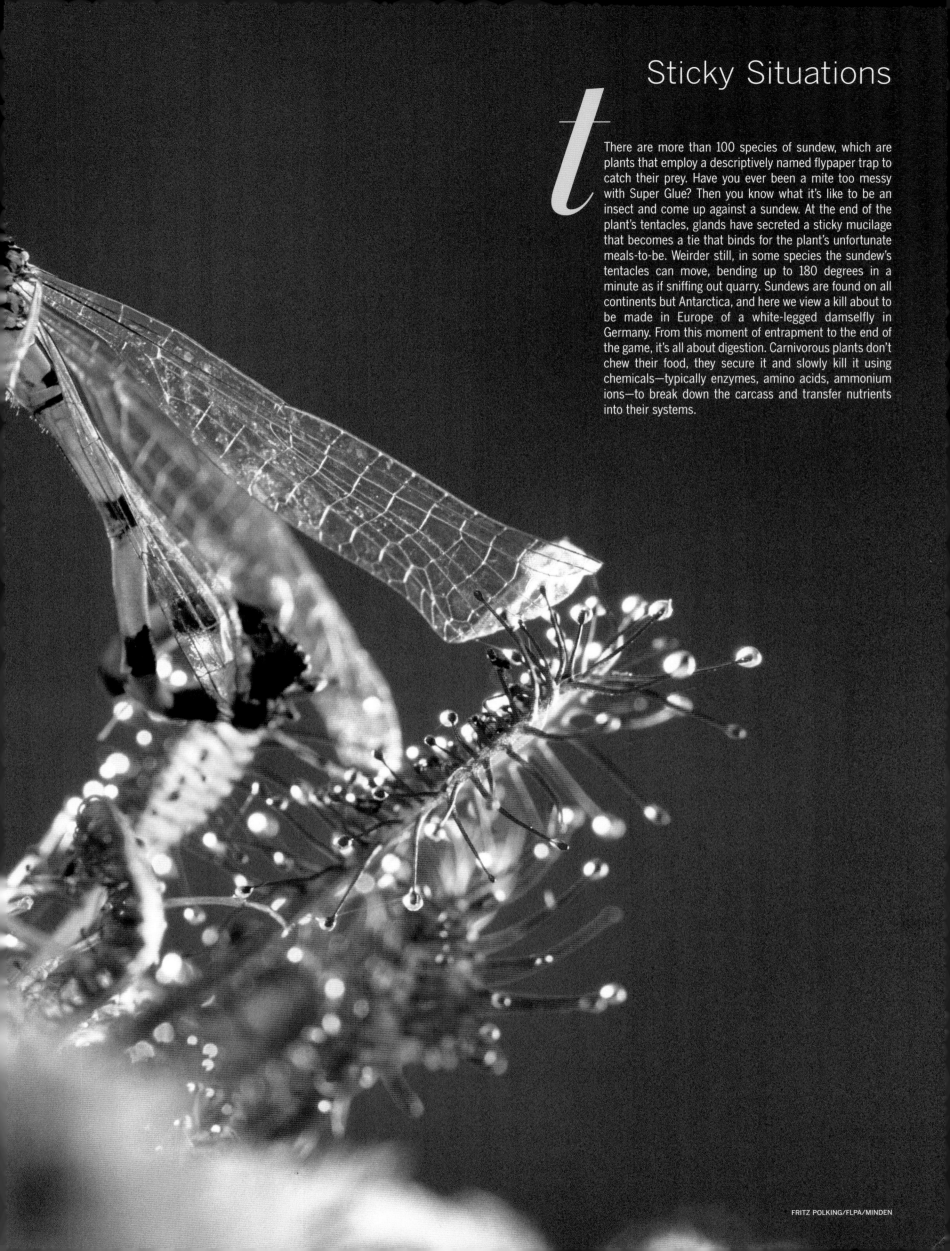

Sticky Situations

t

There are more than 100 species of sundew, which are plants that employ a descriptively named flypaper trap to catch their prey. Have you ever been a mite too messy with Super Glue? Then you know what it's like to be an insect and come up against a sundew. At the end of the plant's tentacles, glands have secreted a sticky mucilage that becomes a tie that binds for the plant's unfortunate meals-to-be. Weirder still, in some species the sundew's tentacles can move, bending up to 180 degrees in a minute as if sniffing out quarry. Sundews are found on all continents but Antarctica, and here we view a kill about to be made in Europe of a white-legged damselfly in Germany. From this moment of entrapment to the end of the game, it's all about digestion. Carnivorous plants don't chew their food, they secure it and slowly kill it using chemicals—typically enzymes, amino acids, ammonium ions—to break down the carcass and transfer nutrients into their systems.

Tricks of the Trade

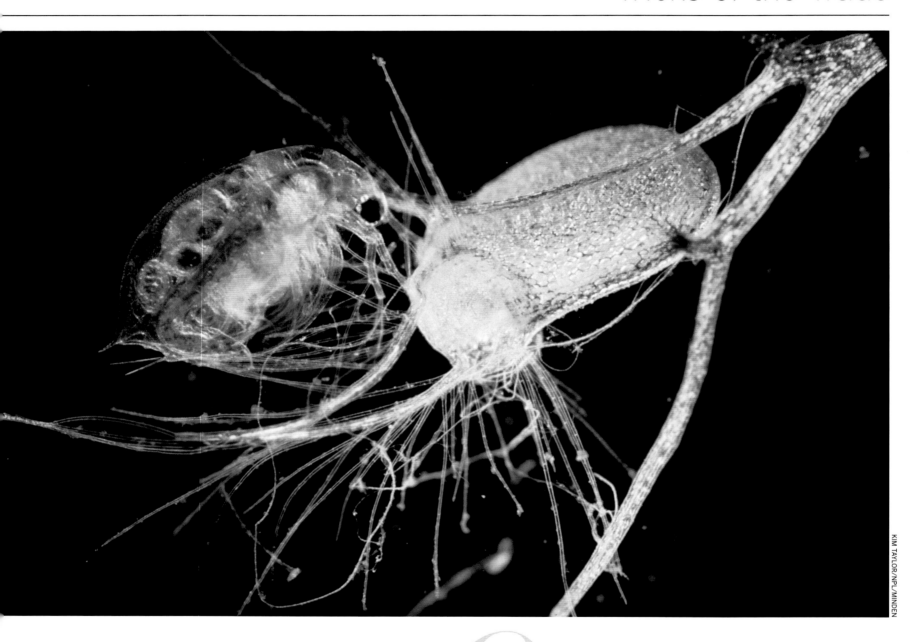

On the opposite page is a flowering common butterwort, having caught a horde of insects in its native habitat in a Scottish peat bog. Above, we have an up-close look at a lesser bladderwort using its antennae to capture a water flea in Surrey, England. In butterworts, of which there are perhaps 80 species worldwide, it is the surface of the unmoving leaves, rather than the come-hither tentacles of such plants as the sundew, that feature the flypaper. Two aspects of butterworts can be readily gleaned in the image we see here. First, they are often found in ecosystems like this bog that offer poor mineral nutrition, and hence suffer a diet that needs supplementing with animal nutrients. And second, butterworts have stems to keep their flowers well away from and usually above the sticky leaves, so as not to dissuade or, worse, entrap potential pollinators, who are also crucial to the plant's existence. As for the aquatic bladderwort: This particular picture allows us a vivid view of how its trap works, and you're not going to believe it. The bladderwort, floating about, has encountered its prey. The plant's bladder has now voided itself of ions and some water, creating a partial vacuum within. The ill-fated water flea will soon touch one of the bladderwort's trigger hairs, which will cause a small, hinged door in the bladder to open. *Whoosh:* The flea will be sucked into the bladder—its coffin—as the vacuum is filled. The permutations of nature are multitudinous, of course, and yet the behavior and talents of carnivorous plants are truly astounding.

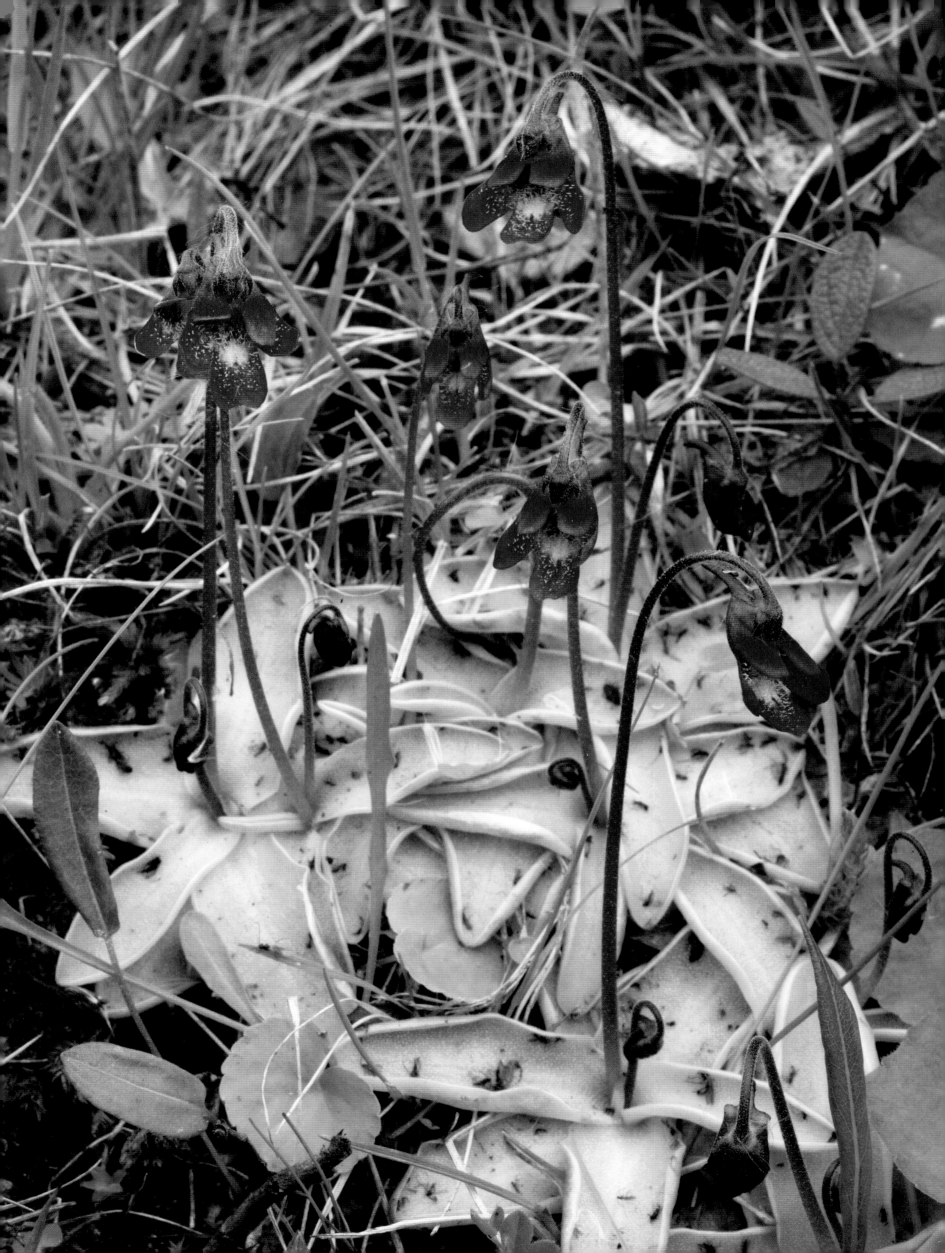

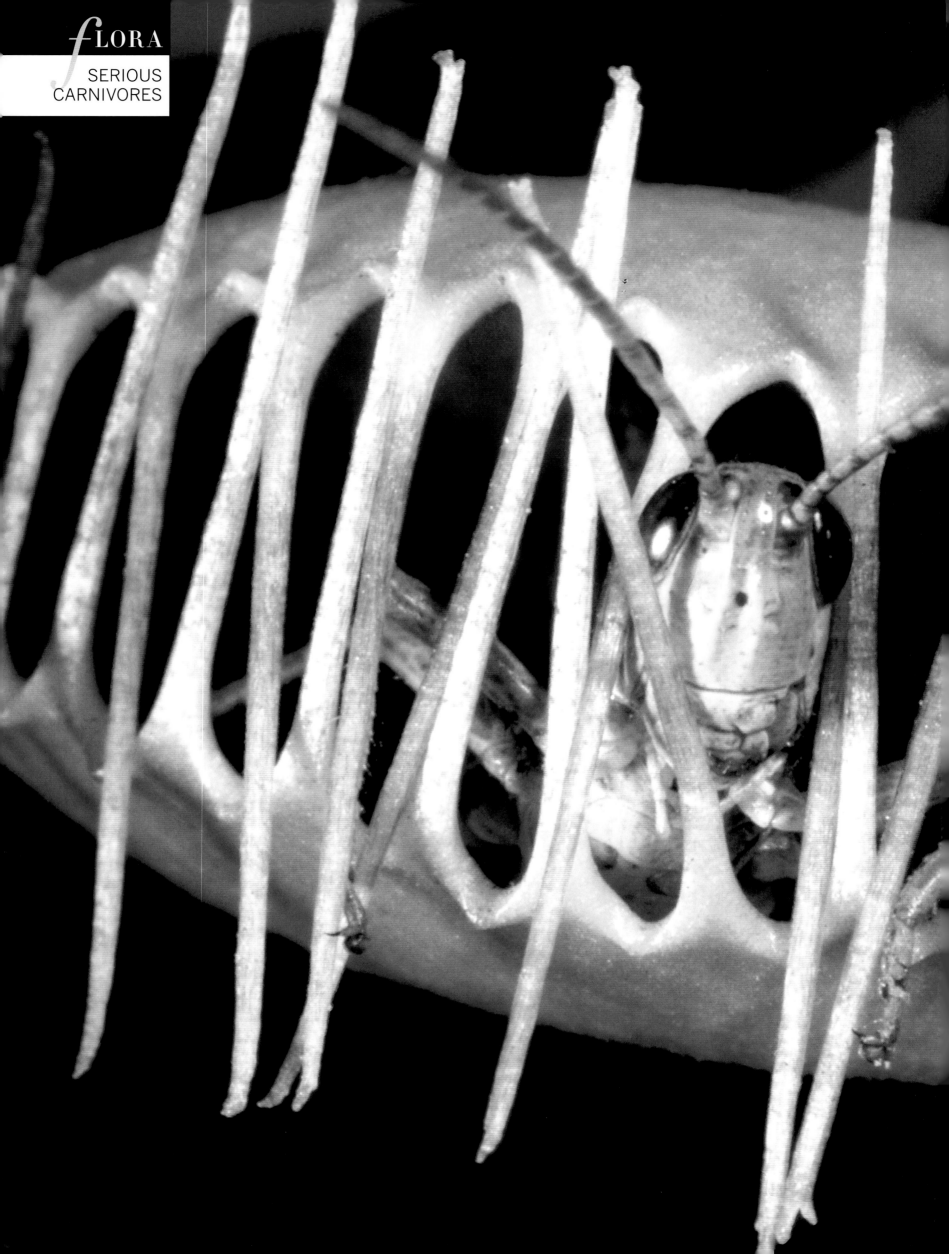

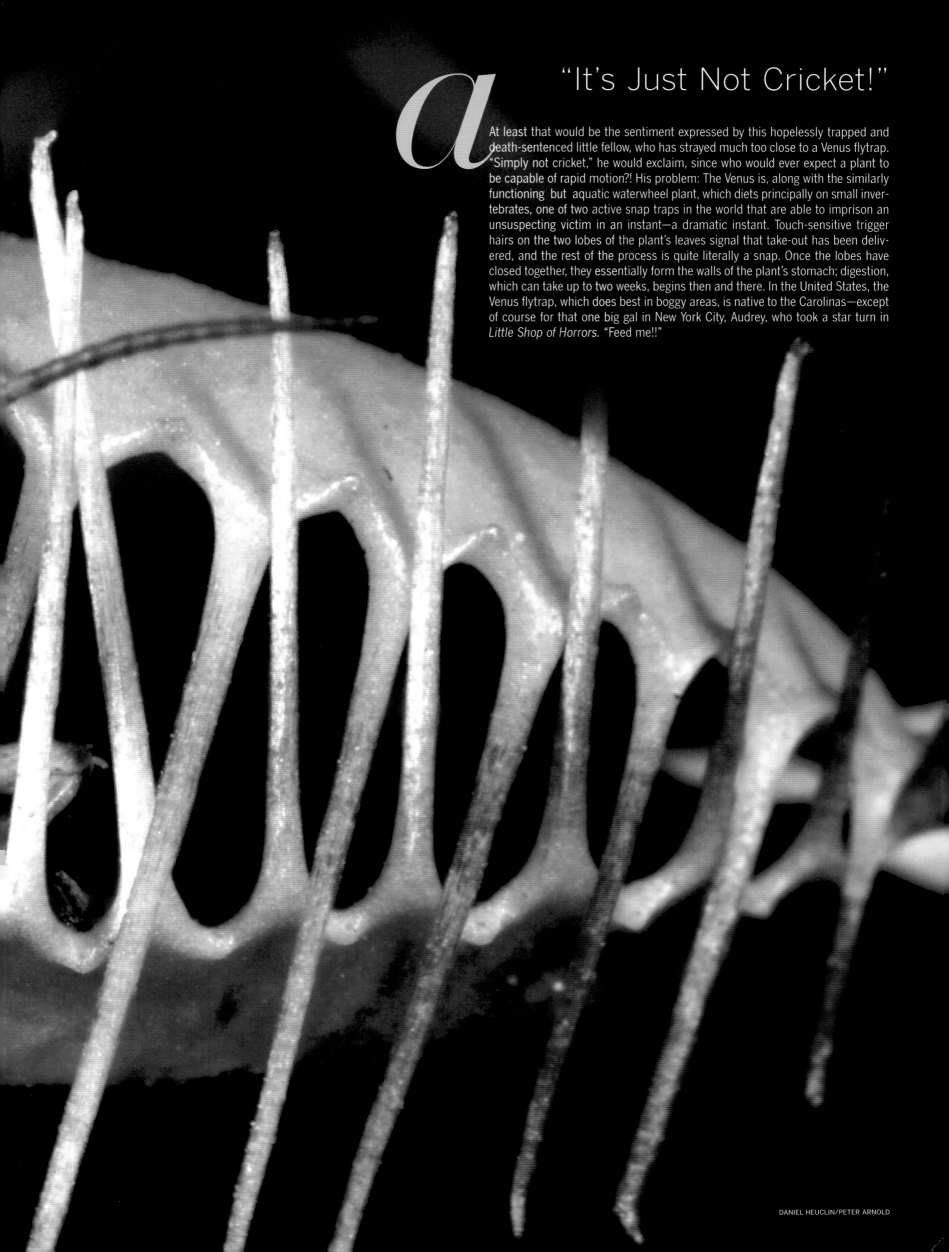

a "It's Just Not Cricket!"

At least that would be the sentiment expressed by this hopelessly trapped and death-sentenced little fellow, who has strayed much too close to a Venus flytrap. "Simply not cricket," he would exclaim, since who would ever expect a plant to be capable of rapid motion?! His problem: The Venus is, along with the similarly functioning but aquatic waterwheel plant, which diets principally on small invertebrates, one of two active snap traps in the world that are able to imprison an unsuspecting victim in an instant—a dramatic instant. Touch-sensitive trigger hairs on the two lobes of the plant's leaves signal that take-out has been delivered, and the rest of the process is quite literally a snap. Once the lobes have closed together, they essentially form the walls of the plant's stomach; digestion, which can take up to two weeks, begins then and there. In the United States, the Venus flytrap, which does best in boggy areas, is native to the Carolinas—except of course for that one big gal in New York City, Audrey, who took a star turn in *Little Shop of Horrors.* "Feed me!!"

Making Do, with Barely a Drop to Drink

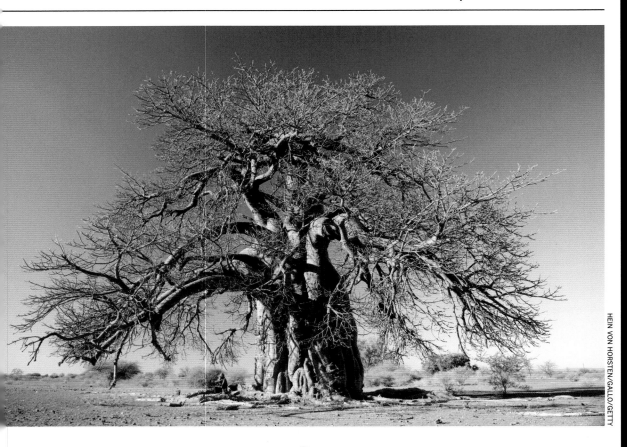

HEIN VON HORSTEN/GALLO/GETTY

i In this "Tough Customers" section of our book, you will meet plants that survive and in cases thrive against seemingly insurmountable odds—and some that look plenty odd because of the way they have adapted to their harsh climes. First up is the baobab tree, a common name for the genus *Adansonia*, which comprises eight species that, besides baobab, are nicknamed bottle tree, monkey bread tree or, most descriptively, upside-down tree. The example seen above is in the Limpopo Province of South Africa, where the largest-known baobab, with a massive circumference of 154 feet, grows. *Adansonia* is also native to Madagascar and Australia, and in order to survive in the drought-plagued regions where they exist, baobabs store every bit of water that falls upon them in a hollow trunk, and some trees can hold more than 30,000 gallons at a time. As an aside, Rafiki in *The Lion King* called a baobab home. At right, we see a dragon's blood tree (so-called for its blood-red sap) in a nature reserve on Socotra Island, which lies off the coast of Somalia and Yemen in the Indian Ocean; this is one of six primary tree-size species of *Dracaena*, also native to arid areas of mainland Africa. They too have stout trunks, and they employ broad-based leaves to collect water.

GREGORY GERAULT/GAMMA/EYEDEA

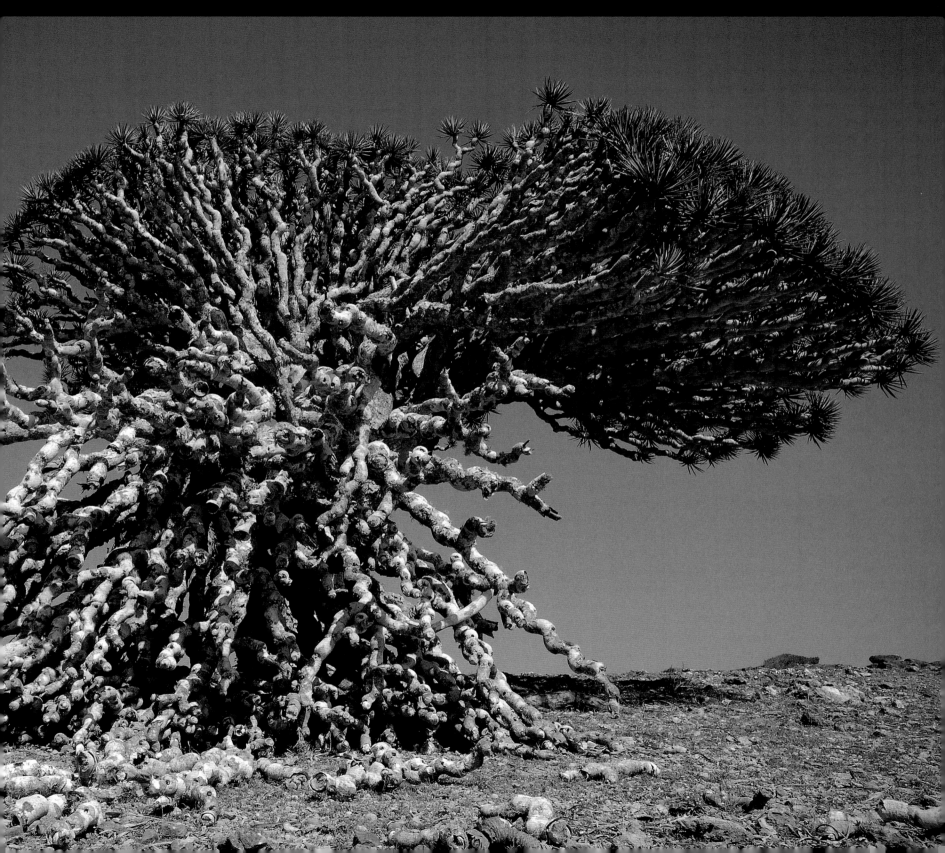

Welwitschia mirabilis, this example of which grows (and has grown for a long, long time) in the ancient Namibian desert, is precisely and properly named. The plant was discovered by the Austrian botanist Friedrich Welwitsch in 1859, and it does indeed seem something of a miracle. The best way to describe it is as a living fossil, hearkening as it does to a time when dinosaurs roamed the region in southwest Africa to which it is native. You cannot tell from this picture, but this plant has a taproot and a thick, woody, very short trunk. From it extend two leaves that grow continuously for hundreds of years—some believe the oldest *Welwitschia* extant today is up to 2,000 years old. These leaves split over time into various sections and reach a length in excess of 12 feet, absorbing every bit of water they can and surviving day to day on as little as the morning dew. This exotic plant from a time before man, which is sometimes harvested by collectors and is therefore endangered, is found in only two countries. It is a harsh irony that the *Welwitschia* in Angola are better off than those in Namibia because of the prevalence of landmines in the former country, which, of course, deter potential plant poachers.

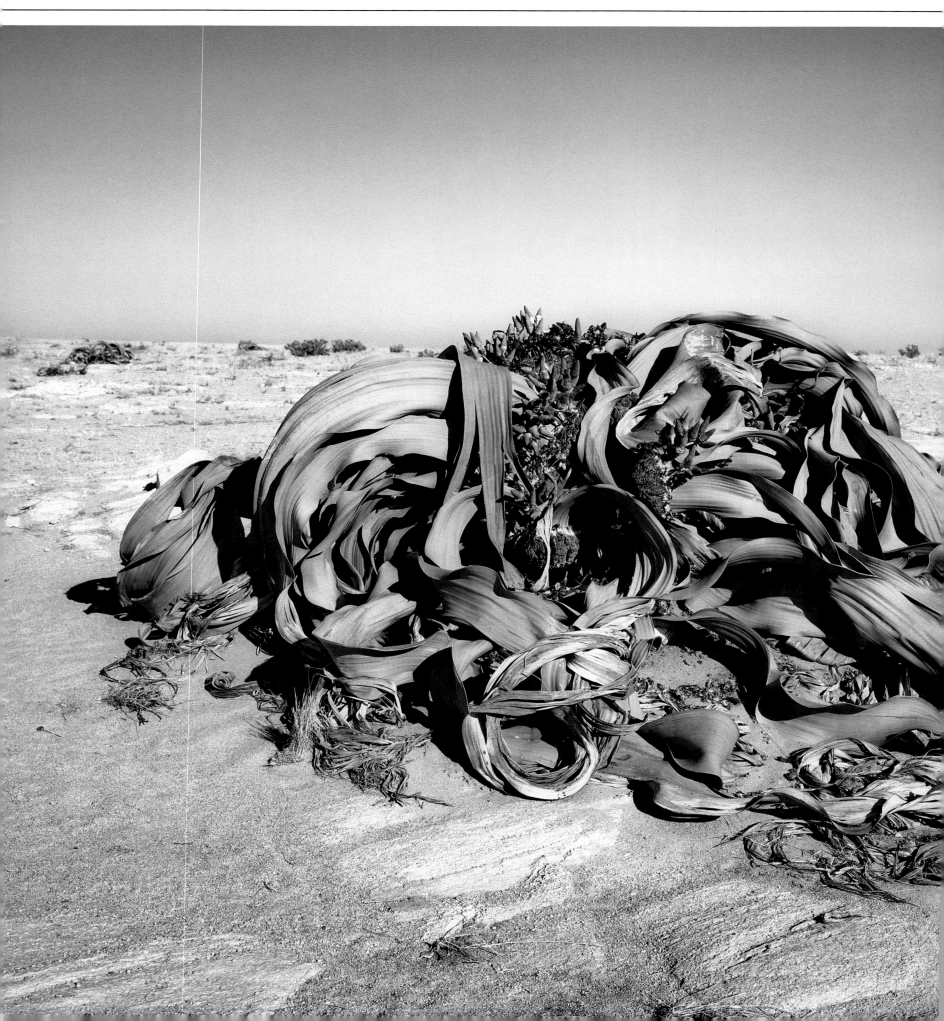

From the Age of the Dinosaurs

The Heights of Beauty

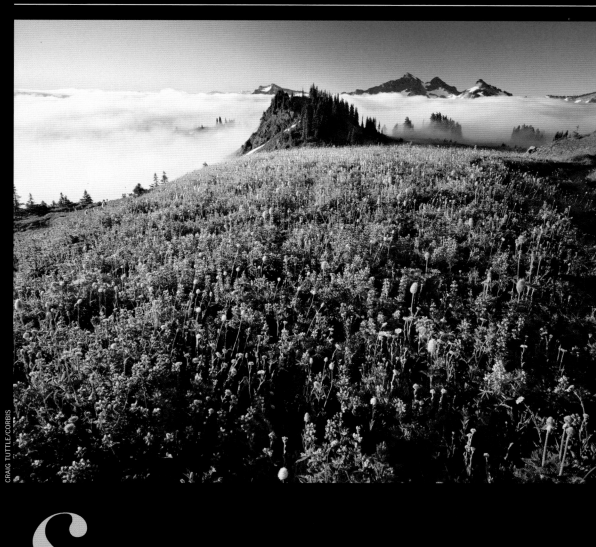

CRAIG TUTTLE/CORBIS

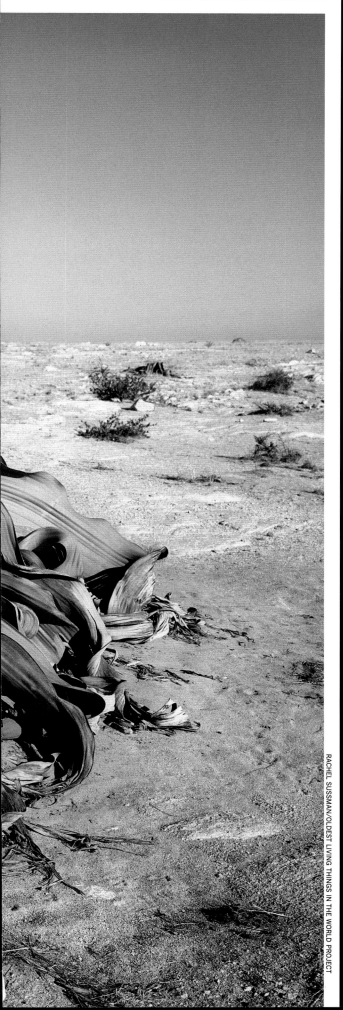

RACHEL SUSSMAN/OLDEST LIVING THINGS IN THE WORLD PROJECT

Some critics could deem *Welwitschia*, which does what it can to survive in barren low-lying sands, to be, well, uhmm, let's be frank: ugly. And these same aesthetes might meantime declare high-country wildflowers to be gorgeous beyond belief. Life is, as has been said, unfair. Each plant has done what it can—what it *must*—to adapt, and then it is judged by a human audience according to a value system that simply doesn't take into account such factors as wind, aridity or temperature but rather criteria like "color" and "brilliance" that fit preconceived notions of beauty. This meadow of wildflowers in this indisputably splendid setting in Mount Rainier National Park in Washington state is, beyond any reasonable argument, "beautiful"—as we and Webster's dictionary would define the word. But these flowers have had no easy and lovely go of it, to this point. These perennials have, like *Welwitschia*, survived their own particular struggles with nature, including battles with snow, ice, wind and drought. Hikers worldwide and since time immemorial have been impressed and regularly astonished by the vibrant plant life they encounter at extreme heights. Hunkered between rocks or, as here, grabbing hold of a small field of soil at a high altitude, these flowers are heavenly—exalting all living things, exalting us all.

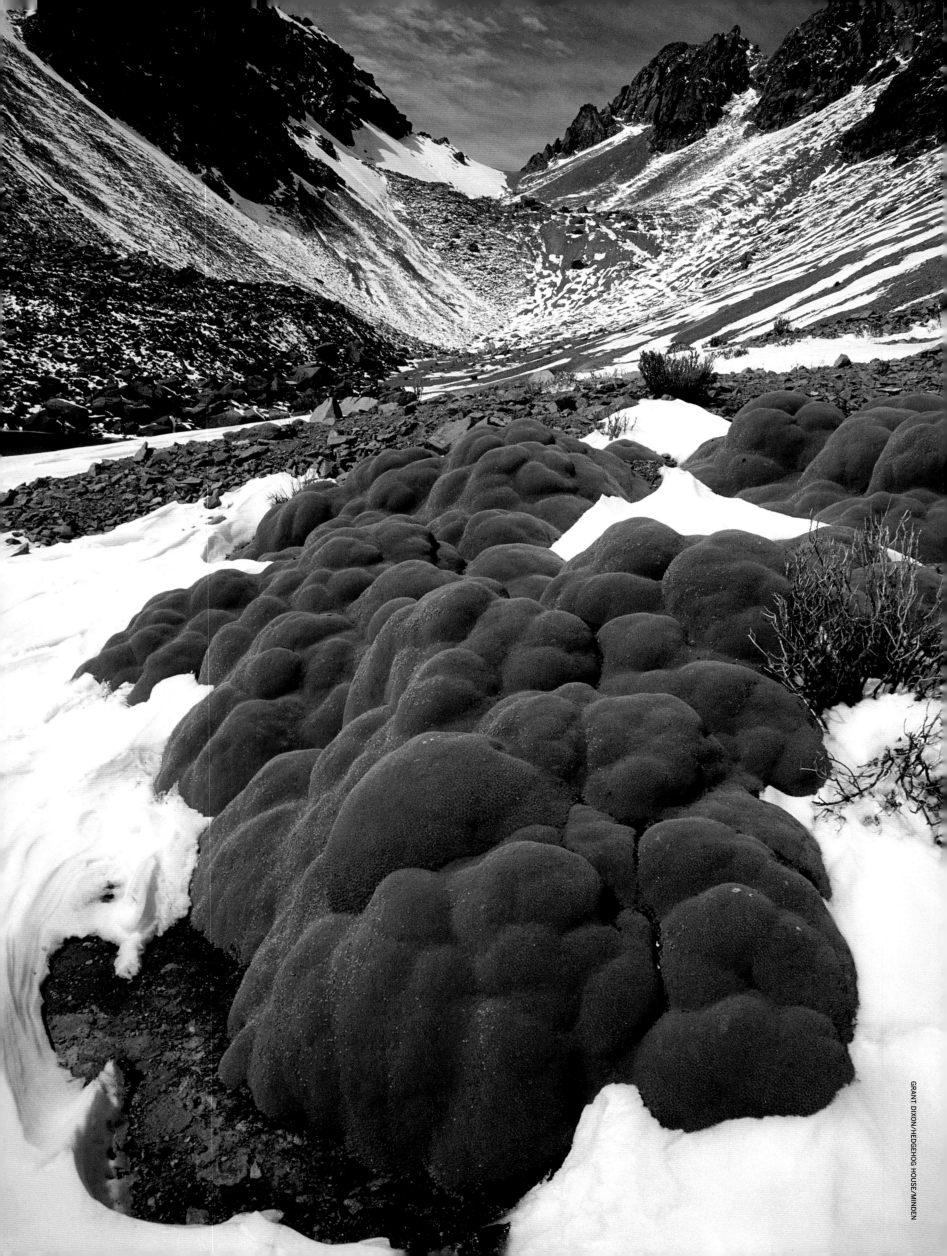

Mountain wildflowers may be the prettiest and among the hardiest of plants that survive at altitude or under cold-weather duress, but they aren't even close to being the strangest. At right, in Alaska's Denali National Park, in the shadow of North America's tallest mountain, we see an example of Arctic willow, which is plenty strange, and opposite we have, growing in Cerani Pass in Colca Canyon, Peru, a fine specimen of the rare yareta, which is stranger still by a significant measure. The Arctic willow, which usually presents as a small shrub growing to six inches in height at a maximum, is indeed a willow, related to that swaying giant that just grabbed your golf ball when you cut the dogleg too sharp, figuring you could get it over the course's legendary "huge willow," insensibly choosing driver over three-wood. It grows in tundra near and even above the Arctic Circle—it is the northernmost woody plant on the planet—and can be found high above the treeline in environments as harsh as northern Greenland. As for the yareta, well: This is a truly bizarre customer. Native to regions of South America above 10,000 feet in altitude, tapering only when the distance above sea level reaches beyond 14,000 feet, this self-fertilizing plant cannot exist in the shade and takes its considerable time growing at all. It progresses close to the ground with an eye toward curbing heat loss, adding perhaps a millimeter a year to its size, doing this for more than 3,000 years at a crack (to judge by currently existing plants). Meantime, in the depths of the world's oceans, we have seagrass, this example of which (below) sways off Mexico's Guadalupe Island, west of Baja. Seagrass, which is crucial to the food chain and under threat by man, consists of flowering plants, which do need light but nonetheless can exist as much as 230 feet below the ocean's surface. As adaptors, they are as impressive as the yareta.

Up Above and
Down Below

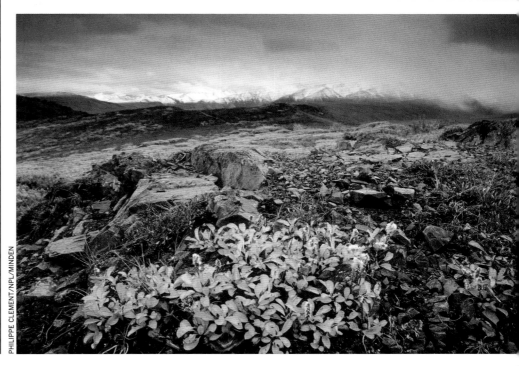

PHILIPPE CLEMENT/NPL/MINDEN

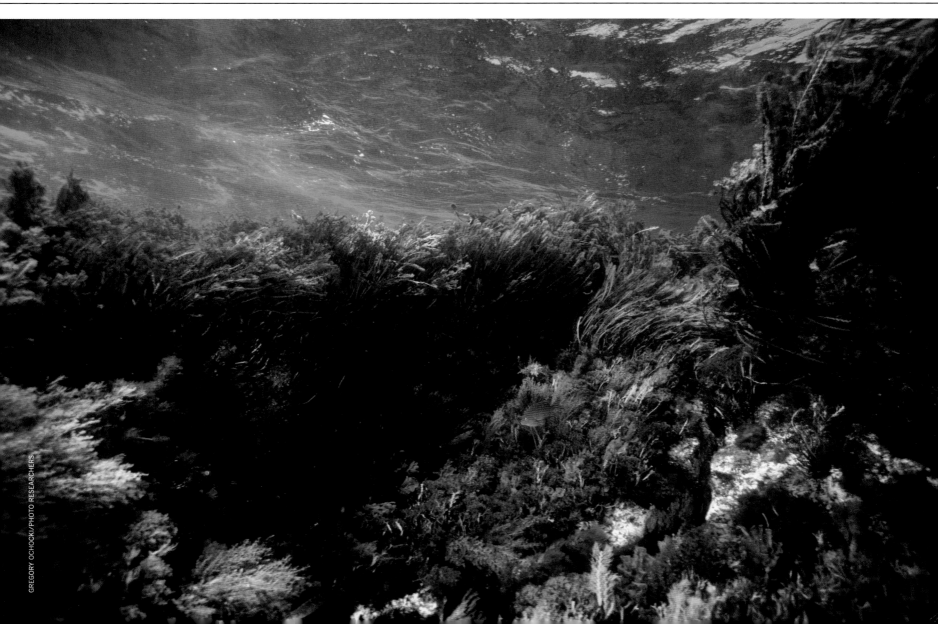

GREGORY OCHOCKI/PHOTO RESEARCHERS

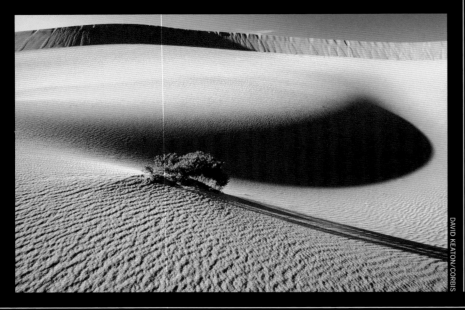
DAVID KEATON/CORBIS

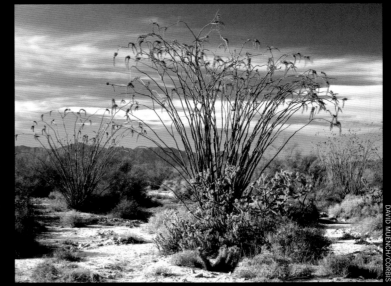
DAVID MUENCH/CORBIS

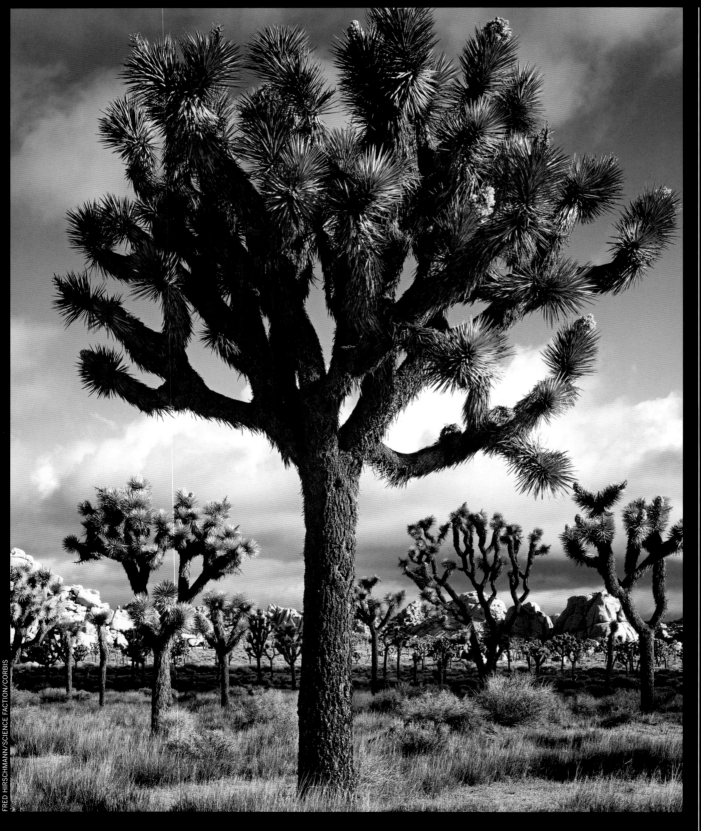
FRED HIRSCHMANN/SCIENCE FACTION/CORBIS

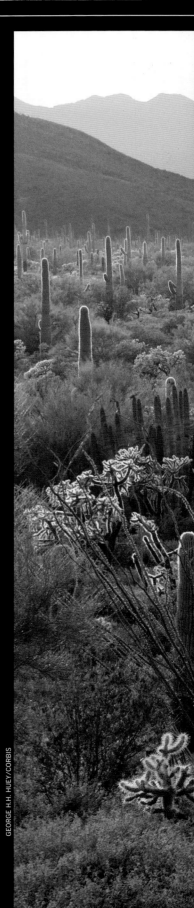
GEORGE H.H. HUEY/CORBIS

South by Southwest

i It is difficult to adapt at altitude and difficult to adapt well below the waves, and it is equally hard to adapt in the desert—as the baobab tree and *Welwitschia* have already illustrated, and as these plants from the American Southwest and Mexican desert serve to confirm. In 1994 a lot of dry land came into the U.S. National Park Service when three new parks—California's Death Valley, where the mesquite plant opposite, top right, is located, and Joshua Tree (opposite, bottom) and Arizona's Saguaro (teddy bear chola and organ pipe cactus, below)—were added to the system. The ocotillo cactus (opposite, top left) grows in Mexico's Sonoran Desert. Mesquite are deciduous trees that can climb as high as 30 feet, and are able to sur-

vive only because of an extremely long taproot (up to nearly 200 feet!) that sucks all H_2O from the water table. The plant burns slowly and very hot, and is a common component in Tex-Mex barbecue. Cacti are the most famous of the world's plants that have adapted to arid environments. They range from 60 footers to the barely measurable. Perennials, they present as trees, shrubs and even vines. The classically formed saguaro grows to nearly 50 feet, though in its first 10 years it remains less than a few inches tall; cacti live between 25 years and 250 years, and this desert giant can hold up to 200 gallons of water. A splendid photograph of this plant, with its flowers in bloom, opened our book's Flora section on pages 8 and 9.

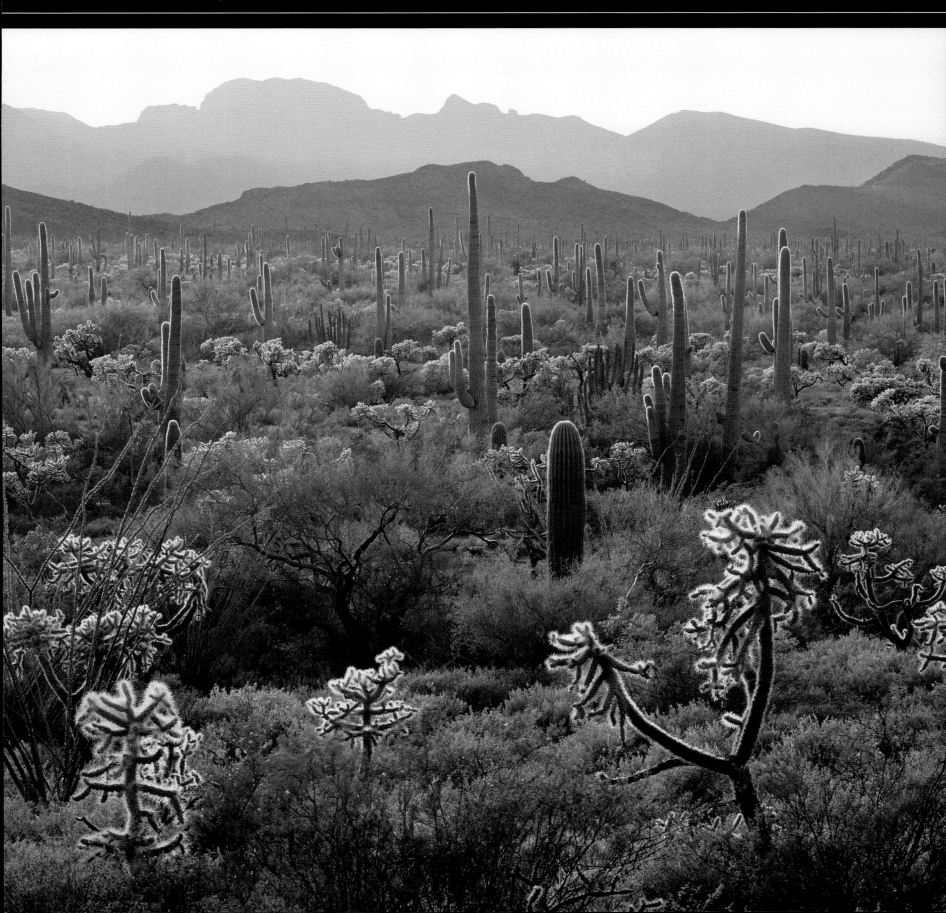

i If cactus and other plants have found a (reasonably) happy home in the driest of places, then mangrove trees have done the same in the wettest; in fact, many mangroves seem, to a viewer standing on shore, to be growing right out of the sea. They are not. Each and every mangrove tree or shrub (and the term, since it has come to mean "coastal trees" generally, is sometimes misapplied to species that are not, in fact, related to *Rhizophoracea*) is always anchored in terra firma. But each tree is also extraordinarily tolerant of saline water, intense sunlight, tidal action and anaerobic (low in oxygen) soil—without mentioning other littoral challenges, including tourism. In the tropics (mangroves exist largely within 25 degrees latitude of the equator), this tree thrives. Once it sinks its emphatically strong and widespread roots in what might typically be considered inhospitable terrain, it becomes a friend to fish and others. Oyster beds hunker by a mangrove, and all manner of sea creatures barnacle themselves to the base of the trees. A mangrove is truly a citizen of two ecosystems: It is at once an undersea plant, useful in that realm, and is also in its essence a terrestrial tree. On these pages, we see aspects of the mangrove. Below: Slender marine halfbeaks and smaller barbs swim past tangled mangrove roots in Indonesia. Opposite, top: Another perspective on that extraordinary root system in Palau. Bottom: An isolated mangrove in the Florida Keys.

The Miracle
That Is the Mangrove

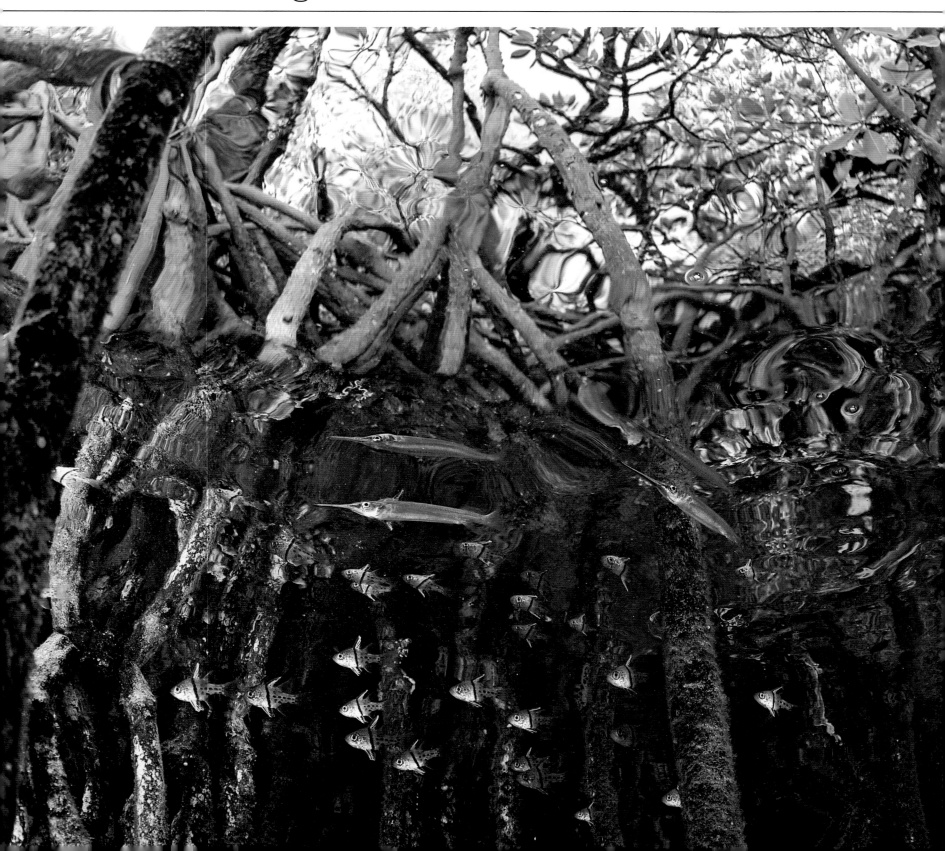

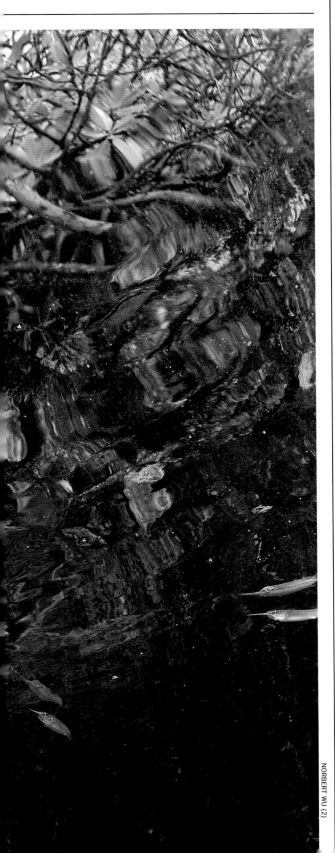

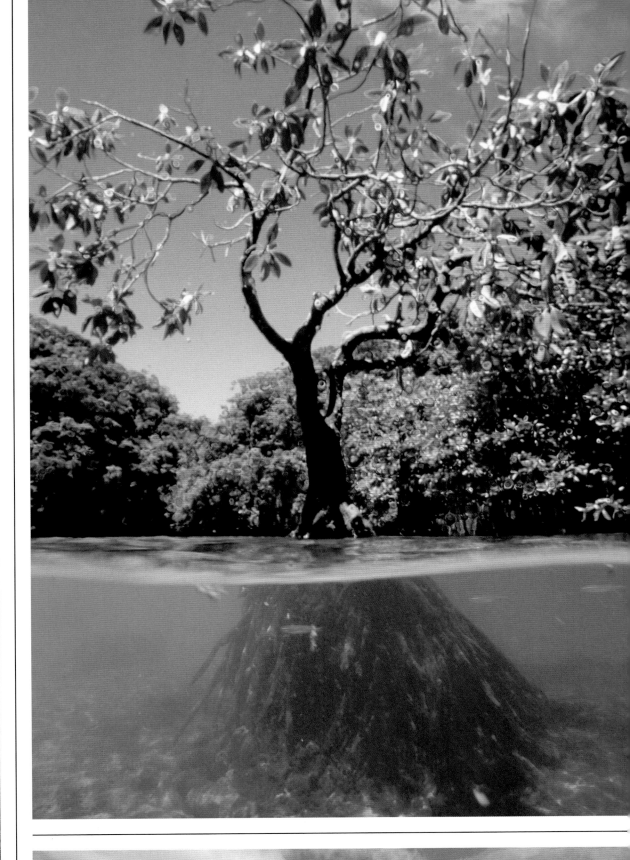

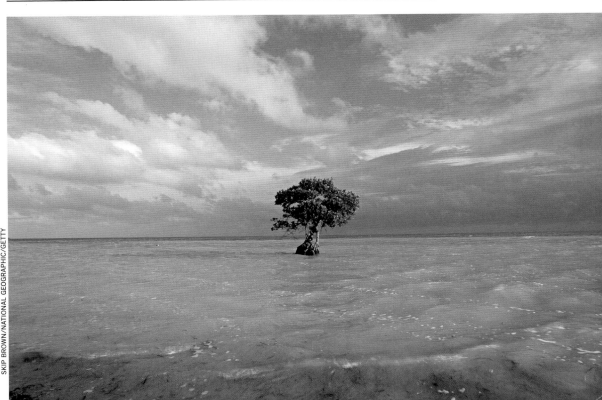

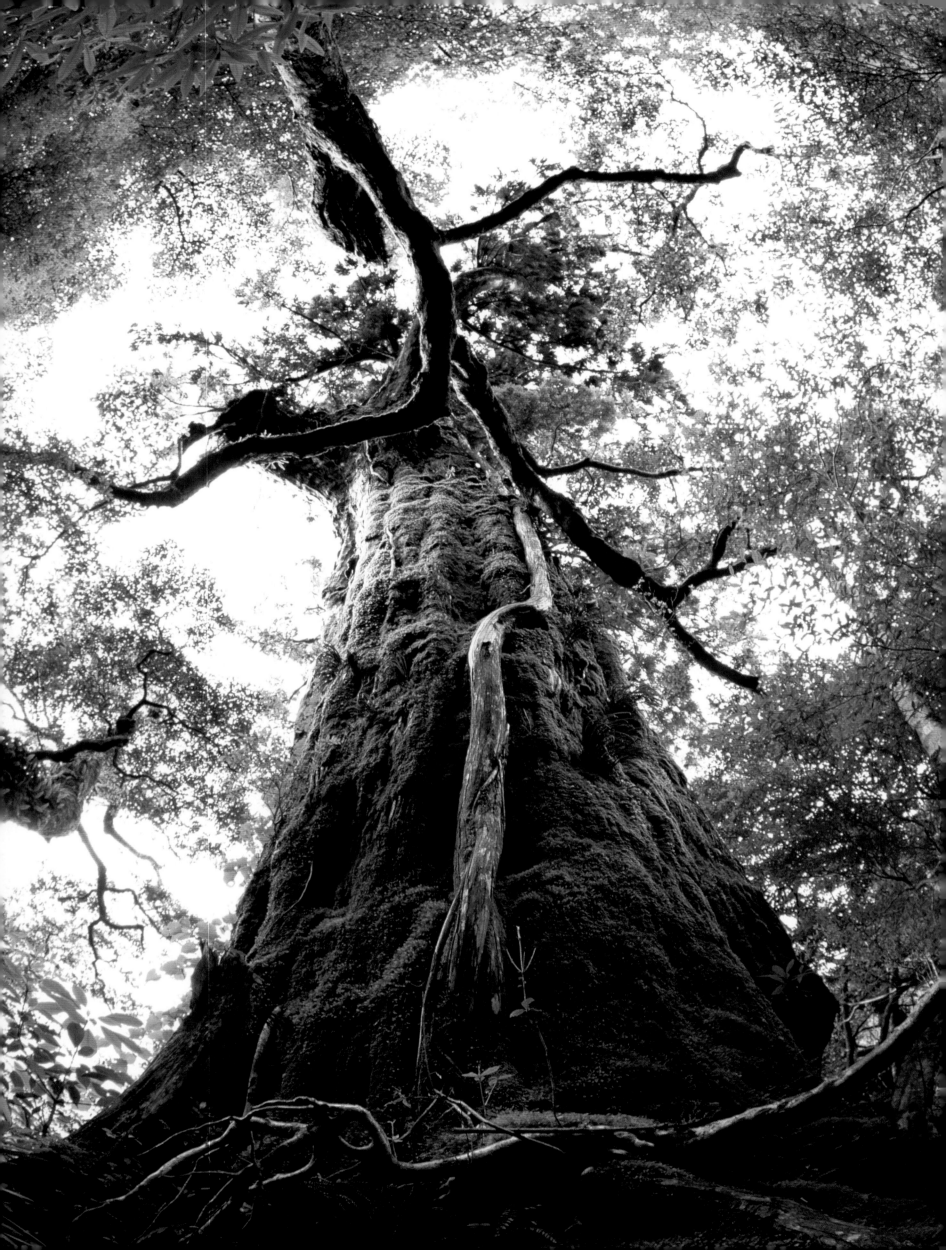

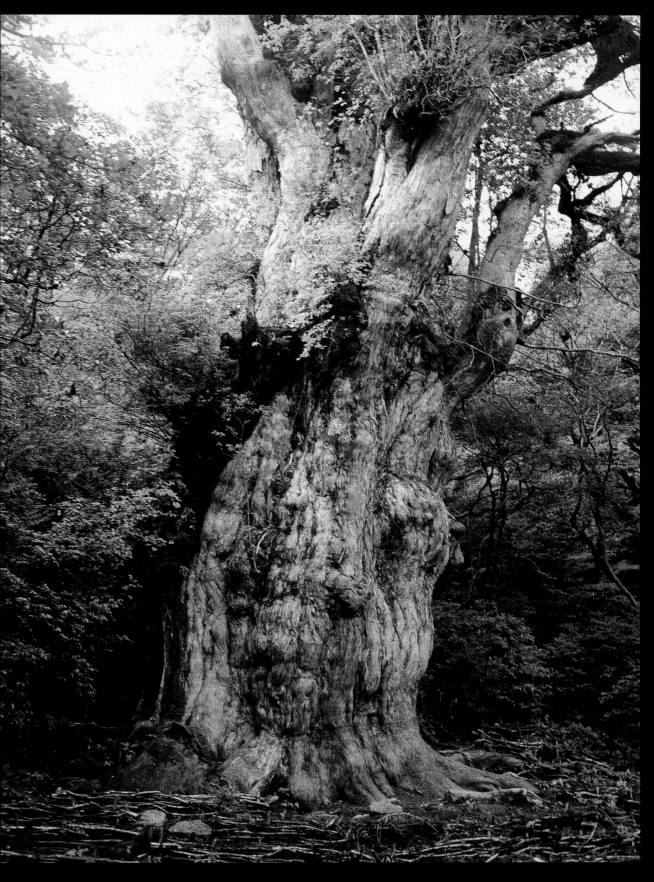

Titanic Zen

t

The plants on these and the pages immediately following are not the biggest or smallest or rarest or most proliferous or stinkiest. They are surely not the most beautiful nor the ugliest. But they are exceptional, and they are well worth pondering as we consider the wonders of life. On these two pages we stroll through a primeval forest in the Kagoshima Prefecture on Yakushima island, Japan, where nothing grows that is not interesting. Above, we encounter the Jomon Sugi, the oldest and largest of *Cryptomeria* trees that are found in Japan and nowhere else. The word *Jomon*

has been estimated to be 2,170 years old, minimum, and perhaps as much as 7,000. It is 83 feet tall, has a volume of 10,000 cubic feet, exists at an altitude of 4,300 feet and was described vividly by Thomas Pakenham in his 2002 book *Remarkable Trees of the World* as "a grim titan of a tree, rising from the spongy ground more like rock than timber." The Jomon Sugi can be viewed only after a hike of about five hours, but it is well worth the effort. So is an audience with the tree opposite, another *Cryptomeria* on Yakushima. A sojourn in this phenomenal forest resonates with a Westerner as might a saunter

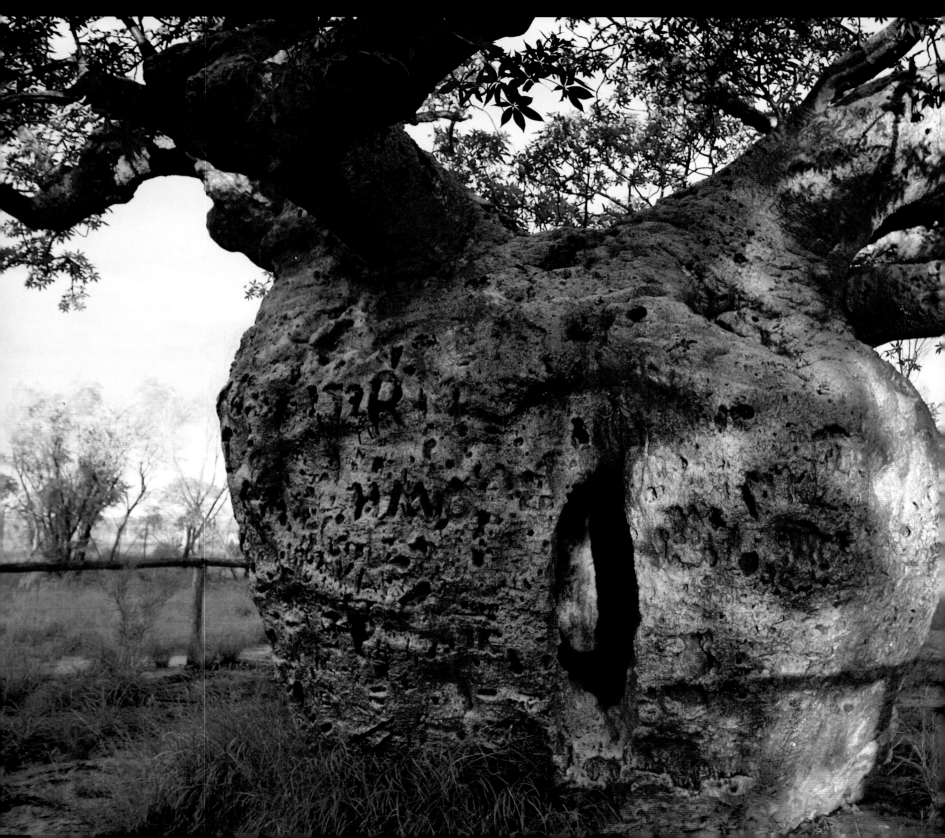

Customized Curiosities

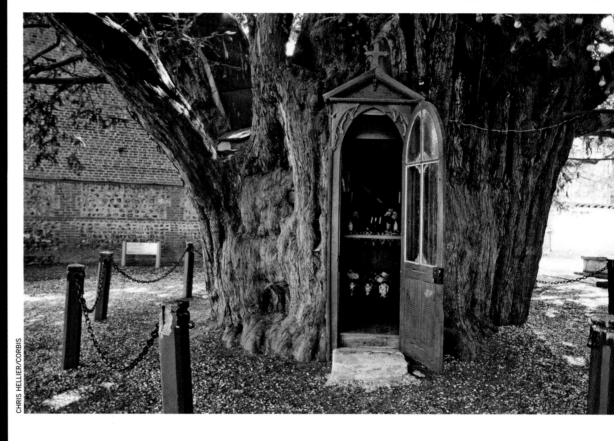

CHRIS HELLIER/CORBIS

RANDY OLSON/NATIONAL GEOGRAPHIC/GETTY

W have met these awe-inspiring species of trees earlier in our pages, and we have talked regularly about how mankind has put the plants we share our planet with to use: as medicines, as foods, as inspirations. We have talked as well about how the baobab stores water for itself in its hollow trunk. But we neglected to mention that some African natives in arid areas harbor their own water supplies in the tree's accommodating cavity. That's pretty interesting, and so is the use to which this baobab in Derby, Australia (left), had been put. It grew sufficiently large during its long life, and developed such an alluring cleft, that it was placed into service by man as a jail for outback prisoners. At the other end of the spiritual scale, this thousand-plus-year-old yew in the village cemetery in La Haye-de-Routot in Normandy, France (above), provided succor for those who wished to worship in its wee chapel.

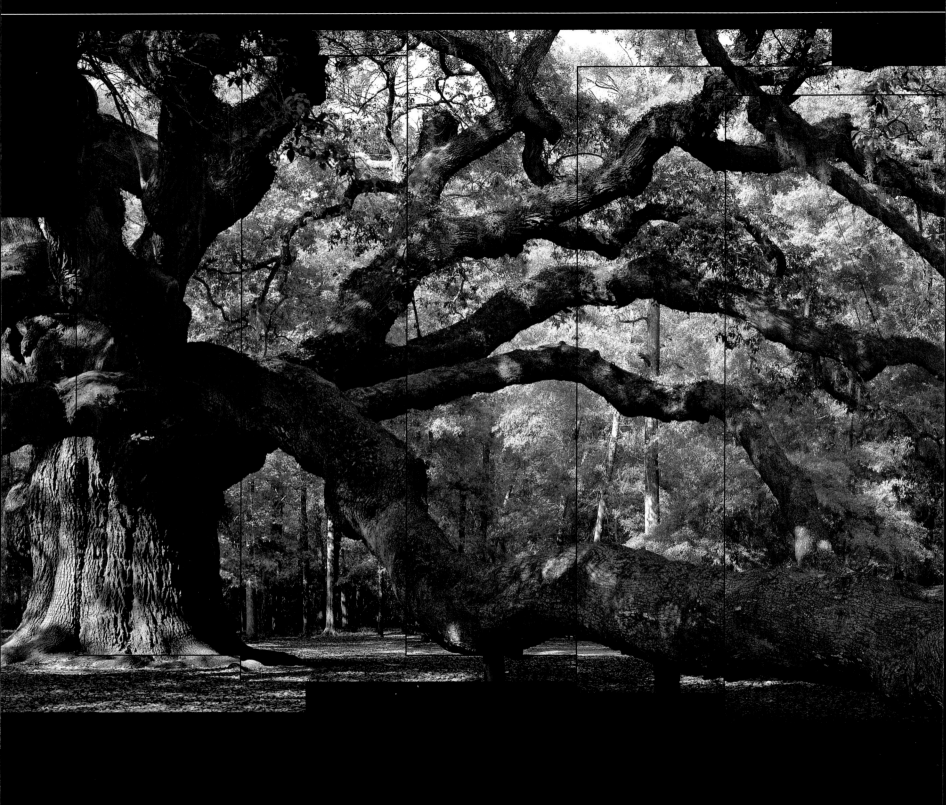

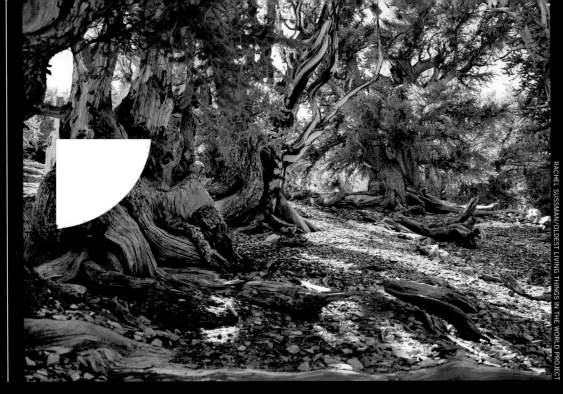

RACHEL SUSSMAN/OLDEST LIVING THINGS IN THE WORLD PROJECT

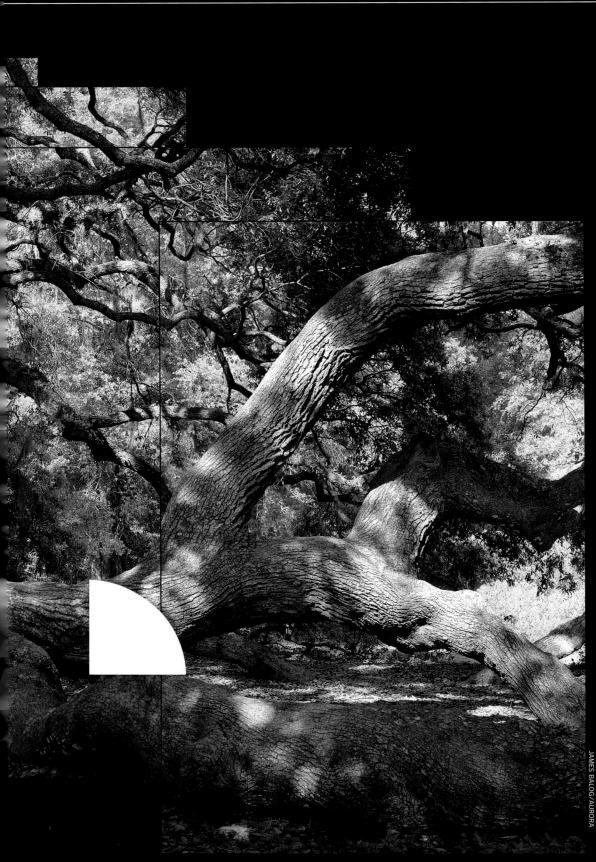

JAMES BALOG/AURORA

Some know the tree at left as Angel Oak, but many locals call it simply The Tree. It is perhaps 1,500 years old, maybe the oldest living or man-made thing in the United States east of the Mississippi River. It stands unassumingly and relatively uncelebrated in a park a dozen miles from the Ashley River on Johns Island, just outside Charleston, South Carolina. It's not that tall by world-record standards—just above 65 feet—but it is stout, with limbs as sturdy as most trees' trunks, and supports an impressive canopy, which yields welcome shade from the Low Country sun. Having survived many hurricanes, with significant damage inflicted in our day by Hugo, it remains a generous tree, with a spread of 160 feet covering 17,100 square feet of ground. It is presented here as a region's signature plant, as is the bristlecone pine (above) on White Mountain in California. Growing in dry soil and high winds at an altitude just slightly below the tree level, bristlecones, native to a few Western states, including Colorado, New Mexico, Arizona, Nevada and Utah, progress slowly but for a long, long time. This specimen may be 5,000 years old, and therefore among the oldest living single organisms on earth. So, then, on these pages: an oak tree and a pine. But hardly your everyday oak or pine!

*O*ur book's first of five removable photographs that are suitable for framing is, suitably, a rendering by perhaps the most famous of all LIFE photographers—one of the original four staff shooters in 1936 and indisputably one of the greatest photojournalists of the 20th century. Alfred Eisenstaedt, born in Germany in 1898, covered war, peace and all else for the magazine for a half century. In his scant spare time, he loved, cared for and photographed flowers. Eisie knew beauty, and knew how to capture it.

*U*nder the assumption that the plant pictures our readers might like to hang on the wall involve flowers, we present a second by a LIFE master, Eliot Elisofon. Born in 1911, he took up photography while working his way through Fordham University, where he was premed but majored in philosophy. Intrepid during World War II—"Elisofon was afraid like the rest of us," said the famous correspondent Ernie Pyle, "yet he made himself go right into the teeth of danger"—Elisofon emerged ready to photograph something other, like the majestic mountains of Africa and the fantastic flora of Hawaii, this example of which was observed in 1945.

Be Kind
to the Plants

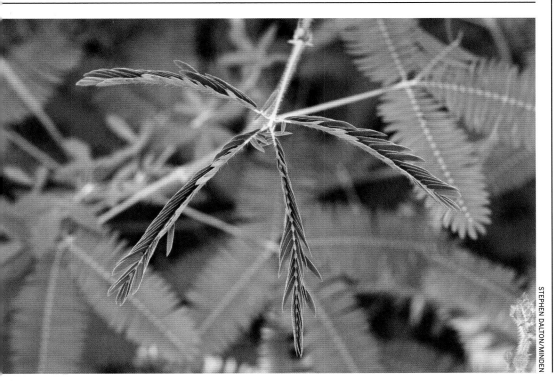

STEPHEN DALTON/MINDEN

*d*o trees and flowers and herbs and shrubs have feelings? Well, not in the sense that you can bruise them with an insult or a slight. But some plants certainly react to stimuli, and in so doing impress us in an anthropomorphic way. Opposite is *Desmodium gyrans,* the so-called dancing plant or telegraph plant or semaphore plant, whose leaves move in response to sunlight, temperature variations or vibrations in the air. Yes, the plant seems to "dance" upon "hearing" music. Some observers insist it is partial to the Grateful Dead, but be that as it may: None other than Charles Darwin and his son Francis, in *The Power of Movement in Plants,* gushed over *Desmodium's* balletic gifts. At left and below is *Mimosa pudica,* the "sensitive plant." So much as a breath aimed in its direction or the barest touch of a finger causes the herb to release chemicals that induce its leaves to collapse, as if in timidity. They reopen minutes later. Why *Mimosa* behaves this way is unclear, but it engenders great sympathy. Native to South and Central America, this creeping perennial is now widespread because we humans are so entertained by its hallmark stunt and have imported it.

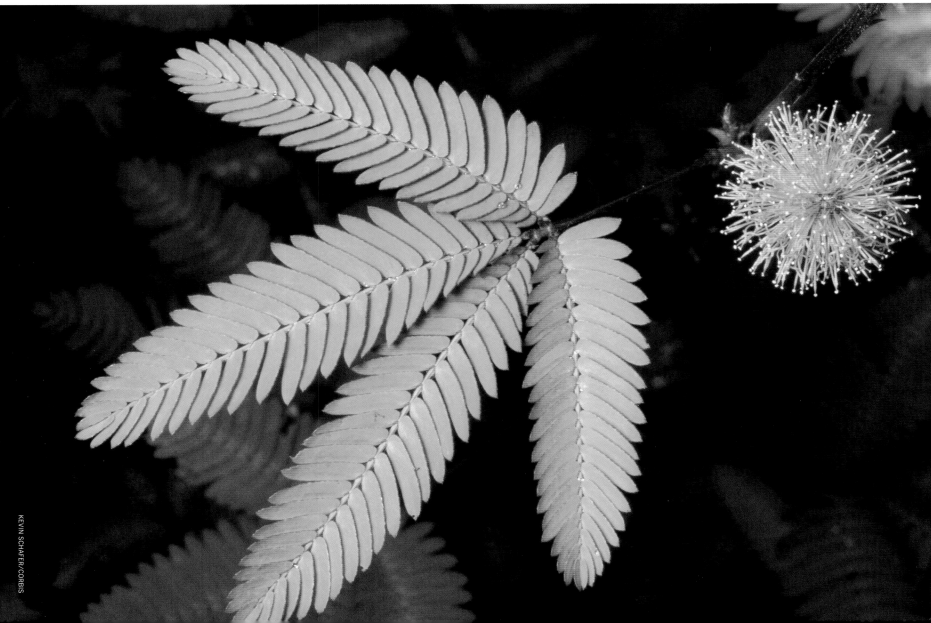

KEVIN SCHAFER/CORBIS

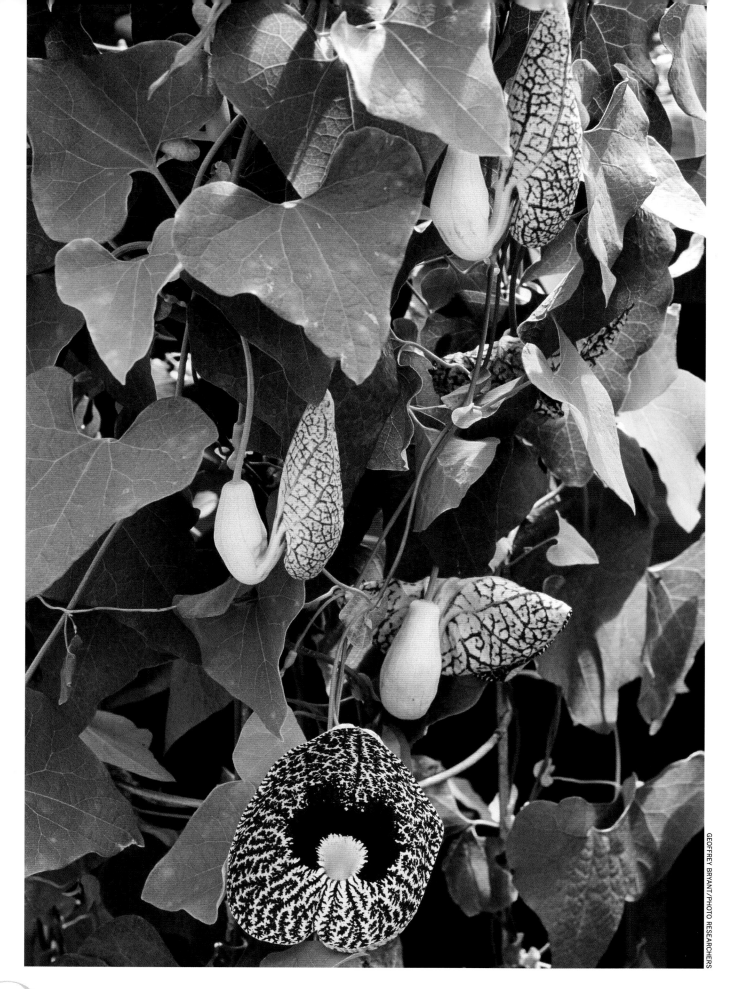

Harmless

Opposite, top, we have *Ceropegia woodii,* the so-called parachute flower, which we might assume, from the look of it, to be a carnivore: It's got the tubular flower, the small hairs inside pointing downward to trap an insect, the alluring proboscis that might attract the attention of pollinators or would-be prey. All of these attributes do indeed function as described, but the plant doesn't consume the captured bugs. It holds them until its hairs wither, and then they're free to fly away again—albeit, covered in pollen. Due to its attractiveness rather than its curious behavior, *Ceropegia* has

become a popular indoor and outdoor hanging plant. On this page we see *Aristolochia grandiflora,* the pelican flower, beautiful in its own right and again looking every inch like a carnivorous plant. It is not. It is a deciduous vine with huge flowers featuring deep chambers instead of petals and, as well, a powerful odor. People hate the smell—it has been likened to that of a dead mouse—but pollinators can't get enough of it. The flowers are often visited by butterflies. A native of the Caribbean, *Aristolochia* has been introduced in Florida, where it is right at home.

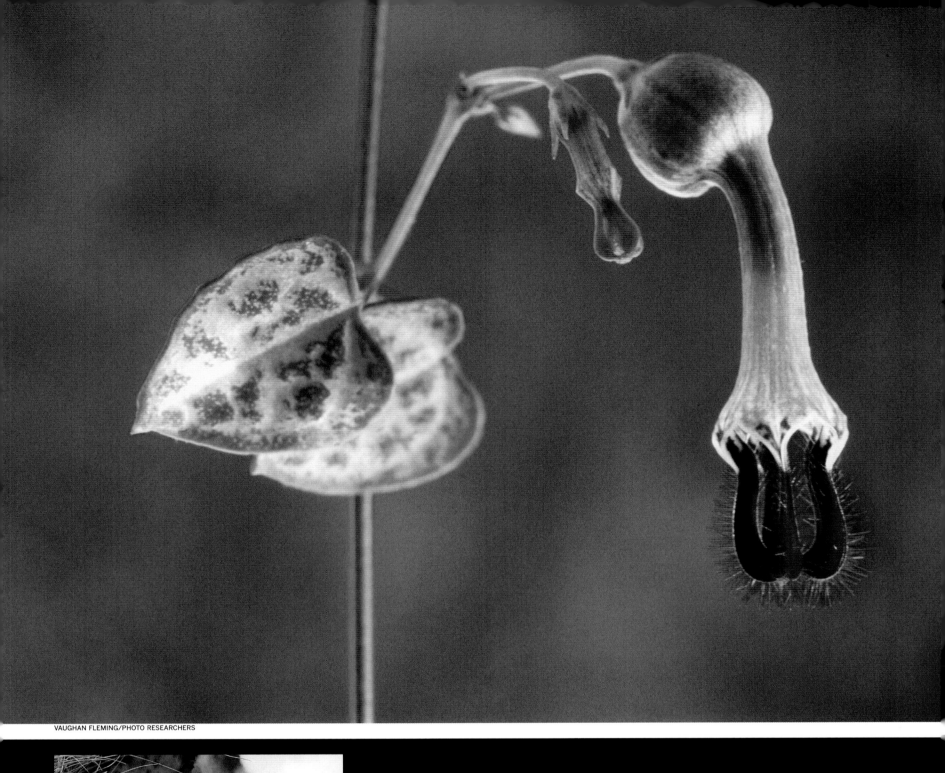

Nothing Extraordinary, Except . . .

Except for the fact that this lovely little yellow flower is part of what is probably the rarest plant in the entire world—and it stands in here, at the end of our chapter on flora, for the resiliency of all living things, none of which should ever be counted out. The Snowdonia hawkweed plant is native to one place: seven or so acres in the valleys of, yes, Snowdonia, in northern Wales. It was discovered in 1880 by botanist John Griffith while he was traipsing about the highlands, doing research for his book *The Flora of Anglesey and Caernarvonshire*. At first it wasn't independently categorized, but in 1955 the hawkweed experts Peter Sell and Cyril West listed it as a species in its own right. Alas, it was believed, at the time, that the Snowdonia was no more—deceased, extinct, gone. Having been nibbled to the brink by grazing sheep, it had last been seen in 1953. The Snowdonia hawkweed, a plant not dissimilar to the common buttercup, did have its mourners, most critically among them Scott Hand of the Countryside Council for Wales. He began searching for the bygone plant in 2000, and two years later he and a team of botanists from a local nature preserve found their quarry. Quickly the local sheep, who no doubt had been nipping Snowdonias in the bud on a perennial basis for a half century, were banished from the hillside—and the planet rejoiced in the survival of one of its plants.

fAUNA

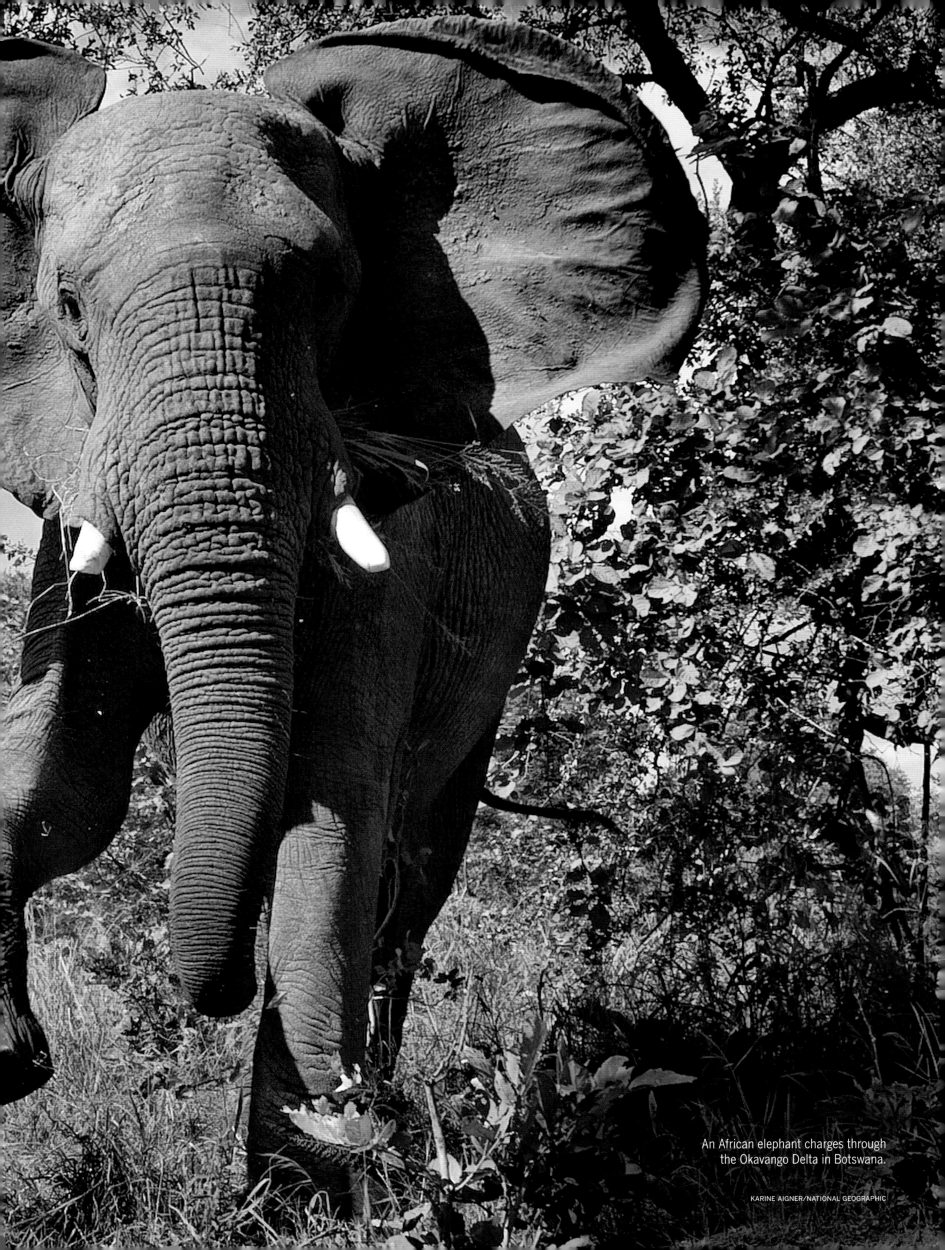

An African elephant charges through
the Okavango Delta in Botswana.

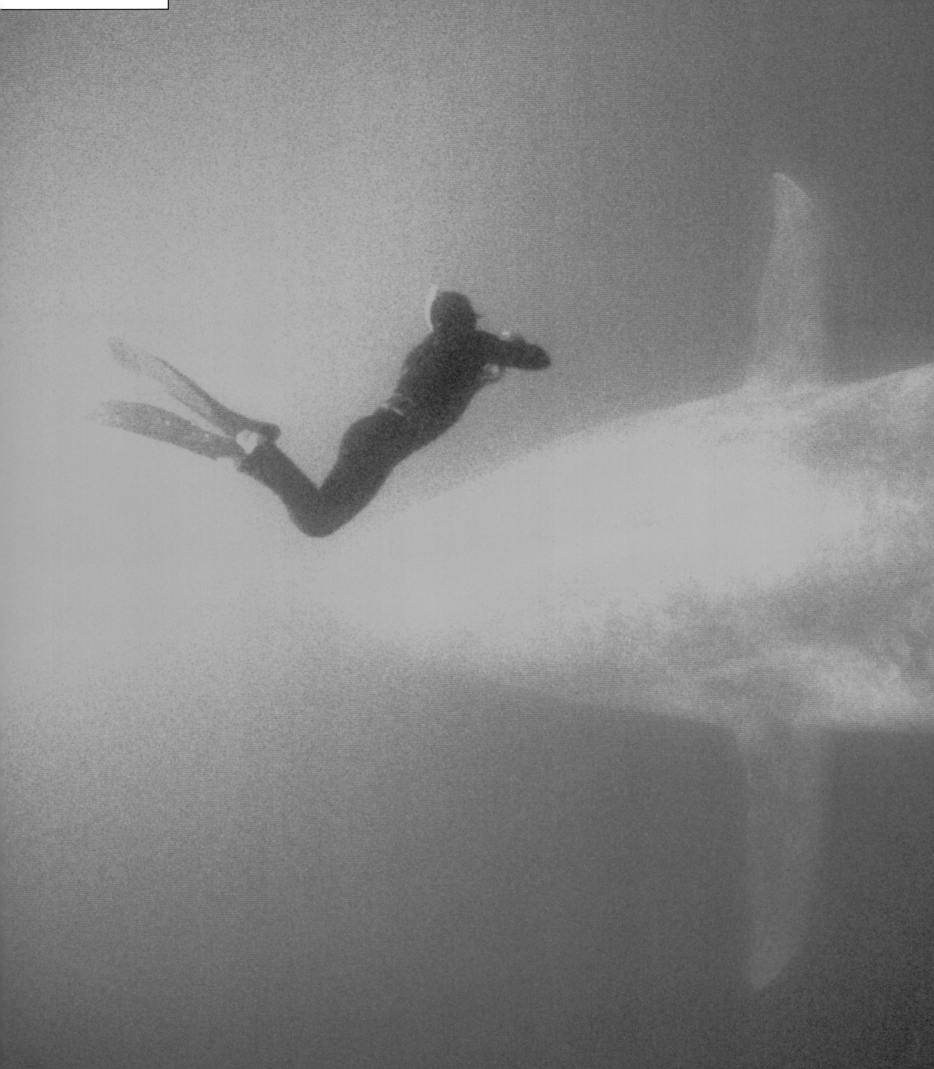

i In fact, the biggest guy—the very biggest since the world began. Measured by mass, a blue whale is larger than the very largest dinosaur ever was. (While we're on the twin subjects of *whales* and *largest,* let us boggle your mind further: Sperm whales, whom we will meet on the very next page, have the largest brain of any animal, including you. A sperm's gray matter is five or six times the size of a human's.) The blue (seen here) is a baleen whale, while such as the sperm and dolphins and porpoises and narwhals are toothed whales. Though you might expect the latter type to be larger, it is in fact the baleens—which include right whales, bowheads, fins, minkes, humpbacks, grays, and others as well as blues—that are the giants. Baleen whales have in their mouths fringes of "whalebone" that, as the behemoth swims, filter organisms adrift in the sea water. The blue, fin and sei whales are members of the fast-swimming baleen community called rorquals. They once navigated the seven seas as unapproachable

gods, able to outrun the earliest human whalers, until the late 19th century. Then with the advent of steam ships and exploding harpoons, that changed. There was a considerable bounty in these huge creatures—the fuel of oil and the food of flesh—and they became a prime target. Today, it is estimated that perhaps 5,000 to 10,000 blue whales still exist, down from an estimated historic high of more than 300,000. We've saved the amazing stats for last: The baby blue whale, which starts from a fetus and develops over 11 months into a two-ton living being, becomes the fastest-growing animal on earth, putting on 250 pounds and growing an inch longer every day for seven months. This is 20 times the human growth rate. An adult blue—say, 100 feet, with a weight of more than 100 tons and a two-ton heart that works super slowly, pumping 60 gallons of blood with each beat—can eat eight tons of krill a day and gain an extra ton every 10 days during the Antarctic summer. *The Big Guy.*

MIKE JOHNSON

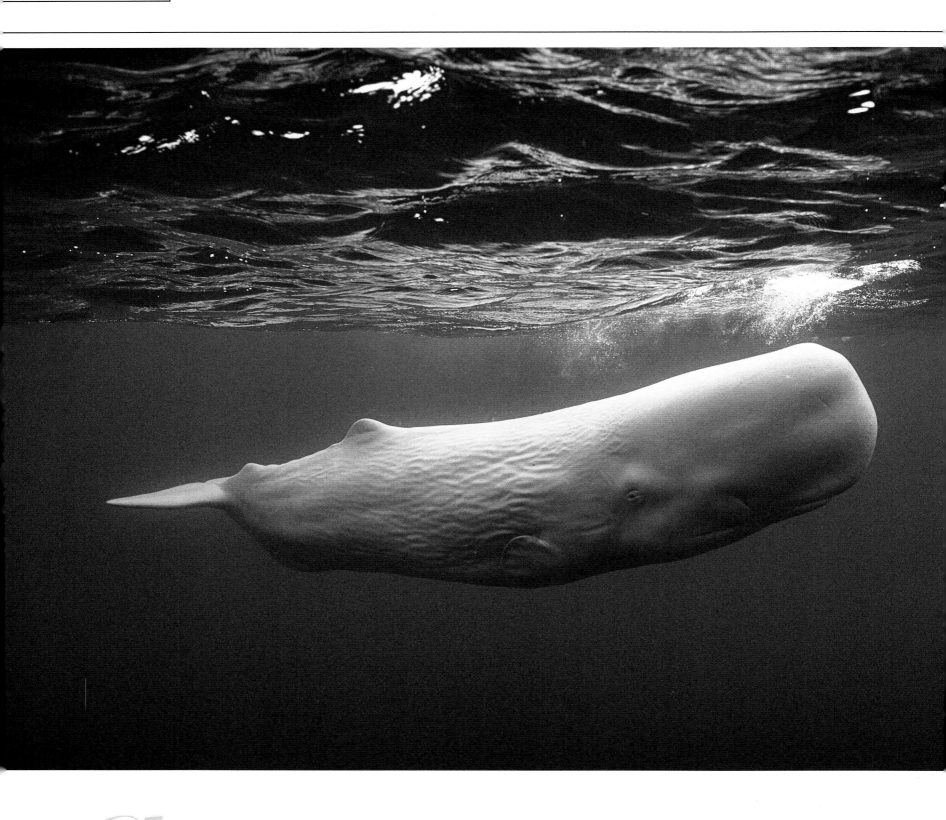

Among the deepest diving mammals on earth, capable of going two miles down and staying under for more than two hours—"Down, down on a long, slanting course through the zones of green and purple twilight to utter blackness below," wrote Victor B. Scheffer in his 1969 classic, *The Year of the Whale*—the sperm whale (above, close to the surface in the North Atlantic near Portugal's Azores Islands) is also one of the most prodigious and voracious. Consider: Found inside the stomach of a 47-foot-long sperm whale that prowled near the Azores was a whole 34-foot-long giant squid weighing 405 pounds. That's like you or us eating a five-foot-long hotdog (with the bun and plenty of mustard ... and sides of potato salad and beans . . . plus dessert). Opposite, top: Orcas, or so-called "killer whales" are in fact the largest members of the dolphin family. They are also the most widely distributed mammal on earth, found north, south, east and west, pole to pole. Their coolest—or hottest—attribute might be their speed: They can reach more than 40 miles per hour, and are among the fastest cetaceans in the ocean. That's bad news for seals and sea lions (an orca will charge an island to try to snare prey), all sorts of fish such as salmon, and even other dolphins and small whales. On these two pages, then, we have a true whale; a big, aggressive dolphin; and a *gi*-normous fish, the biggest in the world (opposite, bottom). To further confuse the already misleading terms in this caption, this fish is a whale shark (*Rhincodon typus*). With a squarish head and nostrils connected by grooves to the mouth, these nonwhales (and nonmammals) look like oceangoing vacuum cleaners, and that is how they act, swimming open-mouthed through schools of very small fish, ingesting these tiny victims as well as plankton. The largest ever measured came in at 41½ feet, but sightings indicate whale sharks half again as large, and they are wanderers: One was tracked for 8,000 miles. The mouth is big enough to ingest a scuba diver but never does so. In fact, like everything else seen here that is not quite what it seems, the whale shark can be notably playful. Would you like to play?

Tales of Another Whale— and More Big, Wet Beasts

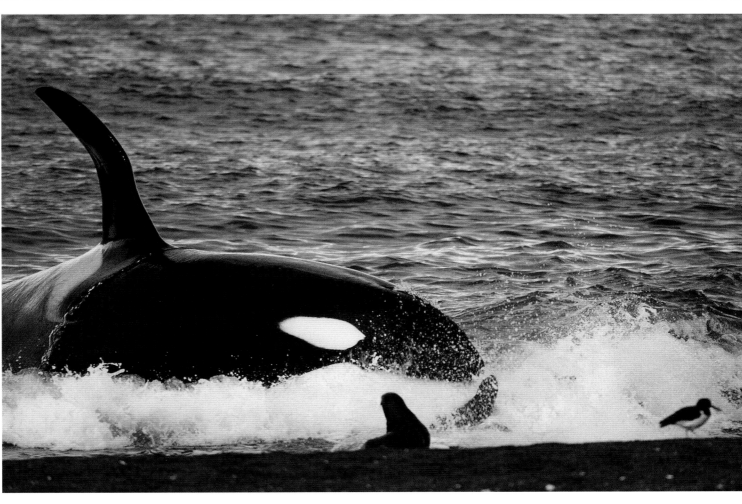

HIROYA MINAKUCHI/MINDEN (2)

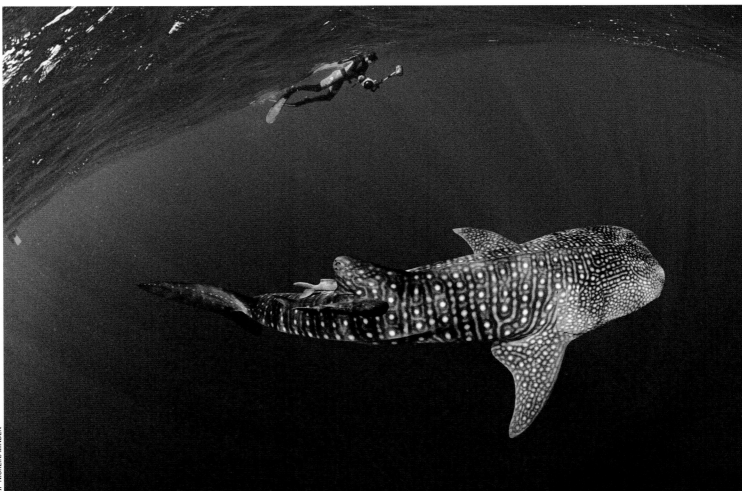

FLIP NICKLIN/MINDEN

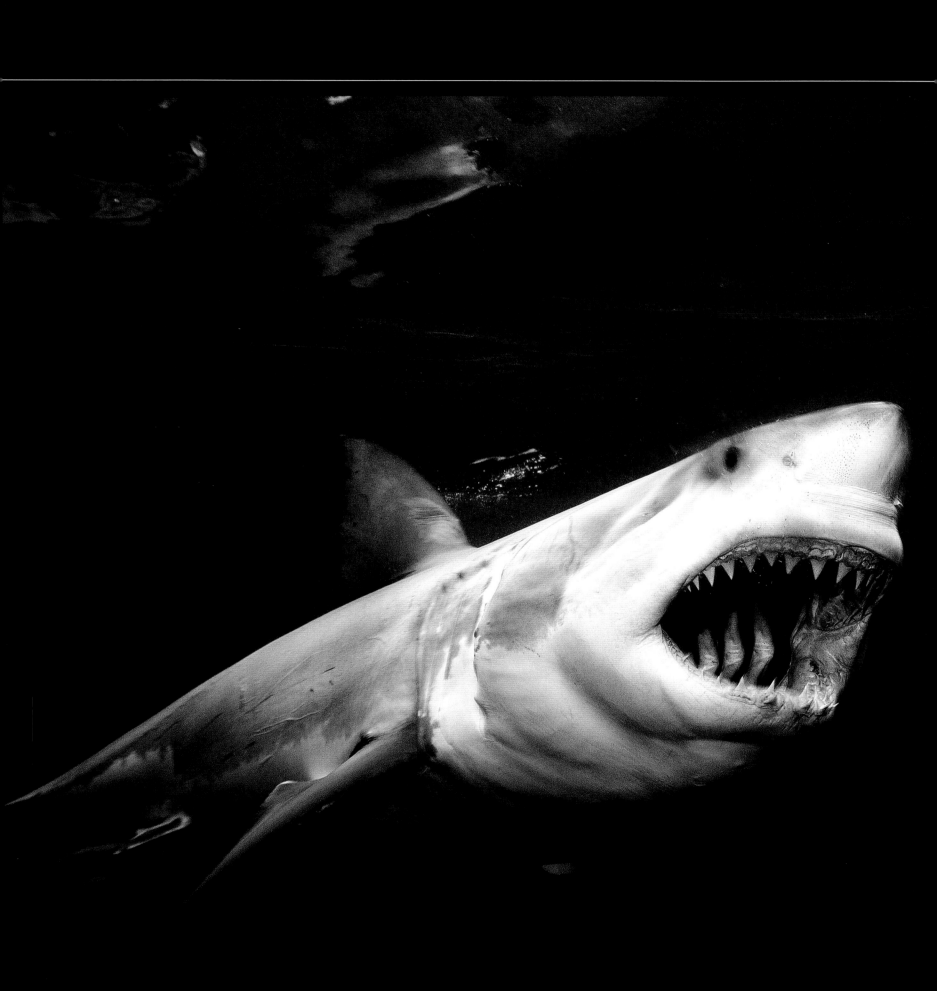

Megastars

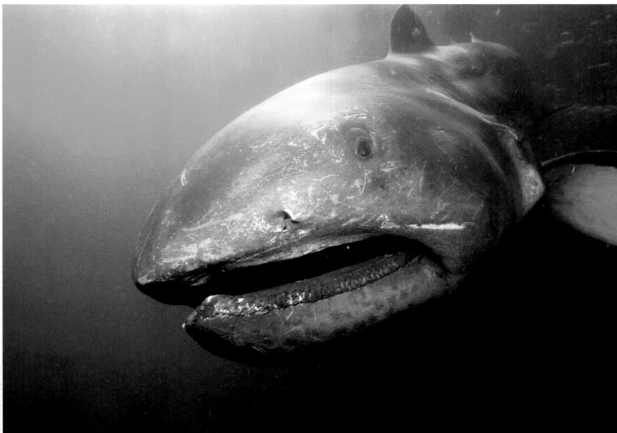

TOM HAIGHT/SEAPICS

STEPHEN FRINK/AURORA

One was entirely unknown until recently; the other has long been a legendary predator looming as large in the public imagination as, say, a man-choking boa (please see page 89) or a rampaging griz (please see page 80). The former is a large shark that behaves like a cross between a deep-diving baleen whale and a shallow-water fish and can pump water over its gills so that it can rest in mid-water and need not keep swimming in order to breath (which is the usual situation for sharks, pelagic creatures that they are). The latter is a large shark that is, for just and unjust reasons, the poster boy for killer sharks. Meet elusive megamouth (above), and rock star–famous great white (left). The colorfully and aptly named megamouth (with a pie hole more than three feet in width) was not even dreamt of (well, except in vivid nightmares) before a specimen was found in 1976; since then, a few dozen more have been sighted, captured or, in one instance, killed and eaten. This giant can grow to more than 15 feet in length—that much is known—but is harmless to most animals of any size, as it dines on krill and other small crustaceans while swimming slowly forward at depths of 500 feet or more, mouth agape. The great white, largest of all white sharks, can grow to more than 20 feet and has evolved into a fast, tireless predator who, during his long-distance sorties, will chomp and saw with serrated teeth other sharks, rays, fish, seals, sea lions and—very, very rarely—that other largish mammal, man. This shark's bad rep has as much to do with Steven Spielberg as it has to do with science.

Choose Your Adjective:
Giant? Colossal?

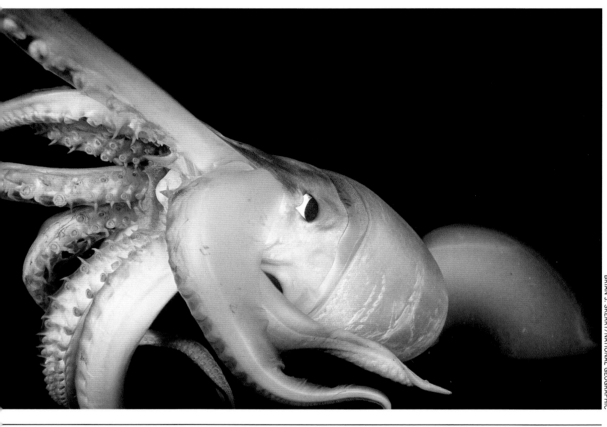

BRIAN J. SKERRY/NATIONAL GEOGRAPHIC

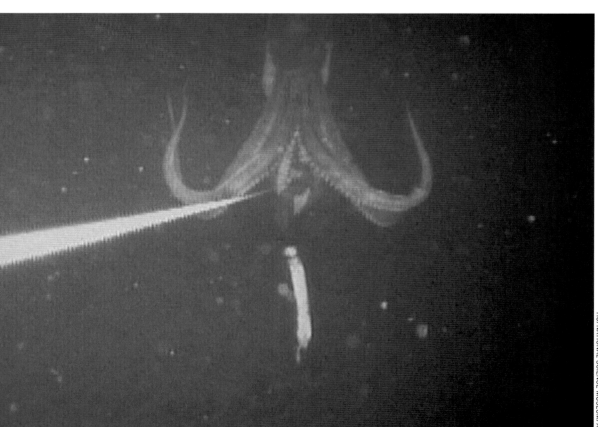

HO/NATIONAL SCIENCE MUSEUM/AP

NORBERT WU/MINDEN

Squid can be smallish or very, very big. Opposite, we see two big ones, with a sharp and close-up view of a giant squid swimming at night in the Gulf of California off Mexico (top), and then an impressionistic rendering of a larger-still, 26-foot-long specimen of *Architeuthis* attacking prey that has been dropped from a white rope extending 3,000 feet deep off the coast of Japan's Bonin Islands in 2004. Bigger still than these giants is the legendary colossal squid, an animal known only from a few captured specimens. Descending to depths well more than a mile down, feeding off large fish and other squid, possessing an enormous beak and the biggest eyes of any animal, and ranging in length to nearly 50 feet, it is the largest known invertebrate on earth. Its very existence is enough to terrify anyone this side of Jules Verne—who, in his fictions, once imagined just such a creature. Below, we see a diver investigating a giant clam on the ocean bottom off Sangalakki Island, Borneo. The largest bivalve mollusk, this endangered species (prized as a delicacy in Japan and elsewhere), one of several large clams native to the coral reefs of the South Pacific and Indian oceans, can attain a diameter of four feet and a prodigious weight of almost 450 pounds. It grows fast by cultivating plants (its food source) in its own body tissue. In the daytime it opens its shell—it yawns—so that the attached algae can receive sunlight for use in photosynthesis. At night, it clams up.

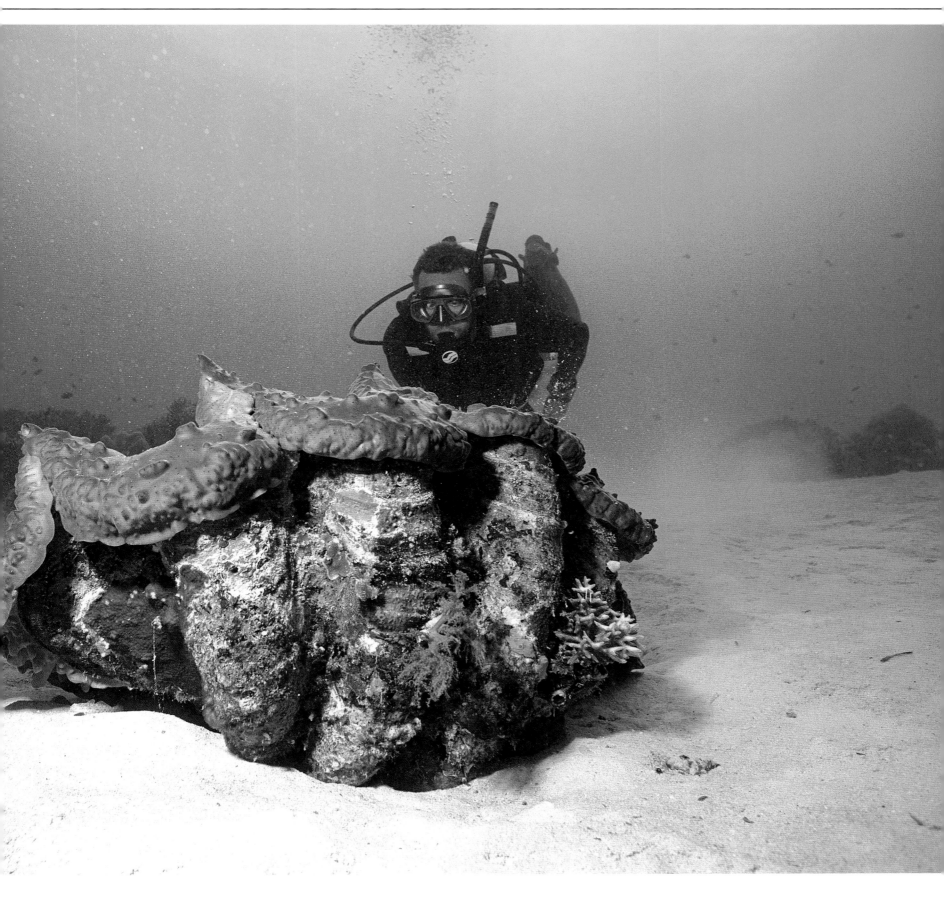

The Big Cuddly

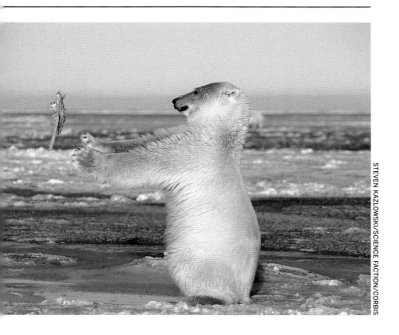

STEVEN KAZLOWSKI/SCIENCE FACTION/CORBIS

W White as snow, fuzzy as a bunny, nothing seems cuter—from afar—than a polar bear. Here we see an *Ursus maritimus* cub playing with a piece of baleen from a bowhead whale at sunrise on Barter Island off the north coast of Alaska (above); and a mother and her cubs, cuddling (right). Thought for the longest time to be its own genus separate from the bear, it is now accepted that the polar bear is part of that family, having diverged from the brown bear about 150,000 years ago; it is, along with the Kodiak bear (which is the biggest brown bear), the world's largest terrestrial carnivore—both species weighing in, in their largest male representatives, at up to three quarters of a ton (females are approximately half that size). The polar bear lives largely within the Arctic Circle and in the modern day is considered a vulnerable if not technically endangered species, as global warming seems to be melting away the borders of its habitat. Nearly half of the 19 polar bear subpopulations are in decline, and according to the International Union for Conservation of Nature: "If climactic trends continue polar bears may become extirpated from most of their range within 100 years." Good news for seals, the bears' primary food source, perhaps; bad news for the polar bear . . . and the rest of us.

KENNAN WARD/CORBIS

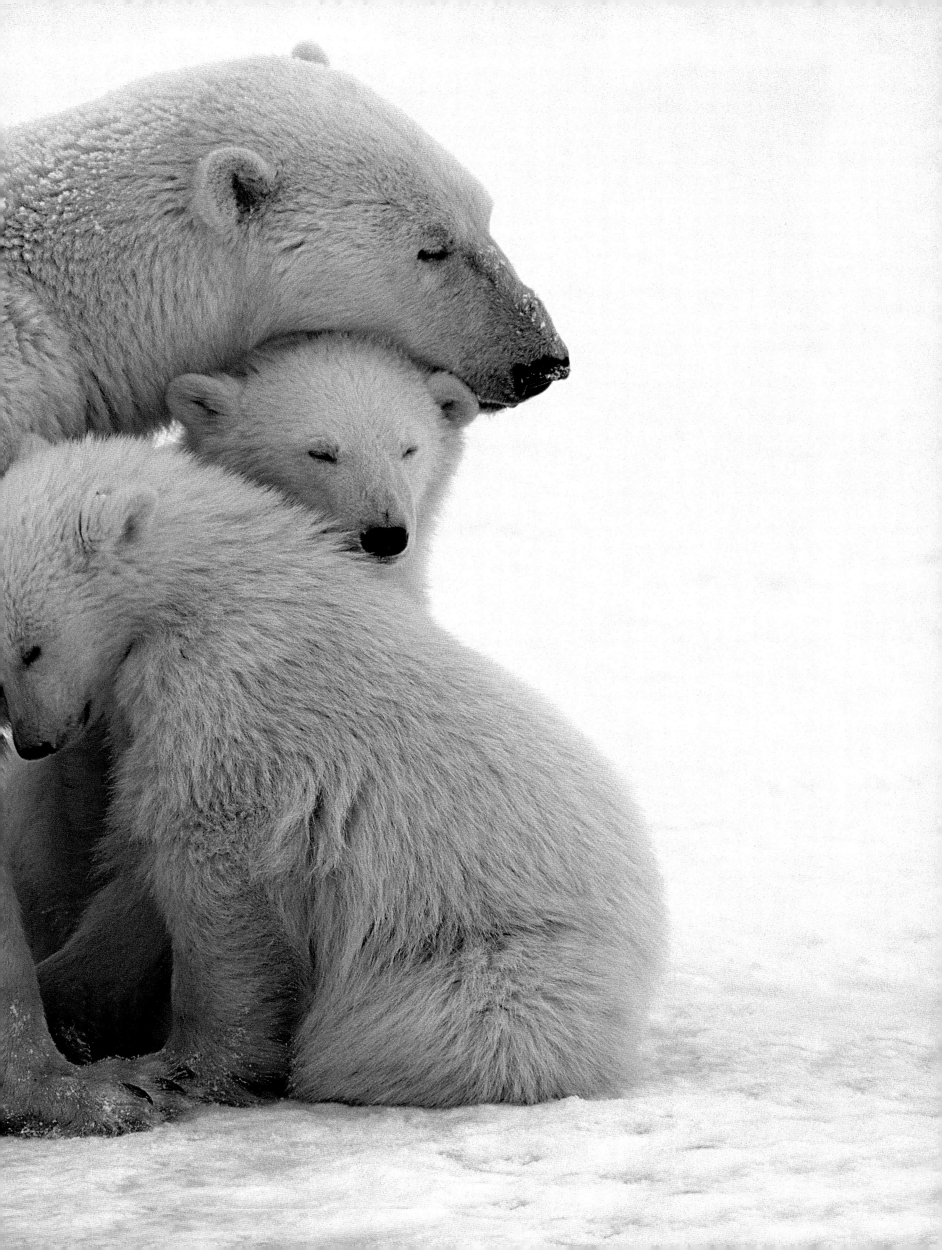

A Wide-ranging Species

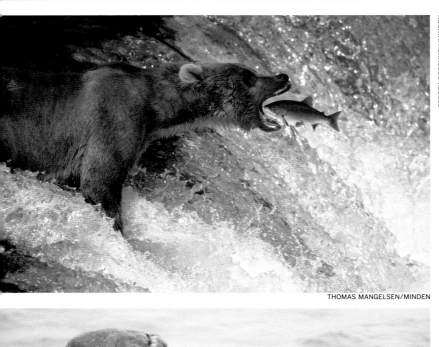

THOMAS MANGELSEN/MINDEN

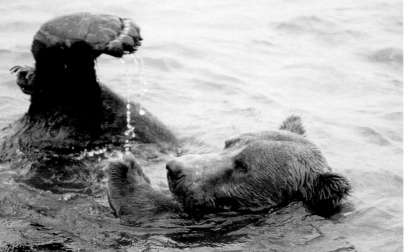

CARY ANDERSON/AURORA

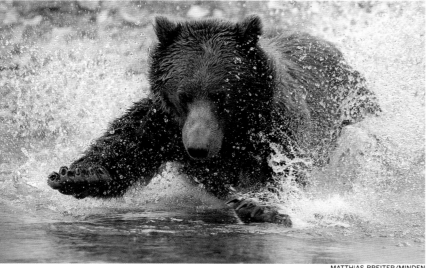

MATTHIAS BREITER/MINDEN

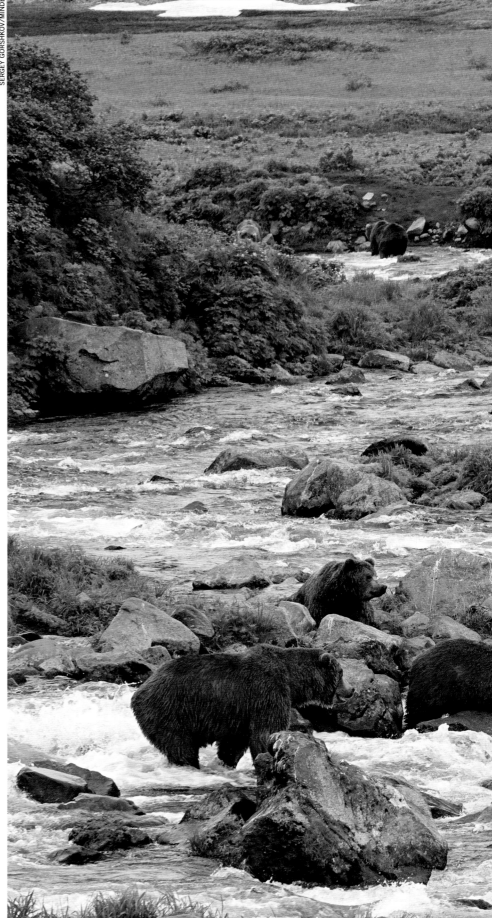

SERGEY GORSHKOV/MINDEN

Two hundred thousand brown bears range across northern Eurasia and North America (in the United States, principally in Alaska) and in their several subspecies, in weight from as little as 150 pounds to as much as 1,700 (which would be the recently mentioned Kodiak bear, tied as the world's largest land-based predator). The animal is the most widely distributed and varied of the three common bear species (including the polar bear and the American black bear). Two of its subspecies are famous and feared for their formidable size, strength and occasional ferocity. One is the Kodiak, and the other is the grizzly. The griz can, in its inland incarnation, top out at about 350 pounds, while a relative nearer the coast, with ready access to a surplus of spawning salmon, can weigh four times as much. The grizzly bear has one of the animal kingdom's most vivid binomial names—*Ursus arctos horribilis*—as well as one of its most firmly set reputations: It is regarded as the terrestrial version of a great white shark. But as with a polar bear, the griz can appear downright sweet when viewed in its natural habitat. On these pages we see a grizzly catching lunch at Brooks River Falls in Alaska's Katmai National Park; another relaxing with its foot in the air at the McNeil River State Game Sanctuary, also in Alaska; a female splashing in a Katmai stream; and a slew of brown bears hanging out at another salmon-rich stream in Kamchatka, Russia. These furry folk seem to have not a care in the world. Of course, the fish have problems.

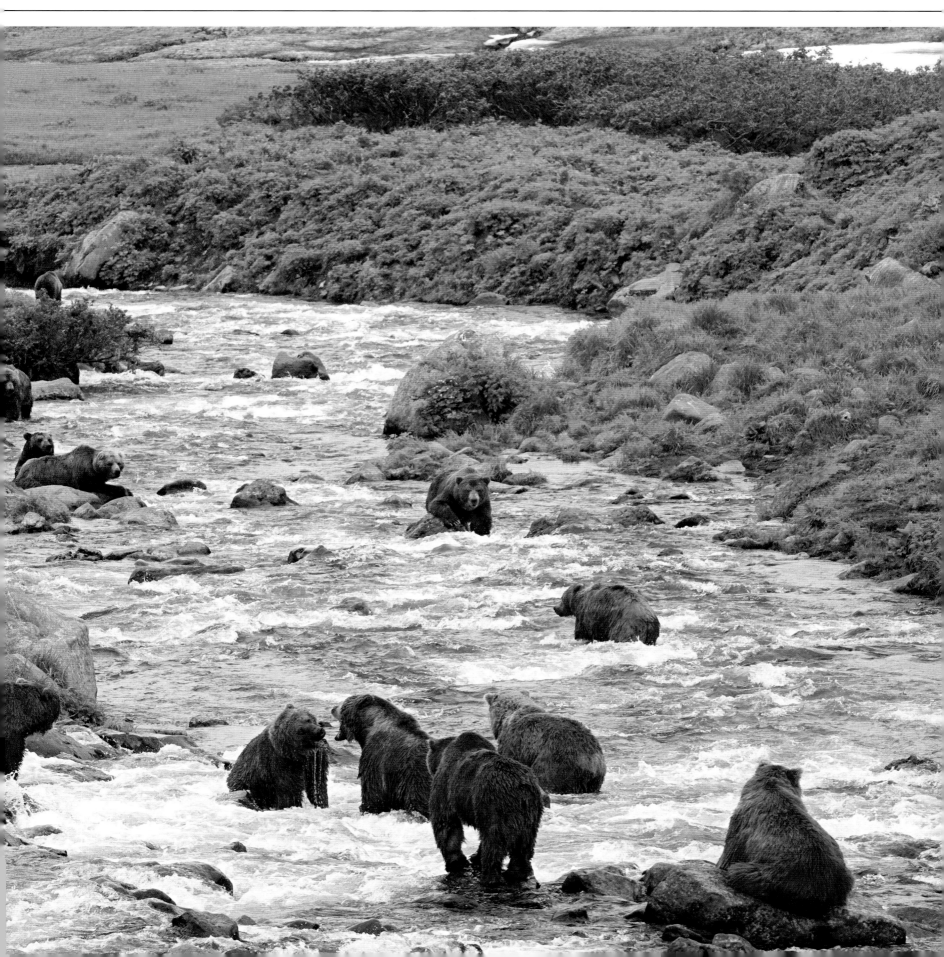

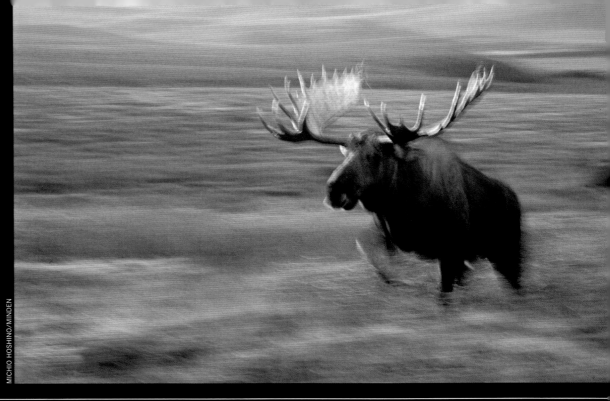

MICHIO HOSHINO/MINDEN

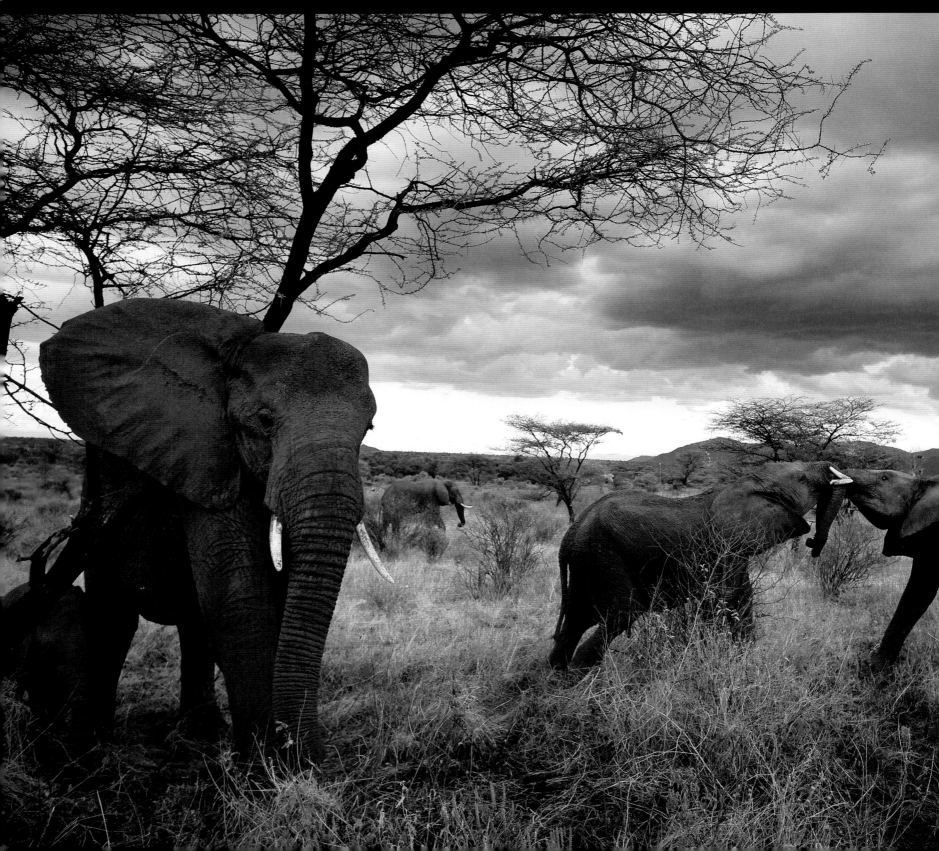

Sometimes Bullish, Always Bodacious

*t*he moose, as the animal is known in North America in a term possibly loaned by the Algonquin Indians (elsewhere, the animal is called the European elk), is the world's largest deer and something of a four-legged baleen whale: an herbivore that, by consuming nearly 1,000 calories of vegetation daily, reaches a mammoth size. An Alaskan moose might stand more than seven feet tall at the shoulder and, in the male of the species (like the charging bull seen opposite), weigh 1,500 pounds or even more—as large as the storied and long-extinct Irish elk. The true blue whale of terrestrial animals is not, however, the moose but the African bush elephant, also an herbivore, which can reach nearly 25 feet in length, 12 in height and a weight of more than 10 tons; the heaviest ever recorded, a bull shot in Angola in 1965, tipped the scales at 27,060 pounds. The elephant travels widely on a daily basis in a quest to ingest as much as 500 pounds of vegetation, covering about four miles an hour, denuding shrubbery and knocking down trees to reach nutrient-rich leaves. At water holes (like this one, below, in Chobe National Park in Botswana that is being shared with an impala) it slurps 50 gallons of H_2O per day to wash down its feed and keep as cool as possible under the African sun. A bush elephant is a tough customer: It can attack and kill a foe as formidable as a rhinoceros. But within its own community, it is familial (a calf feeds on mother's milk for as long as five years) and usually good-natured. At left, below, adolescents tussle amiably in the Samburu National Reserve, in Kenya.

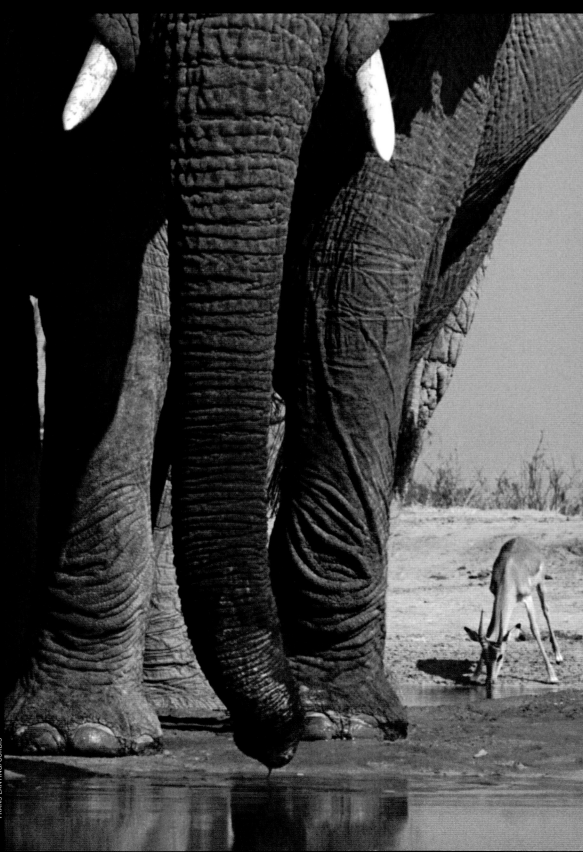

MICHAEL NICHOLS/ NATIONAL GEOGRAPHIC

FRANS LANTING/CORBIS

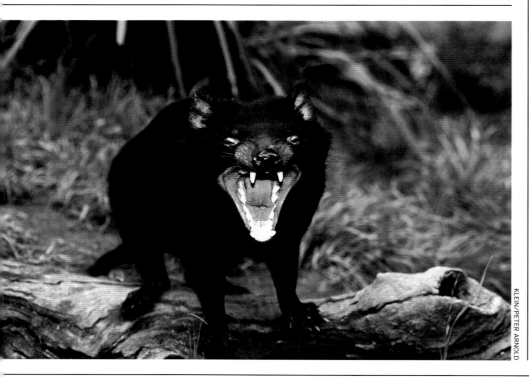

Famous Faces
of the Pacific Realm

KLEIN/PETER ARNOLD

i If you believe in the continental drift theory—and of course we do, as we mentioned earlier—the various islands of the South Pacific, including the island continent that is Australia, began floating free of the land mass Gondwana some 200 million years ago. Think of them, here, as so many Noah's arks. Certain of their animals were isolated from their natural enemies, and therefore survived—even thrived—while their kinfolk in what became Africa or parts of Asia were dominated, then decimated over time. And so we have today the magnificent red kangaroo (below), the largest mammal native to Australia and the largest marsupial on earth, sometimes growing to four and a half feet and to a weight of nearly 200 pounds. And we have the Tasmanian devil (left), an energetically carnivorous (42 active teeth!) pouched mammal (like the kangaroo) that was driven to extinction on mainland Australia 600 years ago but today survives on Tasmania, an island off the south coast. Solitary, smart, strong, nocturnal animals, Tazzies can run as fast as hyenas and can bound up trees—but they have been recently imperiled by devil facial tumor disease, which since 1996 has claimed half the extant population. And we have the giant tortoise, seen opposite, bottom, in its native habitat on Isabella Island—one of the famed Galápagos Islands parsed for the world by Charles Darwin—which can grow to four feet in length and a weight of more than 650 pounds, and can enjoy an average life span of a century or more, among the longest of any animal on the planet. And finally we have the Komodo dragon (top), the largest species of lizard on earth, seen here prowling on its eponymous island, one of four that it inhabits in Indonesia. It can grow to 10 feet, and is one of the world's fiercest predators, with evisceration techniques that are too grotesque to describe in a decorous book such as ours.

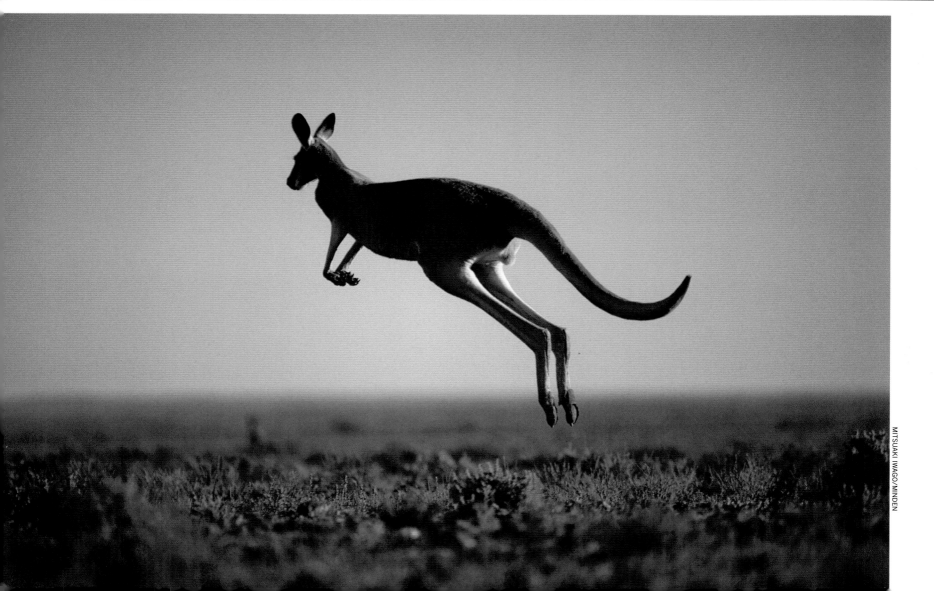

MITSUAKI IWAGO/MINDEN

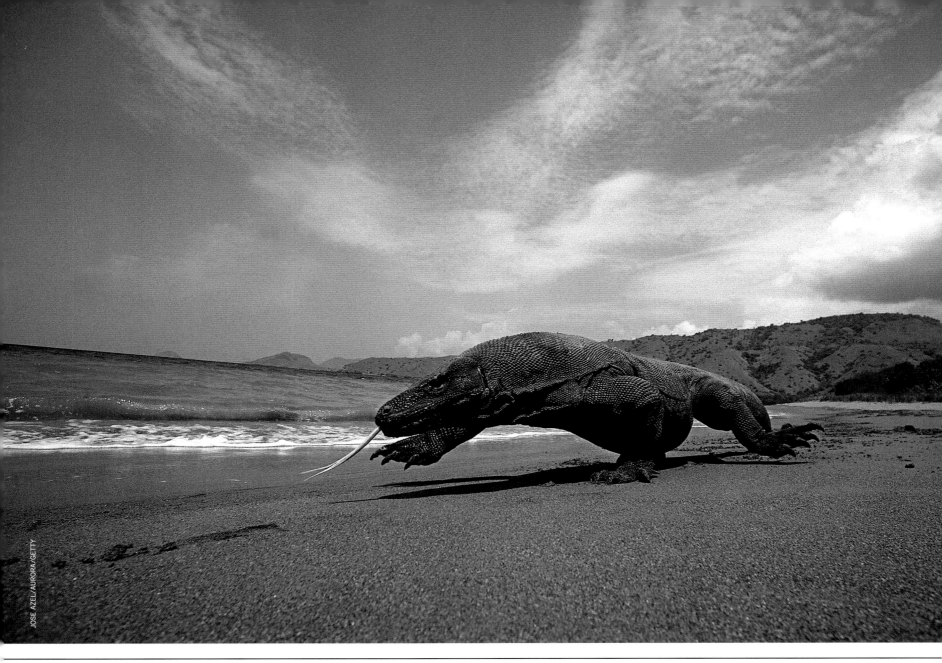

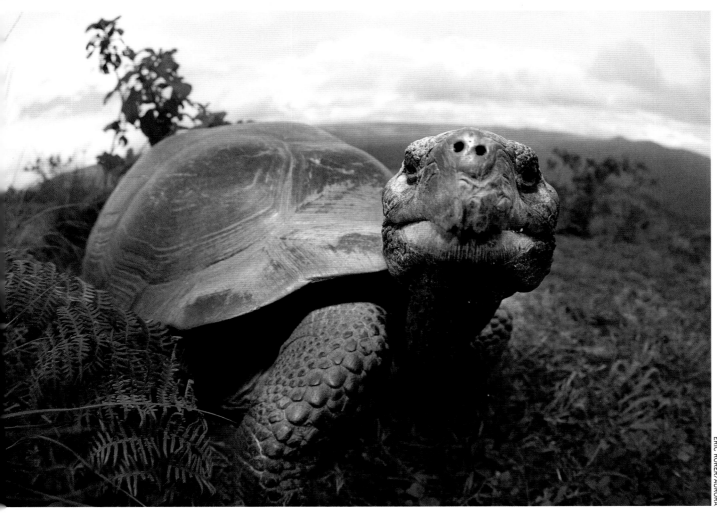

Formidable Feline, Cunning Canine

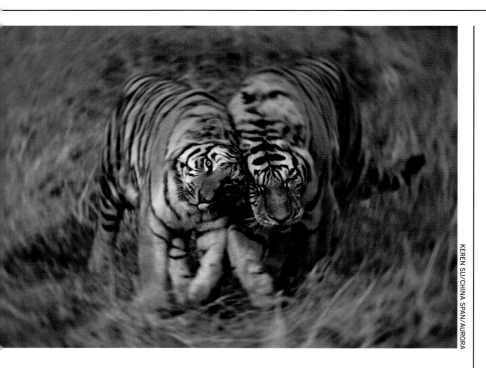

KEREN SU/CHINA SPAN/AURORA

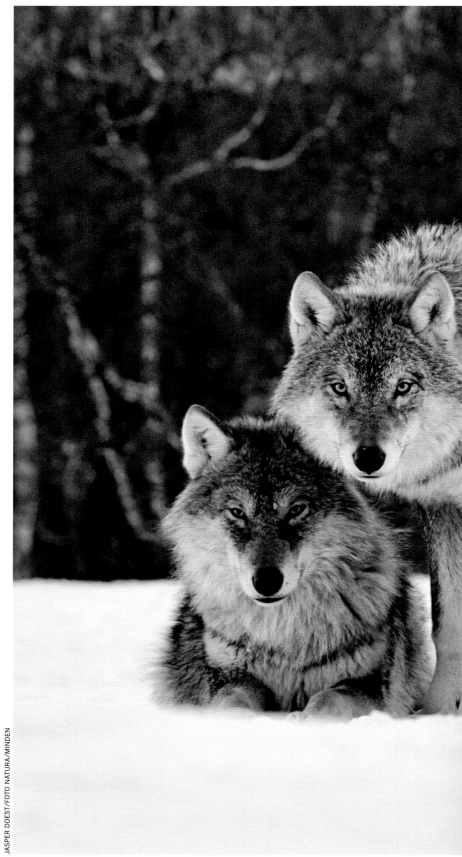

JASPER DOEST/FOTO NATURA/MINDEN

In dreams—or nightmares—we imagine the great saber-toothed tiger, but the most recent of these impressively dentured cats departed the scene approximately 9,000 years ago. Still, of eight tiger subspecies extant today, we have the equally awesome Siberian tiger (opposite), native now to only far eastern Siberia, which can weigh in at more than 650 pounds. This tiger feeds largely on deer, wild boar and sometimes bears, and whatever domesticated animals (dogs, pigs, sheep, cows) it might chance upon. Through the ages, various Asian cultures regarded the Siberian tiger as a symbol of the divine; to watch this magnificent beast move is to understand why. A rival of the Siberian tiger is the wolf, which occupies a similar rung in the food chain. Historically, the tiger has had the upper hand in ranges where both animals are present, but today human pressure has so reduced the tiger population (there are perhaps fewer than 500 remaining in the wild) that wolves, even if they too have been forced into a very small part of their former range, are better off. Best off among them are the largest, the gray wolves, Ice Age veterans that often weigh in between 50 and 100 pounds, four of whom are seen below during a Norwegian winter. The wolf is a stealthy hunter, usually dominant in its habitat, but like the tiger has an enemy in man, who has hunted the animal to extirpation in some places and claimed its habitat through development in others. Size and might are all well and good, but cannot overcome every obstacle.

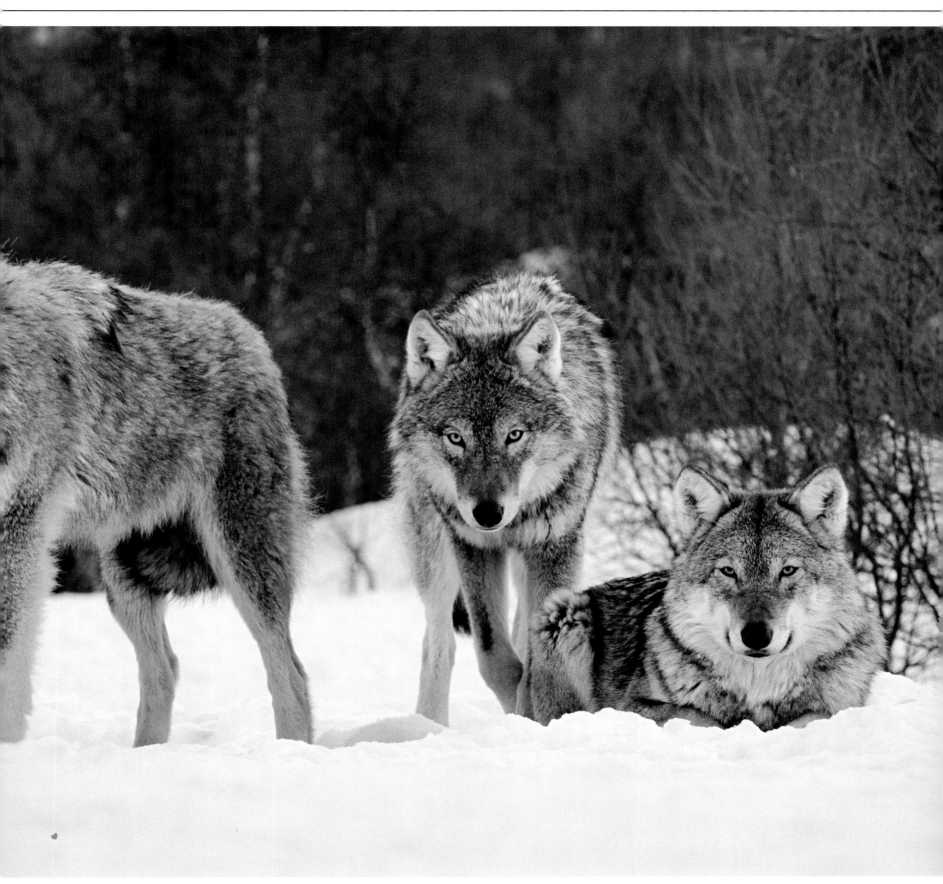

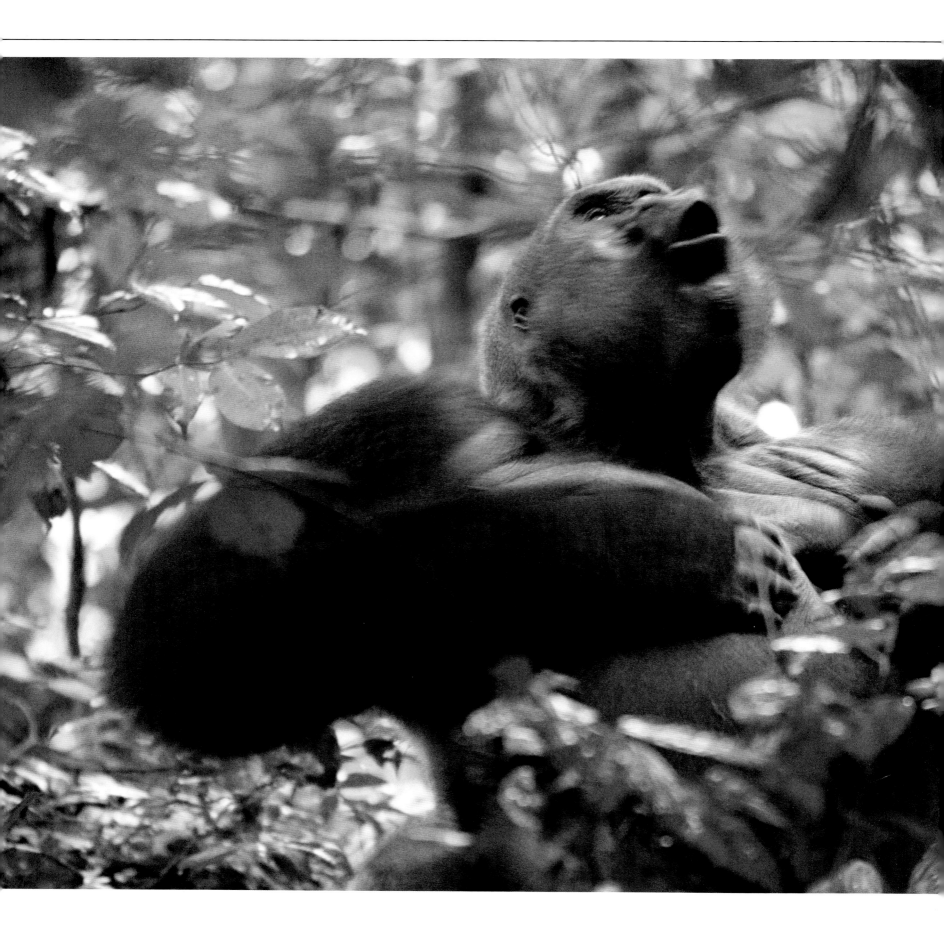

Steer Clear?

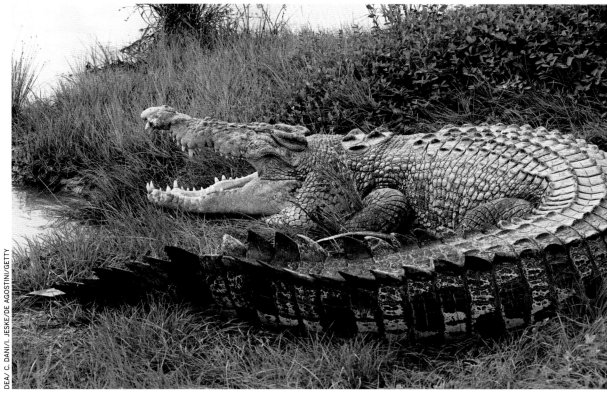

*h*ere we have three animals who have, among many humans, bad reputations. In some cases, the rap is deserved, in others it is not—the beasties would simply like to be left alone. Ever since the original *King Kong* hit the big screen in 1933, scaring the bejesus out of young and old alike, the way we regard lowland gorillas (left), the largest of Africa's primates at up to 440 pounds, has been unfortunate—even with documented incidents such as the famous rescue by a western lowland gorilla named Binti Jua of a three-year-old boy who fell into her enclosure at the Brookfield Zoo in Illinois in 1996. This intelligent, tool-using, family-oriented, herbivorous great ape—so like us (98 to 99 percent like us, genetically)—is far more friend than foe. As for the saltwater crocodile (top, an Australian example), well, it's best to give this largest of all reptiles a wide berth. With the male of the species reaching a length of 20 feet and a weight of nearly 3,000 pounds, this croc is what is known as "an apex predator," capable of taking down, with a sudden burst of speed, nearly all other animals in its range—from monkeys to water buffaloes, wild boars to sharks, woebegone pooches to wayward people. Another to avoid is the anaconda, seen above slithering in search of prey in Venezuela, one of the largest and perhaps the longest snake in the world, growing, in the case of the green anaconda, to more than 18 feet in length. It is a non-venomous but nonetheless deadly boa, with a hug that can choke the life out of river fowl, small horses or careless humans.

Sumo Species

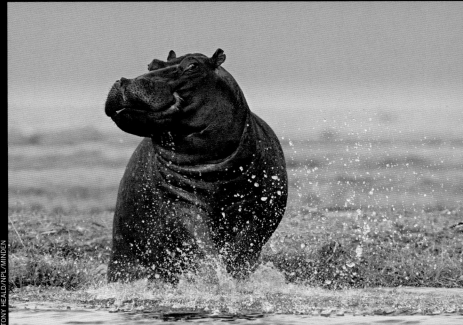

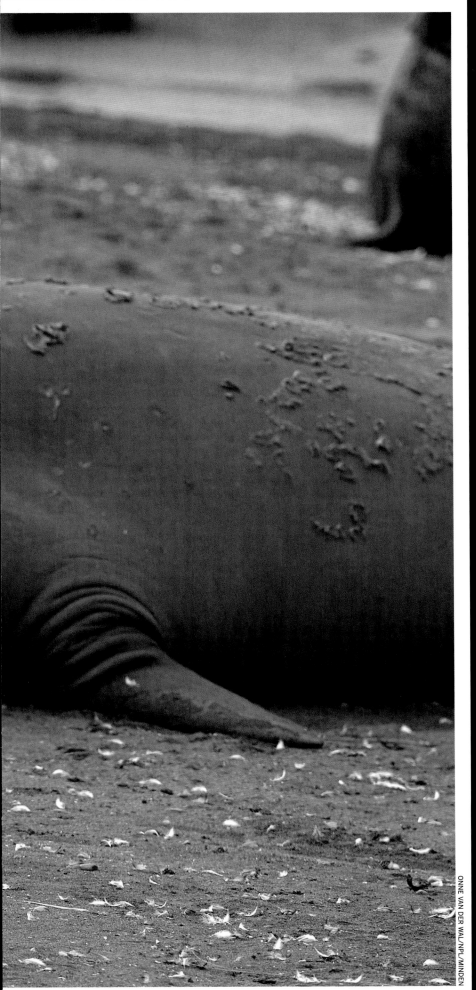

*t*he elephant seal (seen in its larger, Southern Hemisphere incarnation on South Georgia Island near the tip of South America, left) and the hippopotamus (offering his territorial-defense pose at water's edge in the southern African nation of Botswana, above) are, pound for pound, two of the most impressive mammals to be found anywhere. Bull elephant seals can attain a weight of three tons (cows weigh in at a mere ton) and the largest ever recorded was more than 22 feet long and weighed—get this!—11,000 pounds, the biggest carnivore on the planet. Underwater, the seal can dive a mile down and, with its enormous quantity of oxygen-bearing blood, hold its breath for up to two hours while it forages for skates, squid, eels and, yes, penguins (these two king penguins seem not to care). The bull's prodigious proboscis produces a horrendous roar during mating season. The hippo, too, is amphibious, but is mostly herbivorous—the third largest land animal on the planet after the vegetarian elephant and white rhinoceros. Though it looks more like a terrestrial mammal and was long grouped with the pig by scientists, recent research indicates that its close relations are cetaceans such as whales and porpoises, from which it diverged about 55 million years ago. As this picture indicates, the so-called river horse is as aggressive as any animal—perhaps the fiercest fighter in all of Africa, a continent that, as we know, enjoys a super-abundance of heavyweight contenders. Older male hippos can weigh close to 10,000 pounds, so on these two pages we have animals approximating 10 tons of fun.

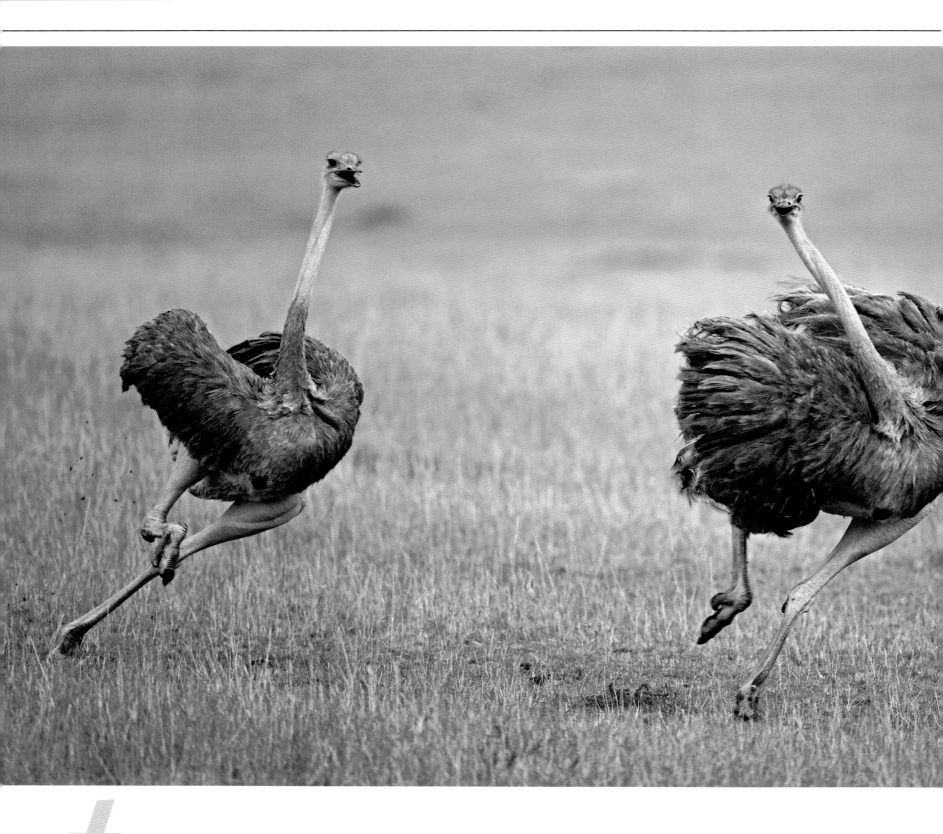

*t*he avian world is as varied and altogether wondrous as life itself: It is, from its smallest to its largest members, from its wee nectar-sippers to its ferocious fish-eaters, a subset reflection of the larger animal kingdom and, indeed, the earthly community of all animated things. The point is proved quickly by contemplating this trio of big birds, who couldn't look or behave more differently from one another if they tried. Above: In the Masai Mara National Reserve in Kenya we have a female ostrich chasing away a rival. This flightless bird, native to Africa and related to the kiwis of New Zealand, the emus of Australia and other exotics, can run as fast as 45 miles per hour (fastest speed afoot of any bird), can attain a height of nearly nine feet and a weight of nearly 350 pounds (largest of any bird) and can lay an egg about 20 times heavier than a chicken's (the biggest egg in the world). Opposite, bottom: A trumpeter swan fans its wings in

Yellowstone National Park in Wyoming. This is North America's largest native bird—usually up to five feet in length, with a wingspan averaging nearly seven feet and an average weight of 25 pounds. It is the largest living waterfowl on the planet. While the ostrich is a land-based bird, the swan feeds while swimming. High above the ostrich and the swan soars the bald eagle (opposite, top), the national bird and symbol of the United States. This large raptor can grow to as much as three feet long, with a wingspan of up to eight feet; a female can weigh up to 15 pounds (the male of the species is slightly smaller). The bald eagle builds a tremendous nest of twigs high up in trees or on cliffs, a nest that is more than a dozen feet deep and eight feet wide, and weighs more than a ton. The ostrich, the trumpeter swan and the bald eagle: all related under the feathers, though it's hard to see how.

Birds Not of a Feather

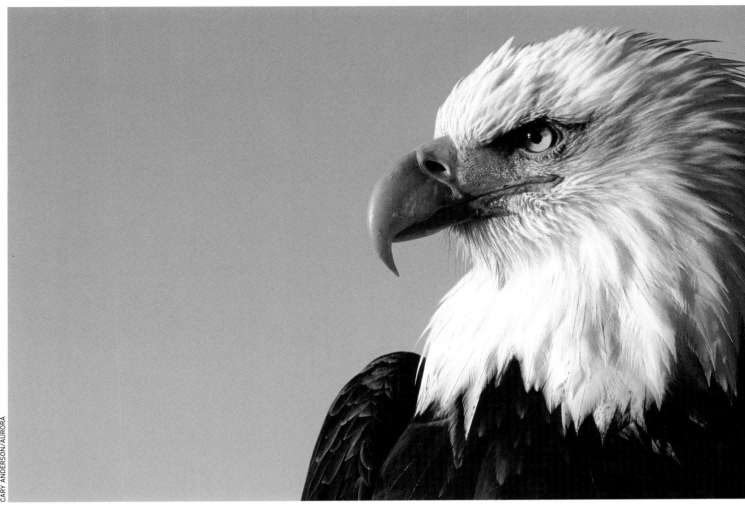

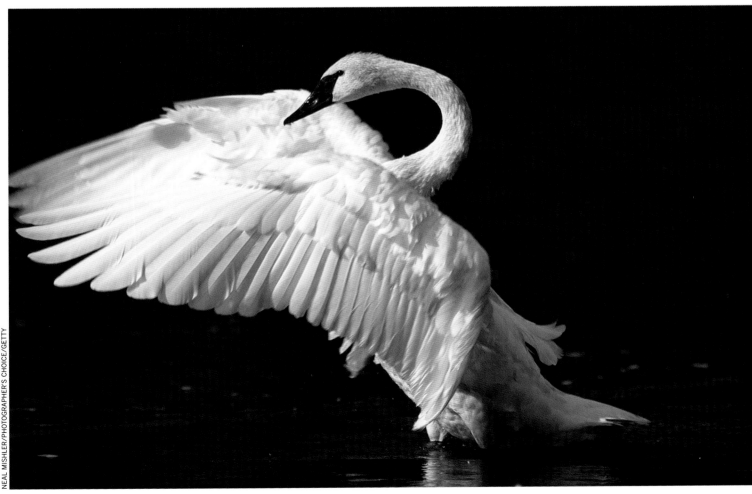

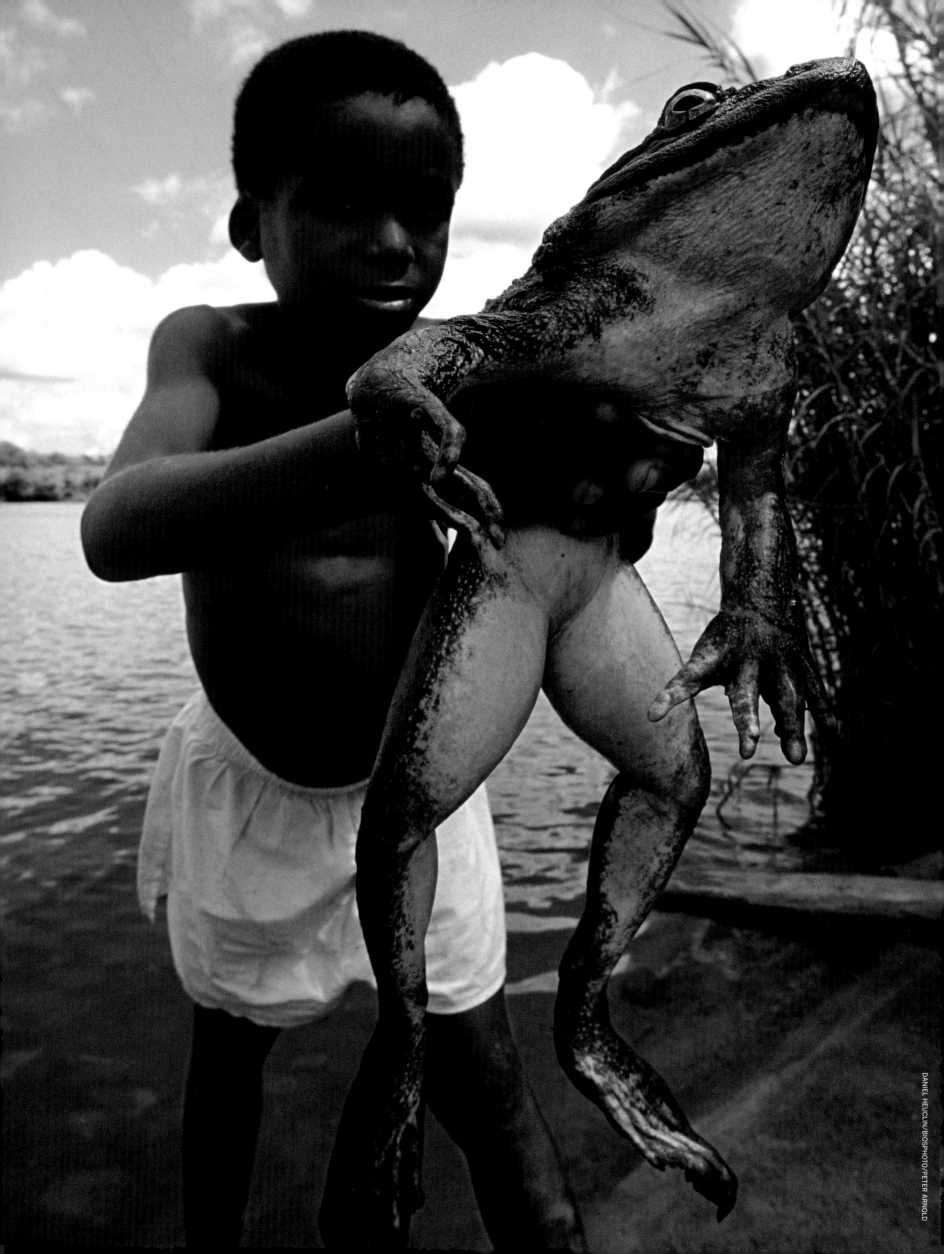

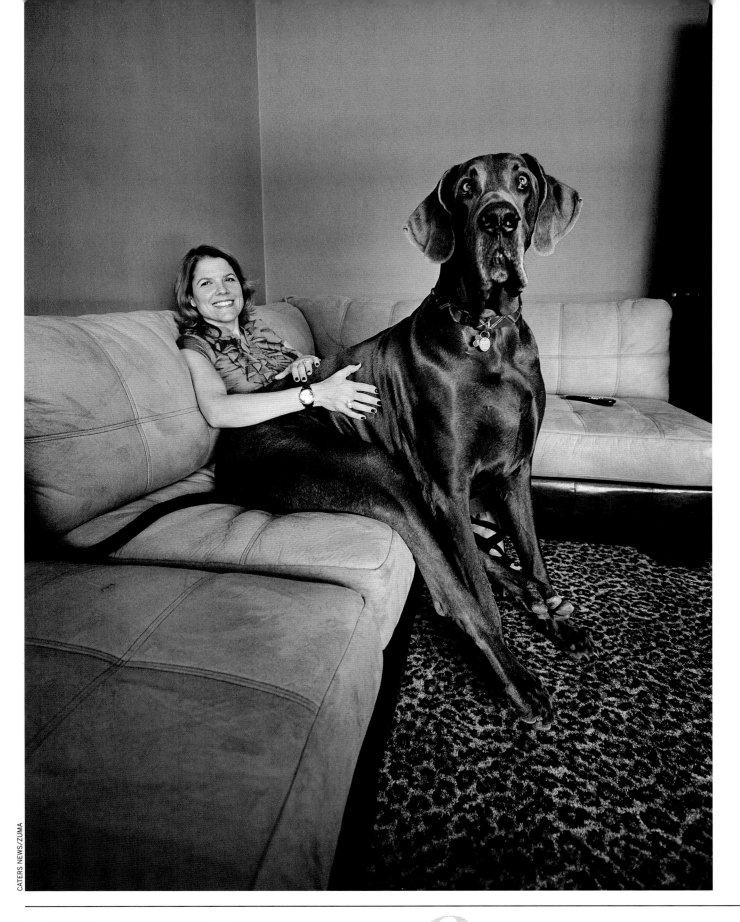

CATERS NEWS/ZUMA

The Biggest Frog, The Biggest Dog

Freakishly large animals tend to freak us out, and so we have here a freaky moment with a frog of extraordinary proportions and a dog who would give *paws* to the most dedicated of animal-control officers. The species name of the frog is *goliath,* and the nickname of the dog is Giant George. Both are fitting. A goliath frog can grow to more than a foot in length and a weight of eight pounds; this example, being held by a boy in the frog's native Cameroon (it also habituates Equatorial Guinea), is representative. Goliaths can live 15 years if allowed, but they are increasingly threatened by a loss of habitat, as well as by their use as a food source or even as exotic pets. Which brings us to Giant George, the Great Dane owned by David and Christine Nasser (seen here) of Tucson, Arizona. Measuring 43 inches from paw to shoulder, George is the current holder of the World's Tallest Dog title as determined by the Guinness folks—and, in fact, is the tallest dog ever to be measured. He weighs 245 pounds and is, thank goodness, friendly. The Nassers obviously have no prohibitions keeping George off the couch, even if such prohibitions could be enforced.

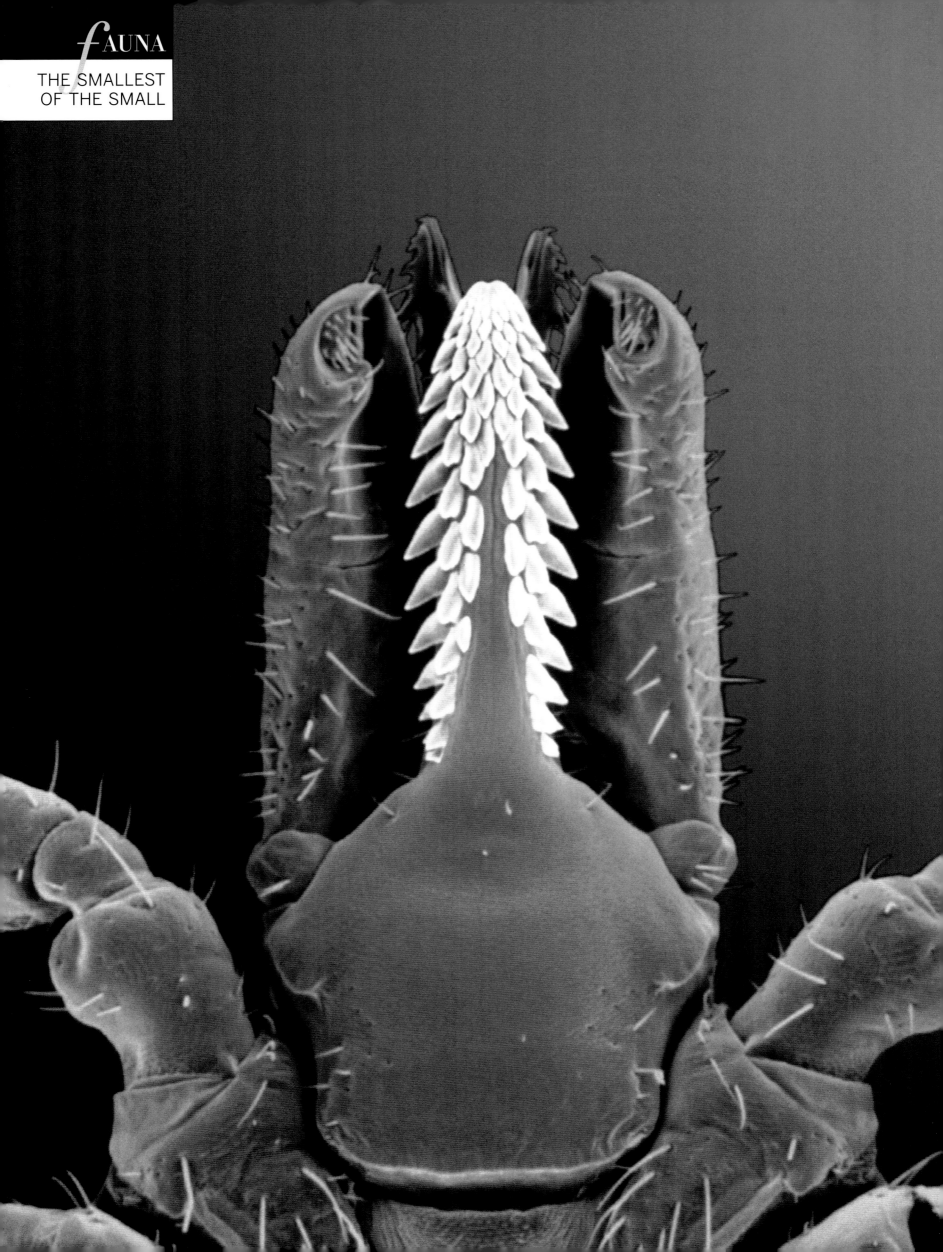

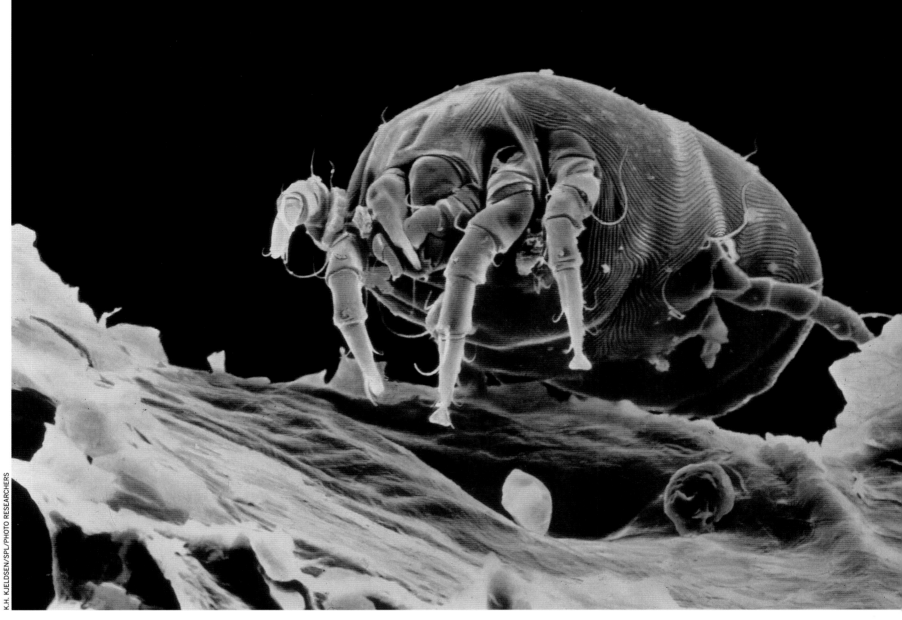

Sweet Dreams

*a*bove we have an electron micrograph of everyone's most common and least welcome house guest, the dust mite, of which there are several species that all behave pretty much alike. Feeding off detritus such as human skin flakes (yuckily, each of us sheds one and a half grams of skin per day, enough to feed roughly a million mites), they proliferate in pillows and under the covers; you are, on a typical night, sharing your bed with hundreds of thousands of them, a single mite barely discernable against a white sheet in bright sunlight. A male can live for nearly three weeks, but a female can survive for 10 weeks, laying up to 100 eggs in her maturity. House mites eat and also excrete, and this fact of natural biology is where the problems come in. Dust mites and their fecal matter cause allergies in many humans and are a common source of asthma, which of course can be quite a serious matter. Several strategies for dealing with dust mites have been published by medical and advocacy groups and are generally available. A first step in all of them can be stated plainly: Keep a clean house. Another pest to be avoided is larger but still small, the deer tick (opposite), famous for bringing Lyme disease into the home. And then, for Kitty (and Fido as well), there is the cat flea (right), one of the world's most common fleas, which is certainly an irritant but can also transmit parasites that can cause serious ailments in cats, dogs and even humans.

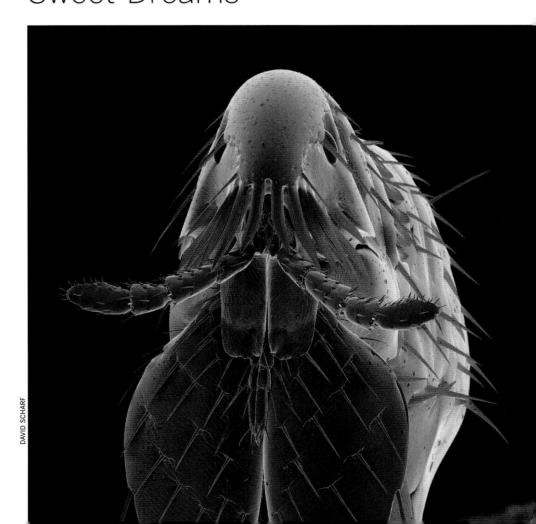

Beautiful, Sometimes Deadly

We have tried to produce an interesting and scientifically accurate book, but this is a good place for us to pause and discuss how we have simplified things in certain cases. There are five kingdoms of living things on our planet: Animalia, Plantae, Fungi, Protista and Monera. Already we have placed Fungi in our "Flora" section because it was an easy thing to do, what with mushrooms and such being considered by many people to be plant matter. Later in these pages, we will accurately present coral and the sponge, which many folks also assume are plants, as animals. Here, in our fauna section, we willfully, however, make a second mistake: Bacteria cells are, let's say, *different* than those of animals. If you want to get technical (and we encourage you to investigate further), they are prokaryotic, belonging to the Monera kingdom, while those of the other four kingdoms are eukaryotic. This means a couple of things, the niftiest of which is: Prokaryotes are the ultimate survivors, the original living habitants of our planet, "beings" that evolved as many as four billion years ago. They've been with us twice as long as the protozoans and more than three times as long as animals. They are small, very small. And they are in all of us, for good and ill, helping with digestion, keeping skin healthy, enabling eyesight, sometimes causing disease. Under a microscope, bacteria and viruses can paint a disarmingly pretty picture, as is clearly evident here. Opposite, top left: Anthrax bacteria in a lung capillary. Top right: *Salmonella* bacteria. Center, left: Tuberculosis bacteria infecting a white blood cell, and right: *Staphylococcus aureus,* which can be a factor in everything from staph infections to boils, carbuncles, cellulitus and more. Bottom: Another staph bacteria, *Staphylococcus epidermidis.* Below: The HIV virus fusing with a host T-cell.

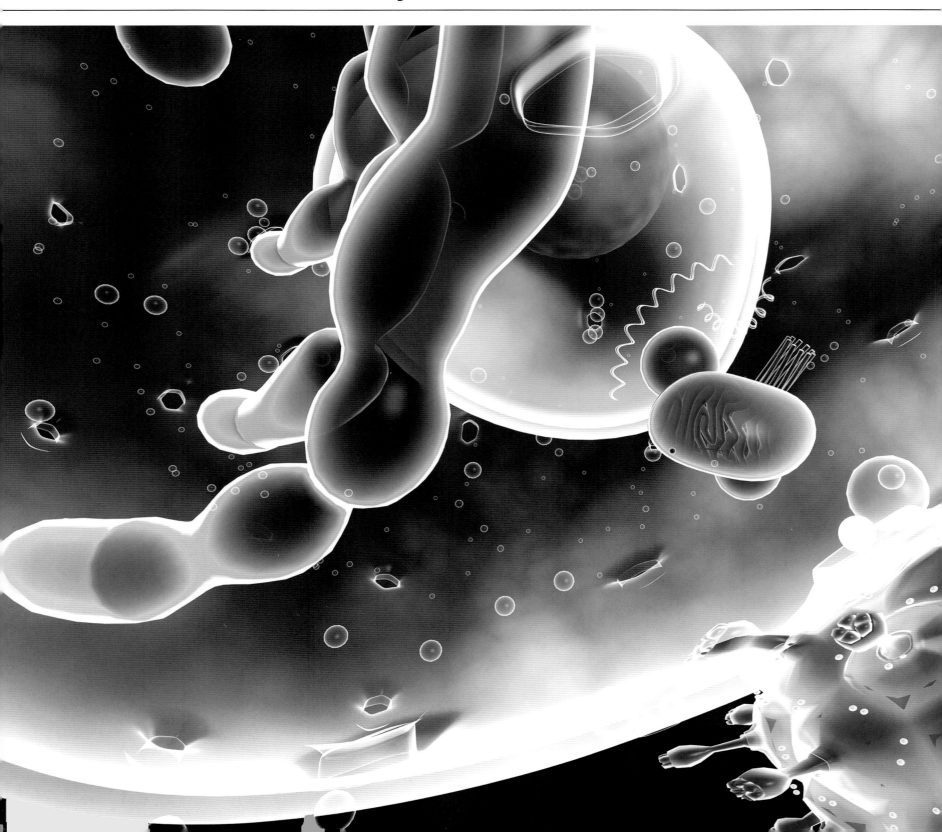

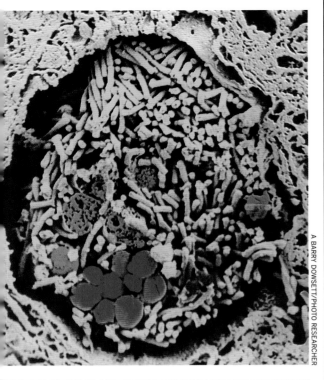

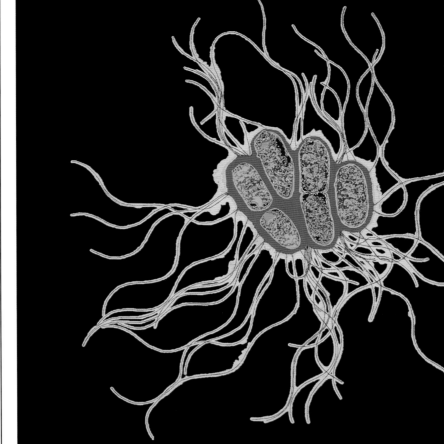

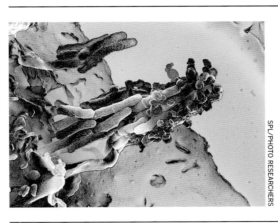

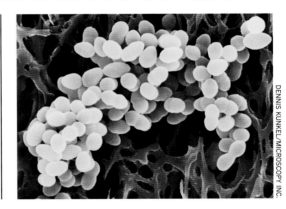

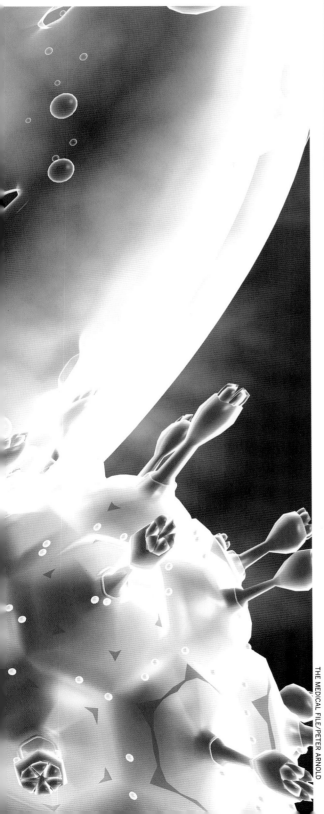

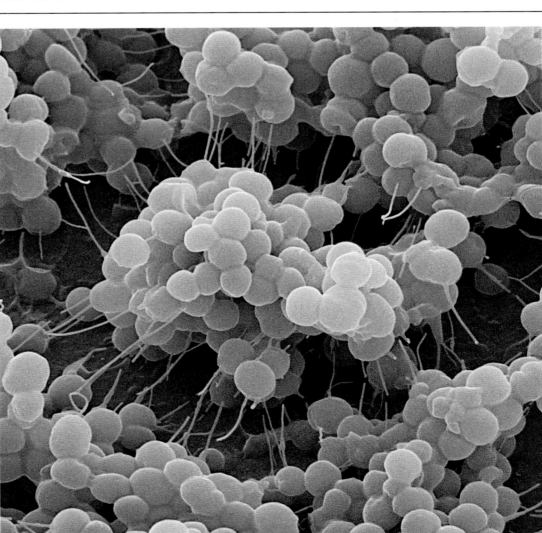

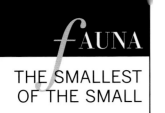
Space Aliens Among Us?
(Yes, Sort Of)

Tardigrades (opposite) have such cute nicknames: water bears, moss piglets. And yet they look so freakishly spooky when seen up close and personal. What are they? Certainly nothing ursine or porcine, but rather extremely hardy water-dwelling animals, usually less than a millimeter in length, that exist in more than a thousand species all over the world, at high altitudes and low depths. Tardigrades look a little like Lilo's pet alien Stitch in the Disney movie, having a stubby body and four pairs of legs. They feed, in their various subspecies, on plant cells, algae and very small invertebrates; most are herbivores or bacteria eaters, but some are predatory. How tough are they? They have, in tests, survived at temperatures north of 400 degrees Fahrenheit and south of 73 below, and in 2007 tardigrades were taken into low earth orbit and exposed for 10 days to the vacuum of outer space. Many survived, and even laid and hatched eggs—the only animals ever to do so in that inhospitable realm. Nematodes or "roundworms" (below) dwarf the tardigrades in diversity, coming at us in more than 28,000 species. Among many remarkable facts concerning them: The worm's digestive system takes in food from both ends. And now for something completely different: The nanobe (left). This just might be the smallest form of life, a tenth the size of the smallest bacteria ever identified, though that claim is a subject of debate. Found in 1996 growing in sandstones off Australia's western coast that dated from the Jurassic and Triassic periods, these filaments are, according to some scientists, living organisms—not dissimilar to the crystal structures found in a Mars meteorite that crashed eons ago into Antarctica.

COURTESY DR. PHILIPPA UWINS

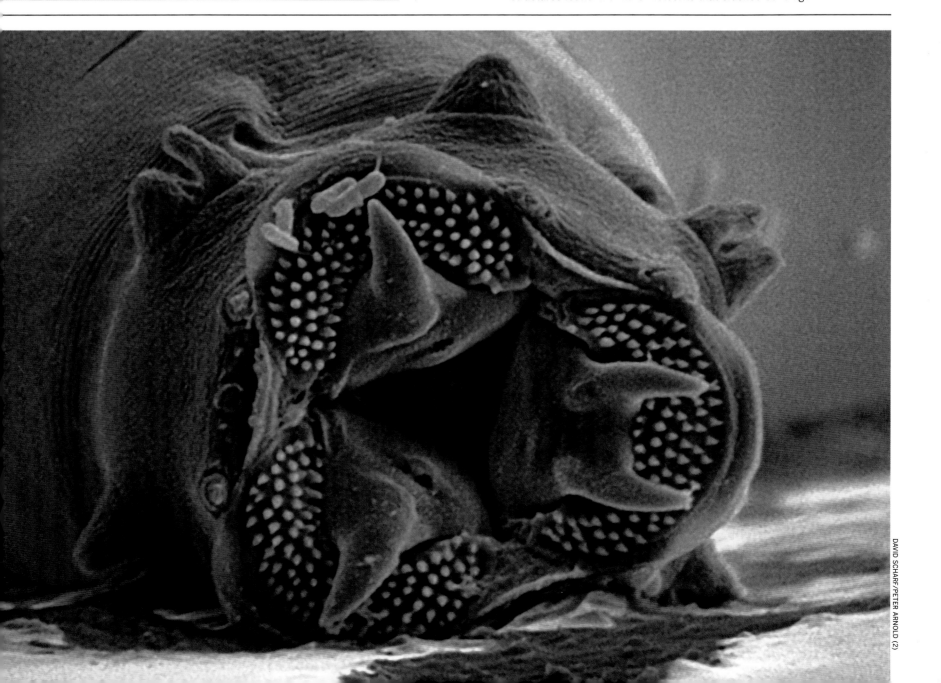

DAVID SCHARF/PETER ARNOLD (2)

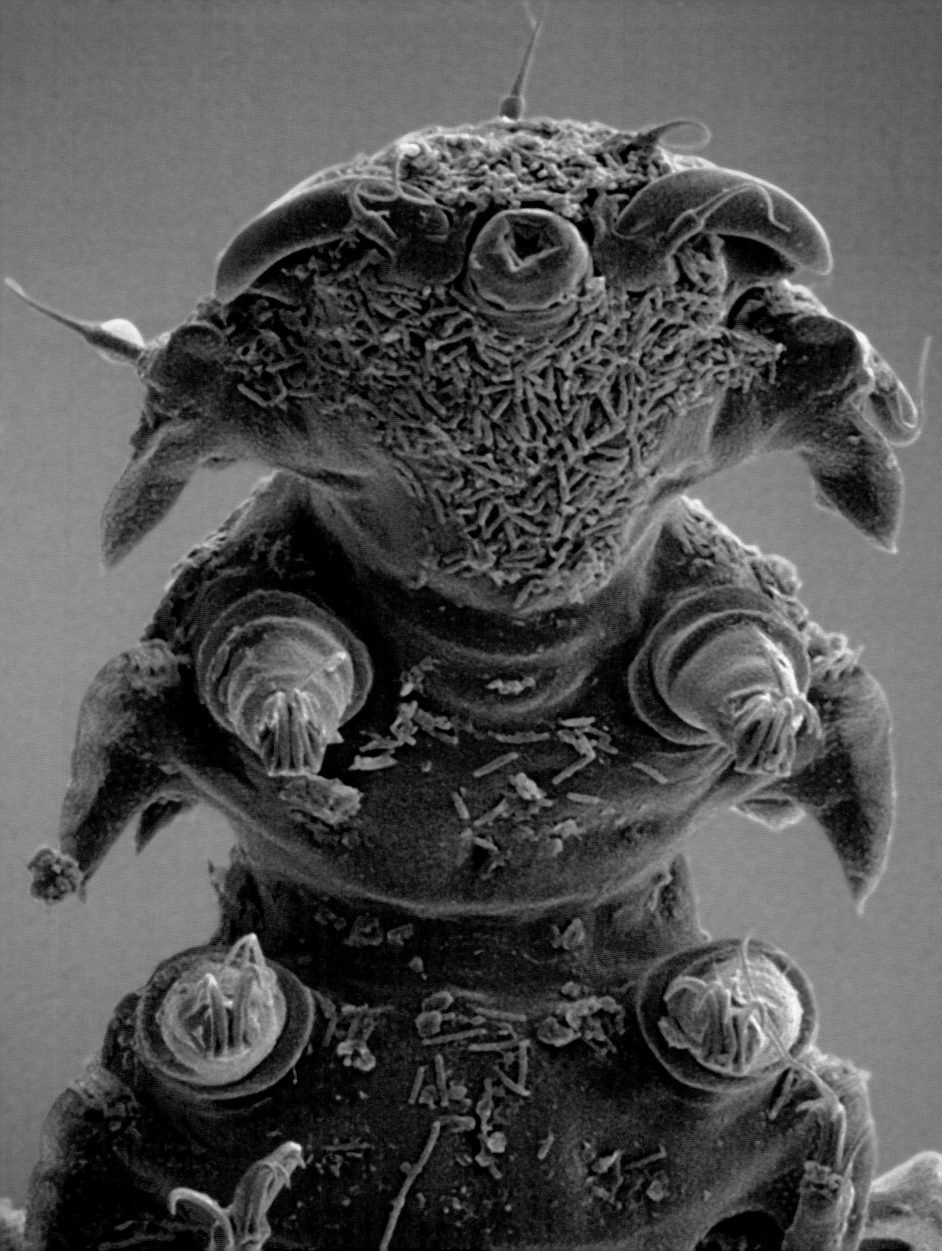

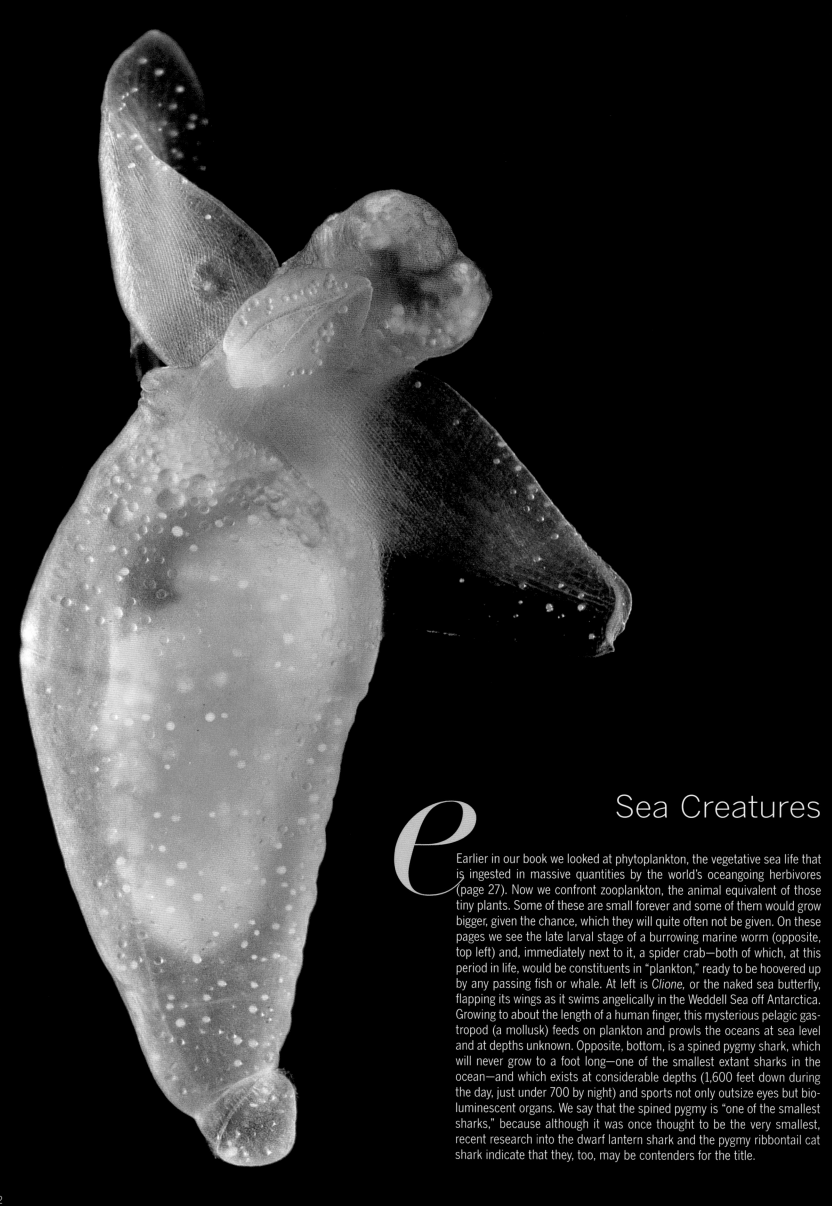

INGO ARNDT/MINDEN

Sea Creatures

e Earlier in our book we looked at phytoplankton, the vegetative sea life that is ingested in massive quantities by the world's oceangoing herbivores (page 27). Now we confront zooplankton, the animal equivalent of those tiny plants. Some of these are small forever and some of them would grow bigger, given the chance, which they will quite often not be given. On these pages we see the late larval stage of a burrowing marine worm (opposite, top left) and, immediately next to it, a spider crab—both of which, at this period in life, would be constituents in "plankton," ready to be hoovered up by any passing fish or whale. At left is *Clione,* or the naked sea butterfly, flapping its wings as it swims angelically in the Weddell Sea off Antarctica. Growing to about the length of a human finger, this mysterious pelagic gastropod (a mollusk) feeds on plankton and prowls the oceans at sea level and at depths unknown. Opposite, bottom, is a spined pygmy shark, which will never grow to a foot long—one of the smallest extant sharks in the ocean—and which exists at considerable depths (1,600 feet down during the day, just under 700 by night) and sports not only outsize eyes but bioluminescent organs. We say that the spined pygmy is "one of the smallest sharks," because although it was once thought to be the very smallest, recent research into the dwarf lantern shark and the pygmy ribbontail cat shark indicate that they, too, may be contenders for the title.

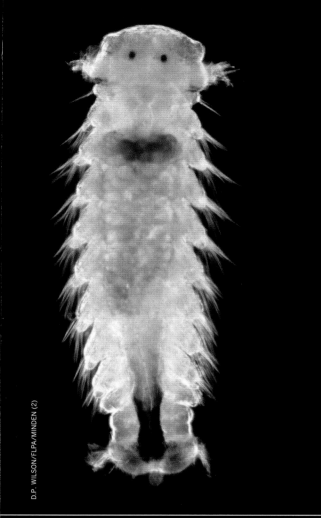

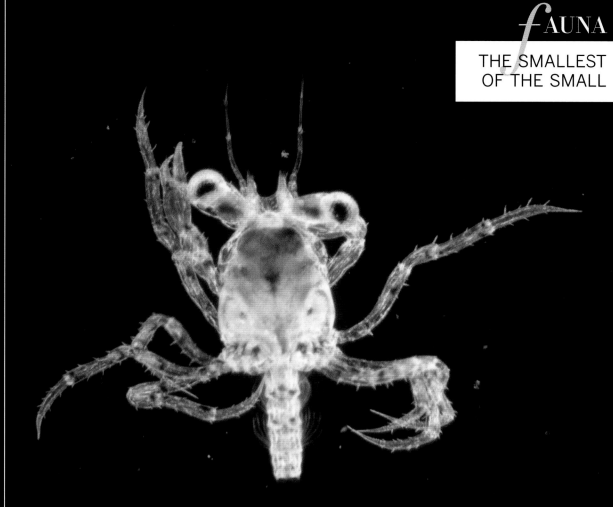

D.P. WILSON/FLPA/MINDEN (2)

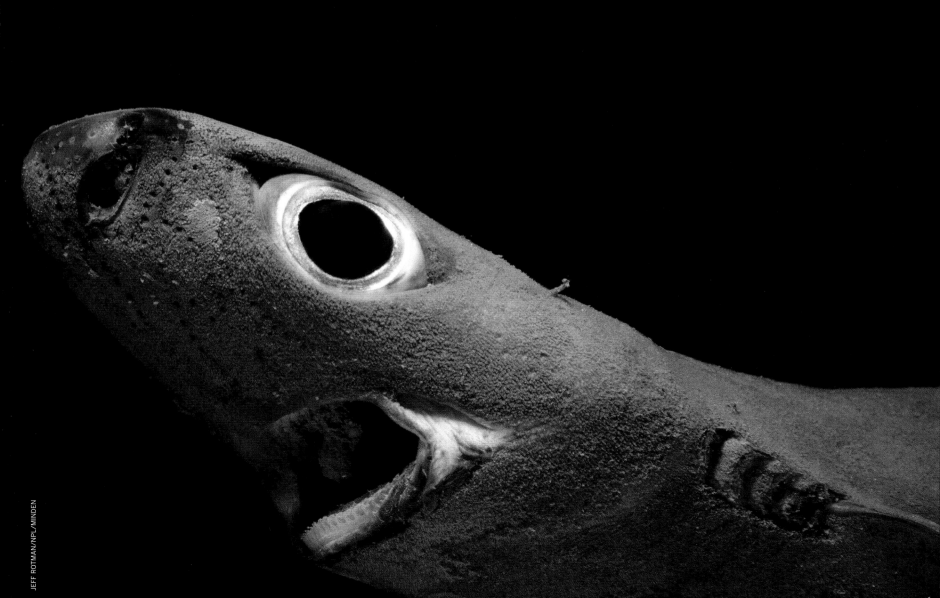

JEFF ROTMAN/NPL/MINDEN

Relativity

On these two pages, everything is put into perspective, and we can gauge just how amazingly small some critters that exist—*persist*—in the wild really are. Hiding in the debris of the forest on the coast of Brazil, and showing itself, opposite, on the nose of a photographer's colleague, is the Brazilian gold frog, the world's smallest frog. This little guy comes in nine species and is also known, in its tiniest iteration (less than a half-inch in length, max) as Izecksohn's Toad or, when yellow hued, the Brazilian gold frog. Barely smaller still is what's believed to be the world's smallest fish, seen opposite in the tube, a member of the carp family, with a see-through body that can grow to three-tenths of an inch. It was unknown to researchers before being discovered in an acidic peat swamp in Indonesia in 2006. On the coin, also opposite: The world's smallest snake, a threadsnake less than four inches long and easily confused with an earthworm, was given the name *Laptotyphlops carlae* after being found on the Caribbean island of Barbados in 2008. Similarly able to fit on a quarter-dollar but compared, opposite, with a butterfly is what is thought to be the world's very smallest reptile, the *Jaragua sphaero,* or dwarf gecko, which exists only in the extreme southwest of the Dominican Republic in the Caribbean and on the nearby island of Beata. Finally, below, we have the world's smallest species of bat. That really means something: There are more than a thousand bat species in the world, constituting approximately 25 percent of all mammal species. This is, then, the most minuscule of them all, and one of the very smallest mammals on the planet, depending upon your measurement method. The Kitti's hog-nosed bat, better known as the bumblebee bat, lives in limestone caves in Thailand and Burma, has the smallest skull size of any mammal and grows to a size of only 1.3 inches in length and two grams in weight. The Etruscan shrew, which we will meet on the pages immediately following, is longer (growing to darn near two inches!) but may be lighter on average, and so the competition continues.

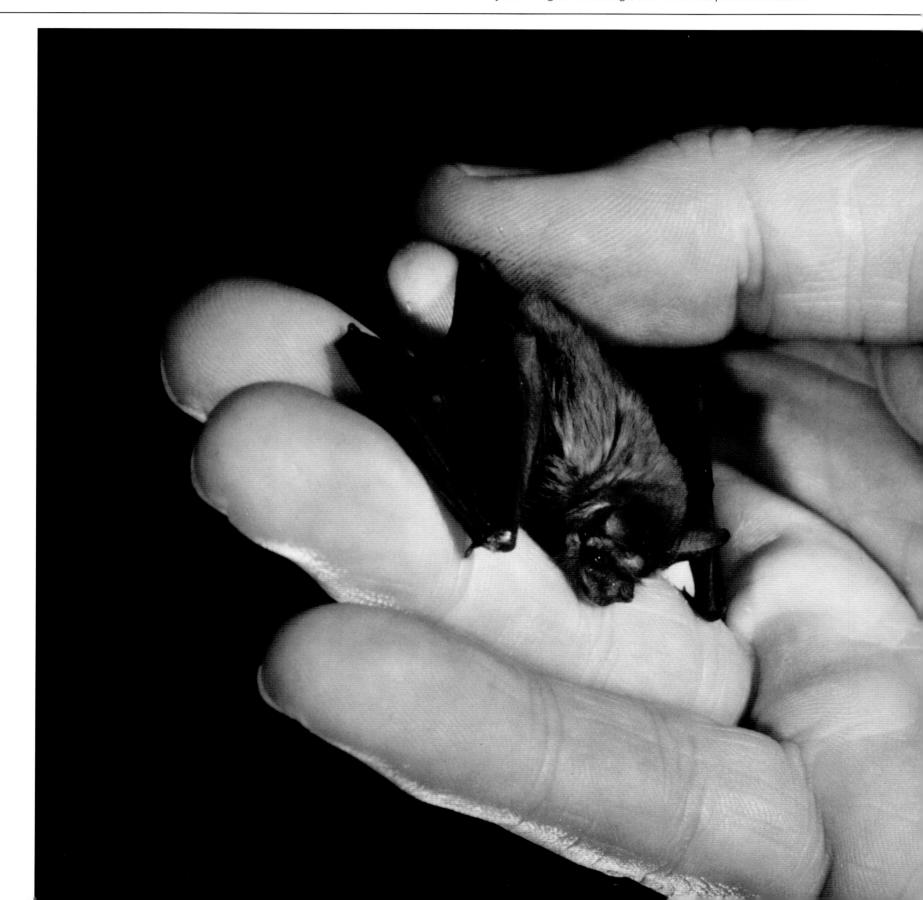

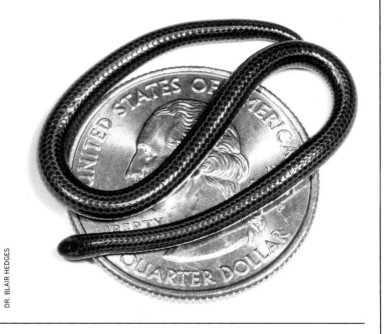

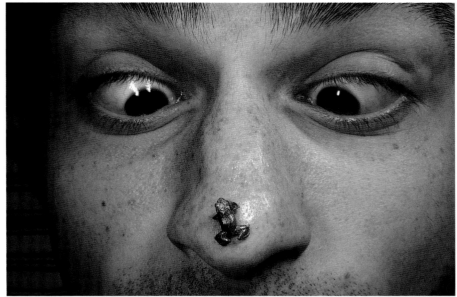

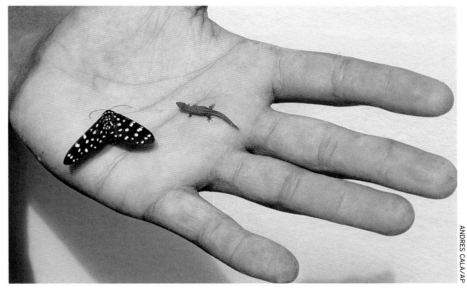

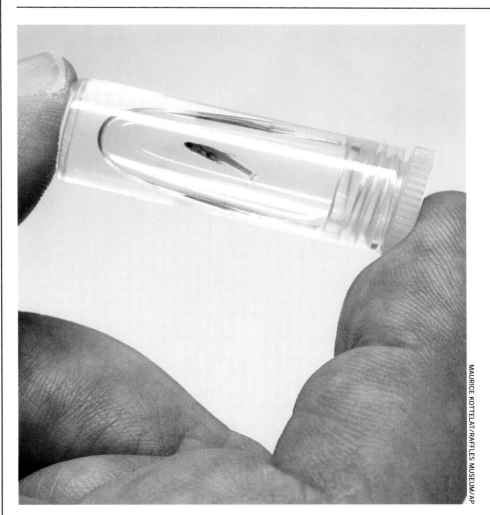

Survival Instincts

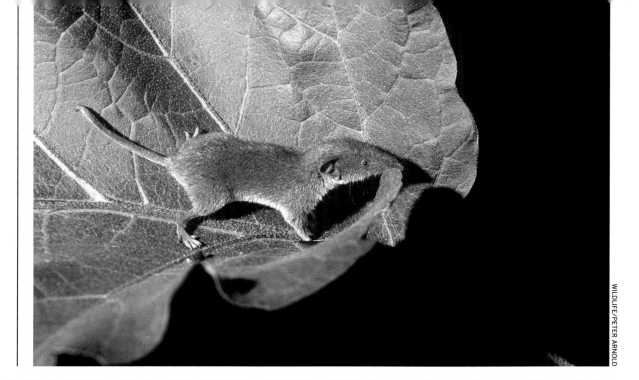

WILDLIFE/PETER ARNOLD

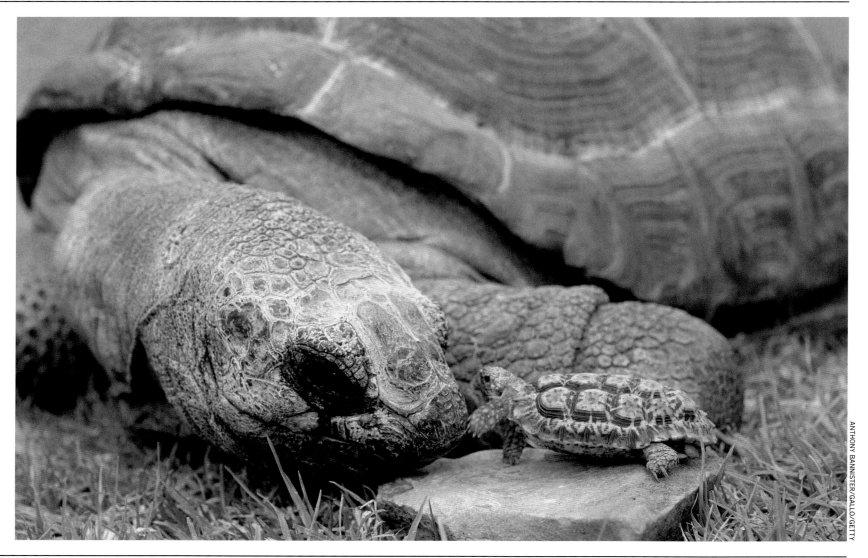

ANTHONY BANNISTER/GALLO/GETTY

It's a tough world when you're tiny, but these little ones have found their way. On the leaf at top is the Etruscan shrew, also called the Etruscan pygmy shrew or white-toothed pygmy shrew, the smallest mammal by mass, which was alluded to on the pages prior. It survives on insects while scurrying in forests and in the brush of southern Asia and Europe. On the leaf, opposite, is the strawberry poison dart (or poison arrow) frog, which is not the world's smallest frog (we met that amphibian on page 105) but is well worth noting for its inventiveness and perseverance in forwarding—indeed preserving—its species. First of all, the frog, which grows to about an inch in length, is toxic to its predators, and boasts up to 30 colorations so that its enemies can readily associate its brilliance with danger. But more: In its domain in Nicaragua, Costa Rica and Panama, this intrepid, family-oriented frog will scale great heights to protect its young. It carries tadpoles on its back one by one, as seen here, to the upper reaches of huge rainforest trees to get these offspring out of harm's way. Above: The Aldabra giant tortoise, one of the world's very largest (ranging up to more than 700 pounds), makes a guest appearance here in our "Smallest of the Small" section only to provide contrast with, and context for, its little friend, a speckled padloper, the world's smallest tortoise, which perseveres in western South Africa while never attaining a length of even four inches.

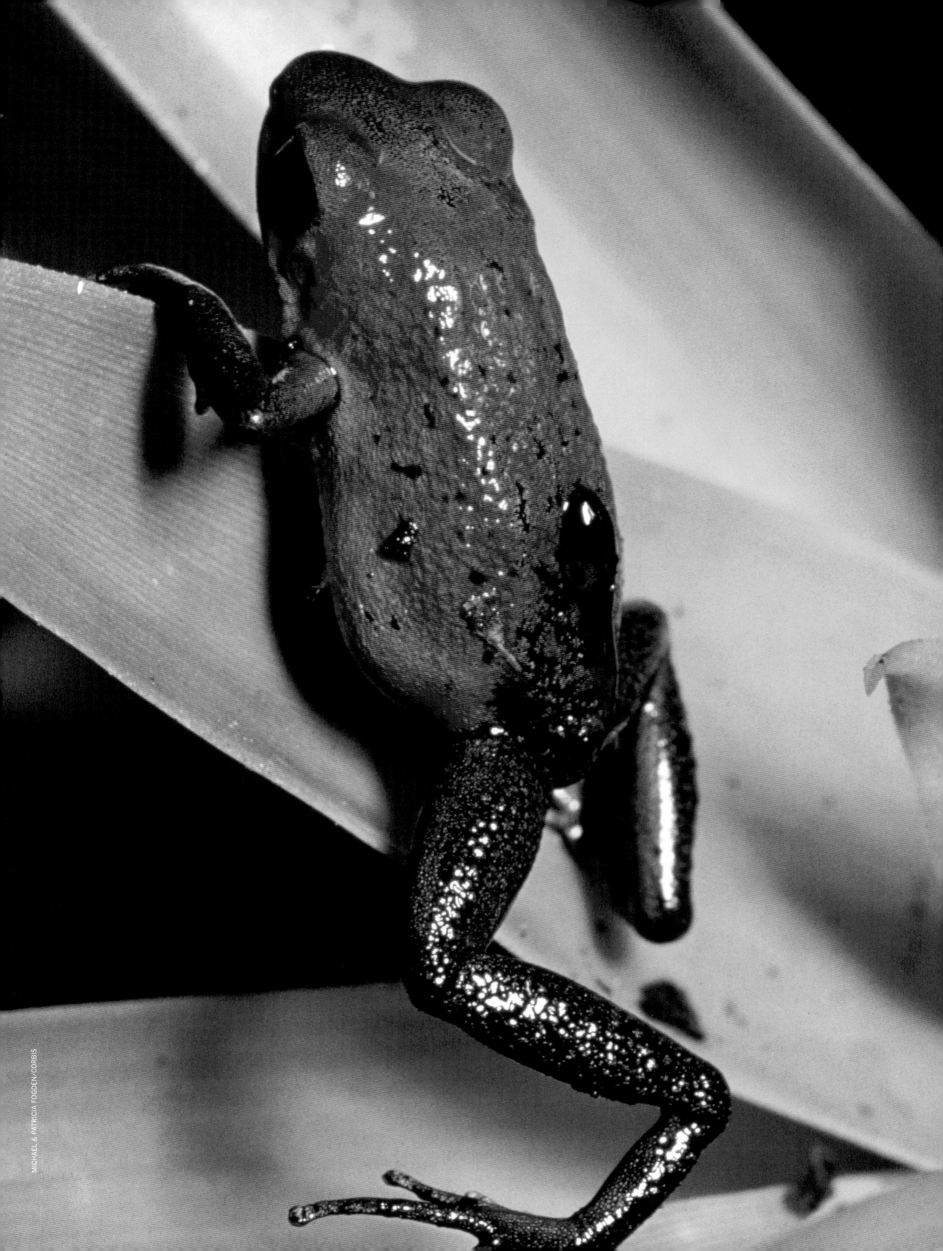

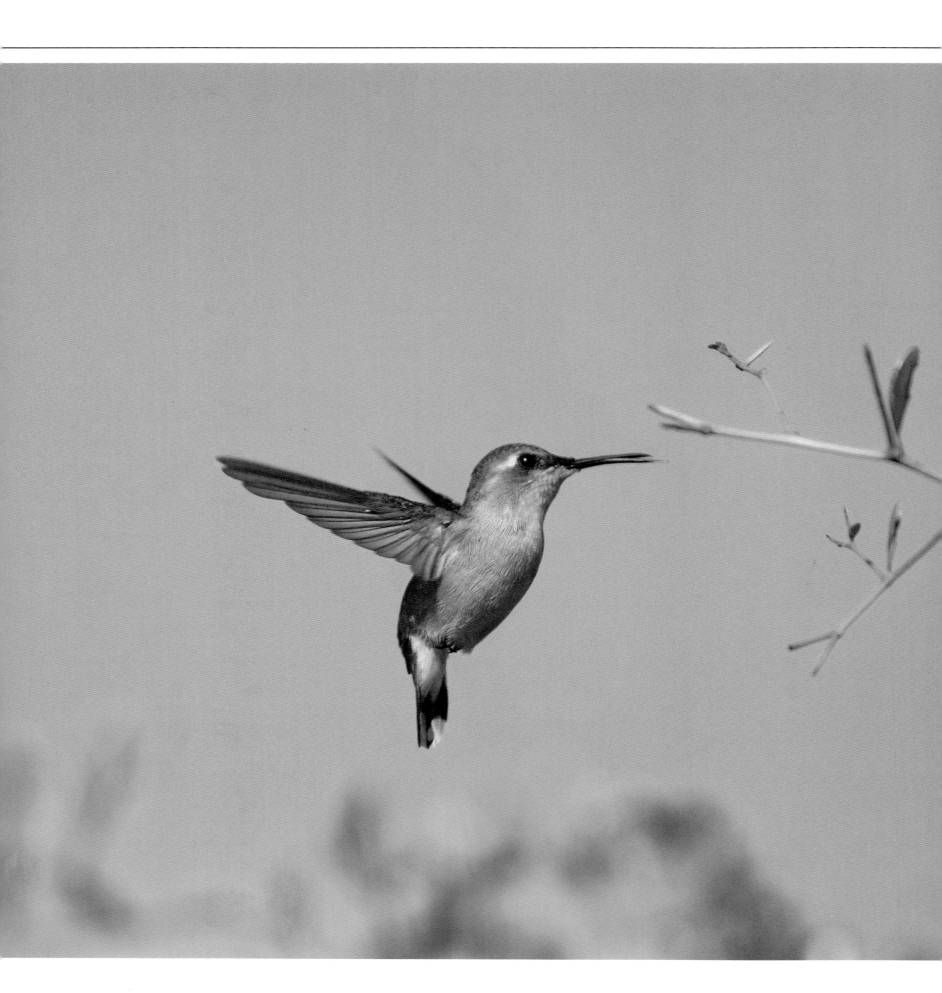

Humming Along

At left we have what is definitively the world's smallest bird, an altogether extraordinary creature with talents and a pedigree beyond compare, and, below, what is thought to be the world's smallest dog, a cute little critter of the noble breed called Chihuahua. In terms of which is the more remarkable animal, there is no contest (profound and profuse apologies extended to all dog lovers, a club that includes us). The bee hummingbird, endemic to mainland Cuba and that nation's second-largest island, Isla de la Juventud, grows to a length of two inches and weight of a tenth of an ounce—approximately the size, of, yes, a large bee. It shares stunning character traits with other hummingbirds: It can hover,

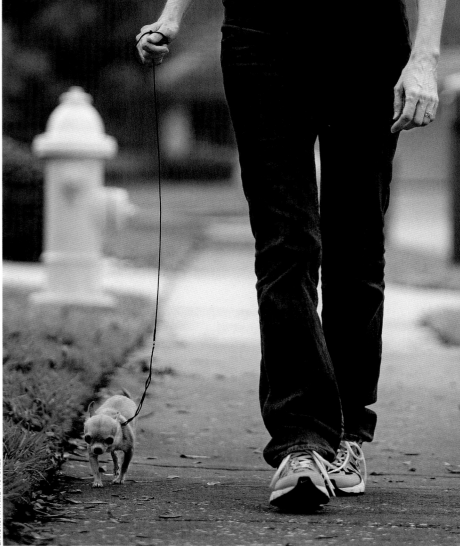

BARCROFT/FAME PICTURES

LEE DALTON

beating its wings something like 80 times every second, and withdraws nectar from a flower, of which it might visit 1,500 in a single day, with its long tongue. To fuel its ferocious energy, it requires about one half or more of its body weight in nectar per day. Now that we've used the word *ferocious,* let's proceed to the best part: One of the famous groups of dinosaurs were the Theropods, whose king in the Triassic and Cretaceous periods was, it can be argued, *Tyrannosaurus.* Theropods were a diverse group, and included Avialans—winged creatures—which survive in our time as birds. The bee hummingbird is one of these, so in this photograph we see the smallest dinosaur extant today. And he's related to T Rex! As for the six-inch pooch, Brandy, here being walked by owner Paulette Keller of Largo, Florida, well . . . As said, she's *way* cute. But her résumé, a *Guinness Book* citation notwithstanding, simply can't compete with that of the bee hummingbird.

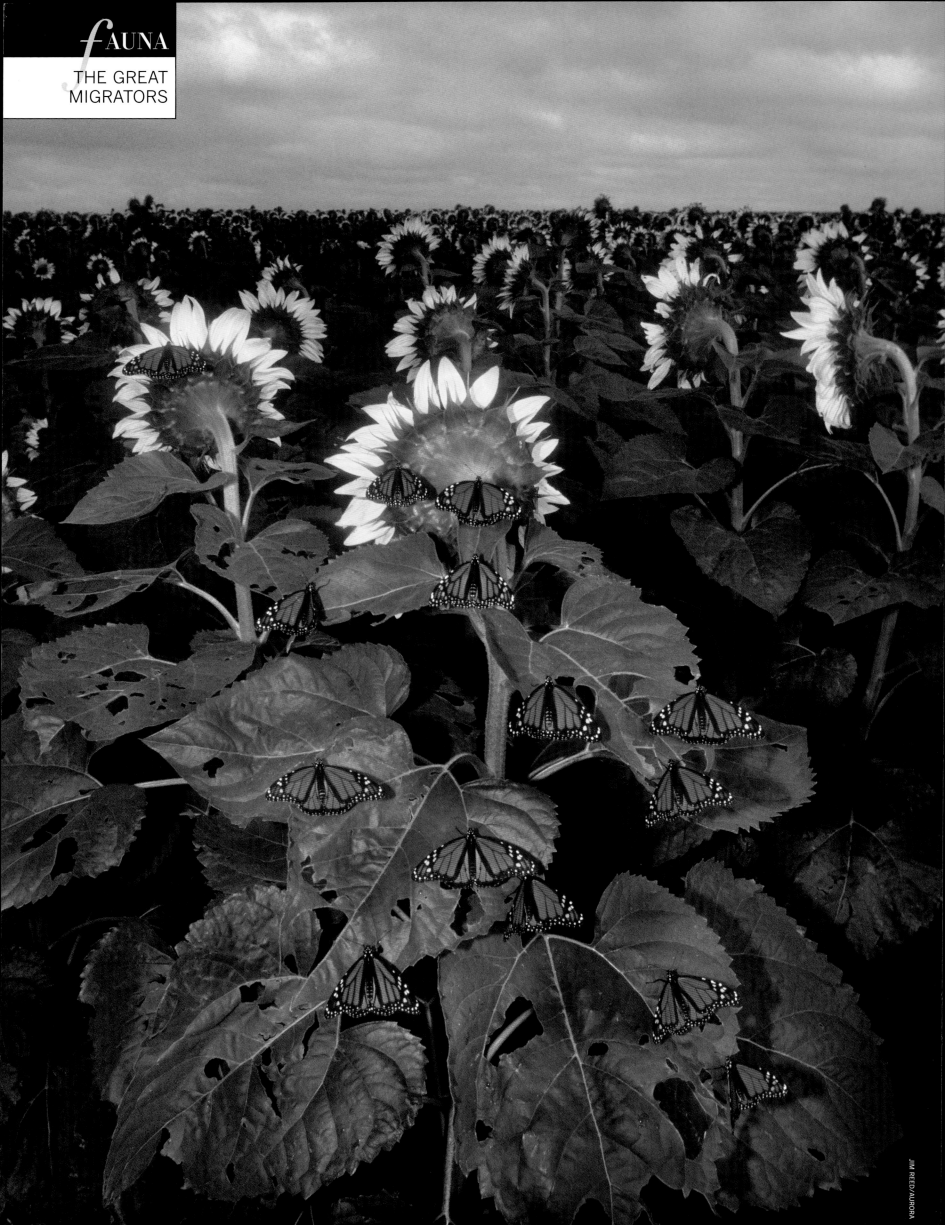

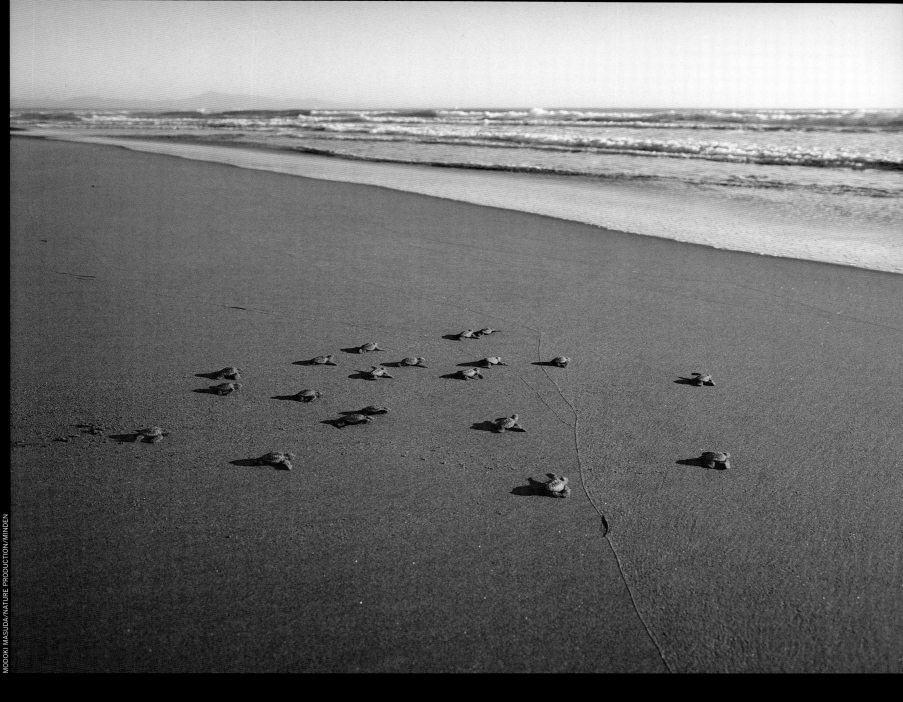

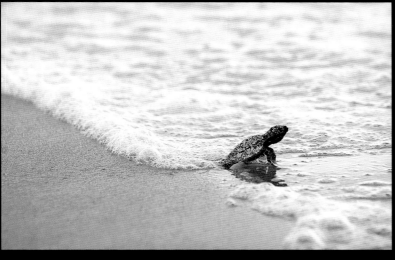

Miles to Go
Before They Sleep

a As we have already seen, certain species' abilities and behavior patterns—not to mention uncanny instincts and bottomless willpower—are such to boggle the mind. Nowhere is this in such tight focus as when we look at the legendary migrations within the animal kingdom. We have heard of the amazing salmon, and have already seen brown bears waiting patiently for the fishes' predestined arrival (page 80). Salmon are born upstream. When they reach their juvenile stage, after a year or more, they have developed characteristics that will allow them to thrive in the ocean, and they move downriver to the estuary—a fresh- and saltwater mix—where they double or triple in size before heading out to sea. This is their home for up to five years, depending on the species. They travel thousands of miles and grow strong before heading home to spawn. It is hypothesized that a salmon may use the sun and the stars to navigate—it can actually detect the odor of its native stream—but whatever: Each one is astonishingly accurate in ascending to the spot where it was born to give birth to the next generation. Loggerhead sea turtles, represented on this page by hatchlings heading for the sea on Nichinan Beach in Miyazaki Prefecture, Japan, behave similarly, breeding and nesting inland, traveling through the ocean hundreds of miles to a feeding ground and then returning to the same nesting beach to make a family. And then there is the greatest of all time, the never-to-be-bested featherweight champ, the monarch butterfly (opposite, a rabble rests on sunflowers in western Kansas during its considerable travels). That many of these insects, which weigh barely more than a hundredth of an ounce and feature a wingspan of just four inches, can accomplish a 2,000-mile trip to their ancestral wintering grounds seems simply too much. But this they do: Monarchs that summer in Canada and the eastern U.S. have learned to migrate to southern states or all the way to Mexico. (Some wandering monarchs, when the wind is right, have even made transatlantic crossings—a truly rare achievement for a bug.) Best guesses as to how the butterflies find their way suggest they use the sun as a compass.

Mammals
on the Move

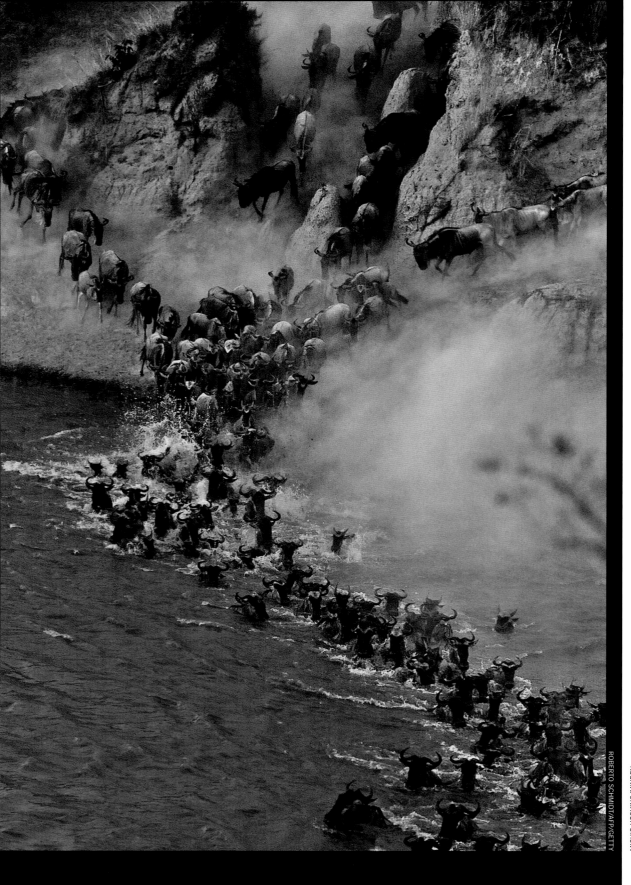

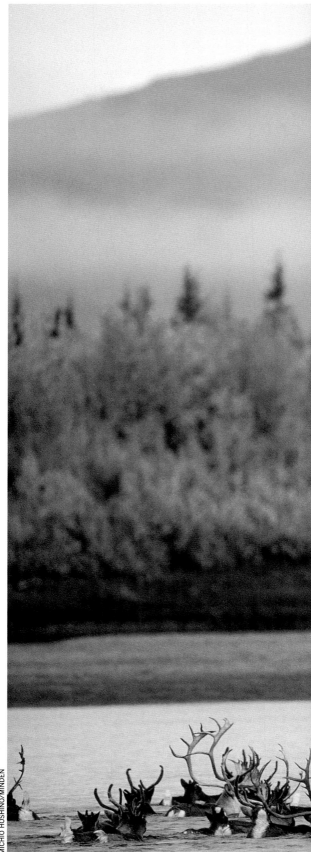

Bigger animals, too, have a natural need to travel. Opposite: The most dramatic of mammalian migrations is probably—with apologies to the extended but relatively serene passages of the gray whale—that of the Serengeti wildebeest. They live in an African wonderland of wildlife, a lush plain of more than 11,000 square miles in Tanzania and Kenya that is positively defined by migration. More than a million wildebeests and 200,000 zebras are on the move every October, venturing from the hills of the north to the plains of the south for the short rains of the coming season. In April they are spurred by heavier rains to head west, then back north. During the so-called Circular Migration, more than 250,000 wildebeests and tens of thousands of other herbivores (Serengeti is home to 70 species of larger mammals) will succumb to predation, exhaustion or other causes (40,000 animals are poached annually in regions surrounding Serengeti National Park), but they will be back at it determinedly the next year. In the 1960s a barbed-wire fence was built to control the wildebeests. The animals promptly flattened it. Below: In northern Canada and Alaska, the betting might be that no fence or mighty stream—in this case, Alaska's Kobuk River—could ever stop the east-west migration of the caribou. But in fact there is ongoing debate about how oil development in calving areas within the Arctic National Wildlife Refuge on Alaska's North Slope might affect those deer, and already there are reports that the Porcupine herd, named for the Porcupine River, has diminished by a third in recent years, with global warming a suspected culprit. Man's fences can be overrun, but his other impacts may prove insurmountable.

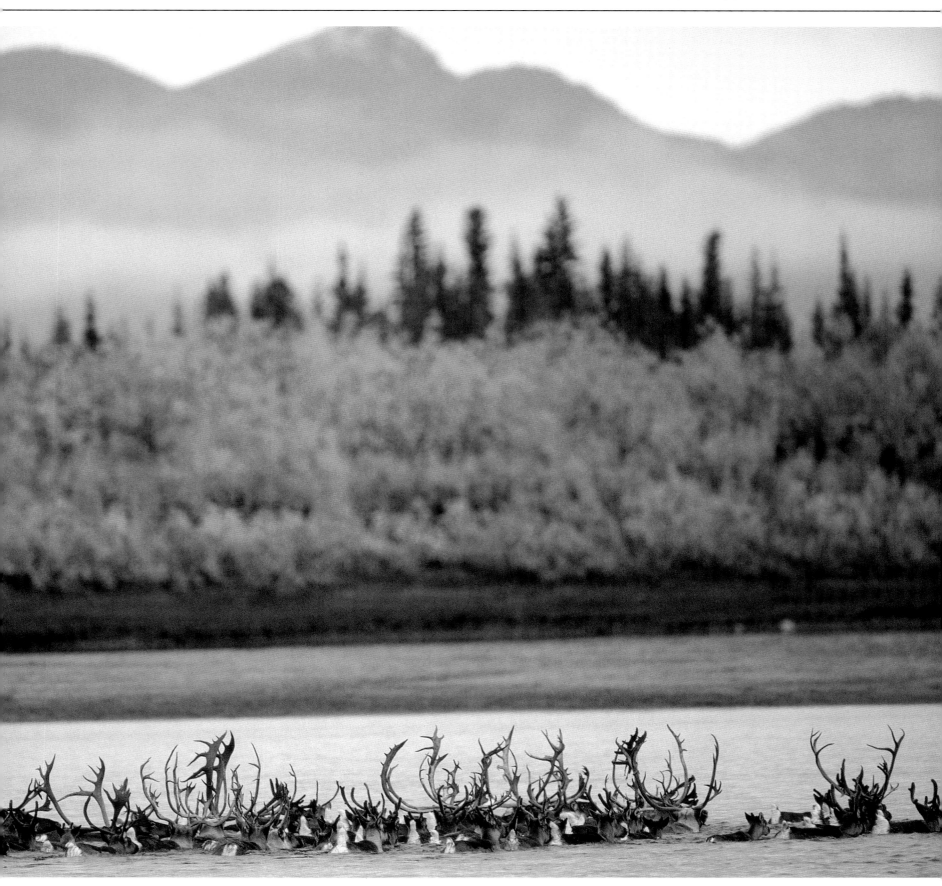

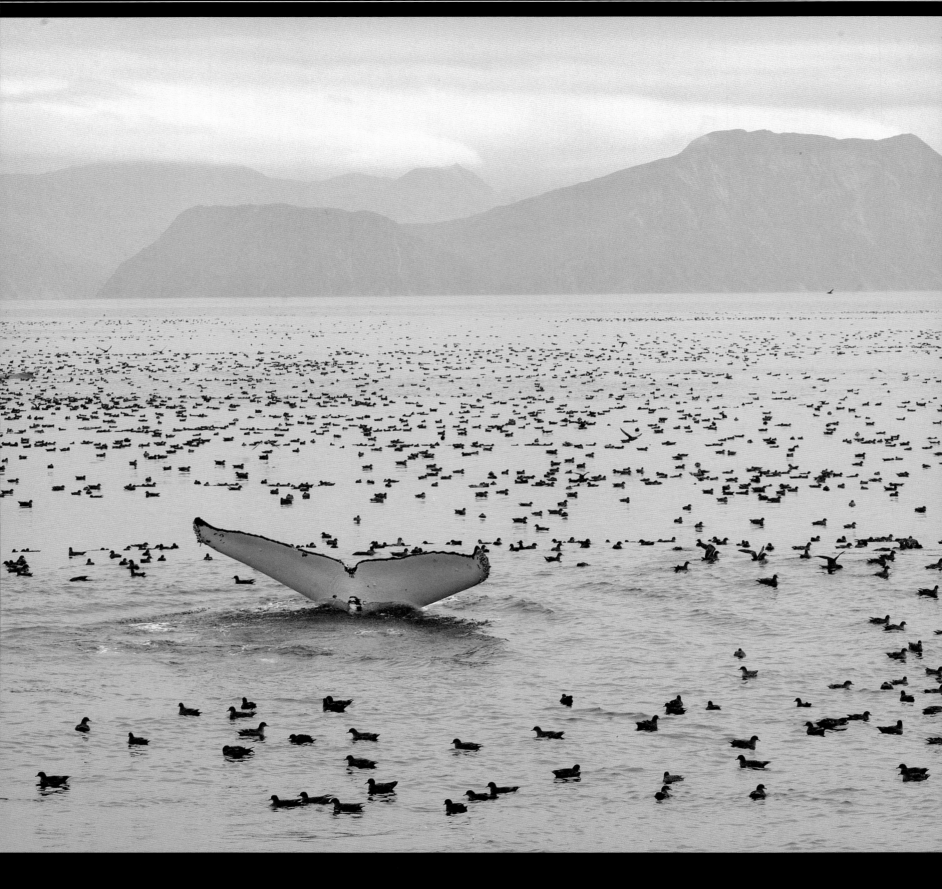

Flying Home

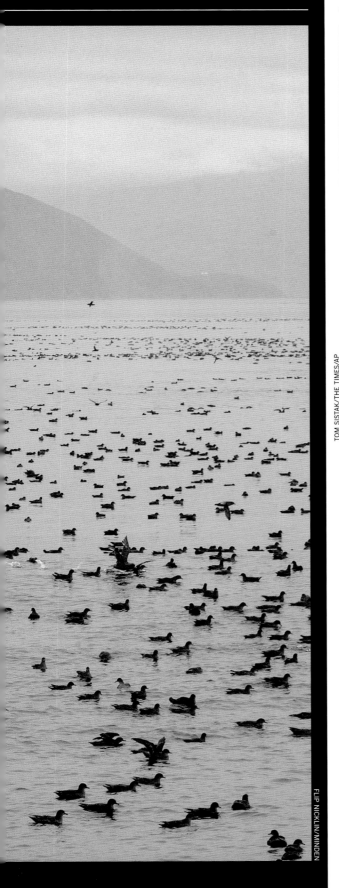

FLIP NICKLIN/MINDEN

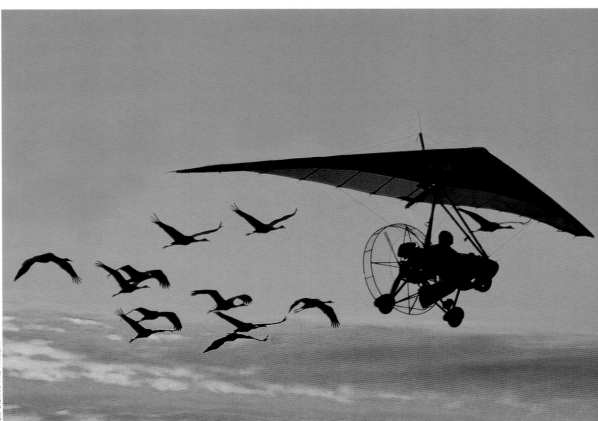

TOM SISTAK/THE TIMES/AP

Fish migrate, reptiles migrate, insects migrate, mammals migrate—and of course birds migrate. In fact, they are the famous, obvious migrators, at least to the common human observer. We look skyward in fall and see great flocks of various species heading south to warmer wintering grounds; in spring we see the same flocks heading north to their summer homes. We know all about the swallows returning to San Juan Capistrano. At left are hundreds of seabirds off Alaska's Aleutian Islands, hunting for herring beneath the surface while being mildly harassed by the immense tail of a humpback whale. These medium-size, strong, stiff-winged, dark-colored birds have a name that treads the line between prosaic and unfortunate—sooty shearwaters—but they also have a spectacular distinction. Breeding in large colonies on small islands in the Southern Hemisphere, sooty parents send their young out into the world where they migrate almost beyond measure, traveling an average of more than 300 miles a day, chalking up in some instances close to 46,000 frequent-flier miles in a year. Above: The whooping crane, the tallest bird in North America (nearly five feet when standing), used to know how to migrate north to south and east to west, but it became severely endangered due to habitat loss and other factors, and individuals that were captured to preserve and perpetuate the species lost the knowledge. In recent years, efforts have been made to reintroduce the birds to their native habitats by retraining them. Since the late 1990s, Operation Migration has been using ultralight aircraft to lead whooping cranes between Wisconsin and Florida's Gulf Coast, with demonstrable success. Mankind has hurt this species in the past, and now perhaps we can help.

Now Appearing in the Tiki Room . . .

KEVIN SCHAFER/MINDEN

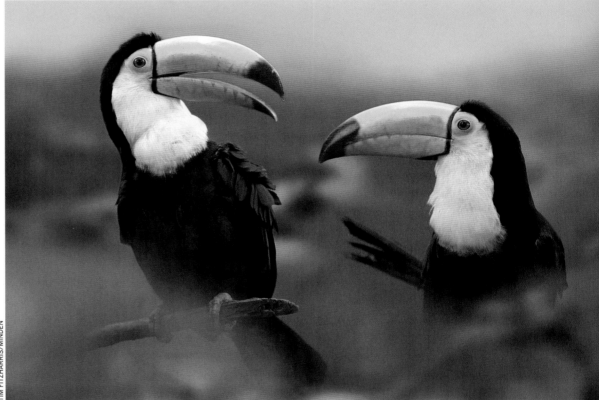

TIM FITZHARRIS/MINDEN

n No, these are not performers in some cheesy saloon sideshow or the animatronic stars of the Disney attraction—not even the renovated Disney attraction. These are the real deal. And they are seen here in their native habitats: a scarlet macaw flying in the Tambopata National Reserve in Peru (left) and a pair of keel-billed toucans in the Costa Rican rainforest (above). "The rainforest" is an abstract idea to those who haven't visited one, but it's a *ne plus ultra* habitat for the wonders of life that our planet simply cannot do without. Let's consider the very biggest, the Amazon in South America. It is so large, at more than 2.1 million square miles, that it affects the world's climate (and thus represents an environmental issue of enormous concern, what with the pressures of deforestation). While its eponymous 4,000-mile-long river is home to some 3,000 species of fish— nearly a third of all freshwater species in the world, among them the ravenous piranha, whom we will meet in the pages following—the forest supports 300 kinds of mammals and all sorts of amphibians, reptiles, insects and birds (the ones seen here among them), along with thousands of plant species, including sheltering trees that form a canopy up to 200 feet high. Name an exotic, and the Amazon's probably got it. Snakes? Anacondas: We have anacondas (whom we've already met, page 89). Want a big cat? We've got jaguars and ocelots (whom we will shortly meet, page 120). Of course, there are monkeys galore, and for fans of winged things, there are not only colorful characters like those on these pages, but such as the fear-inducing vampire bat (please turn the page). The rainforest: where the wild things are.

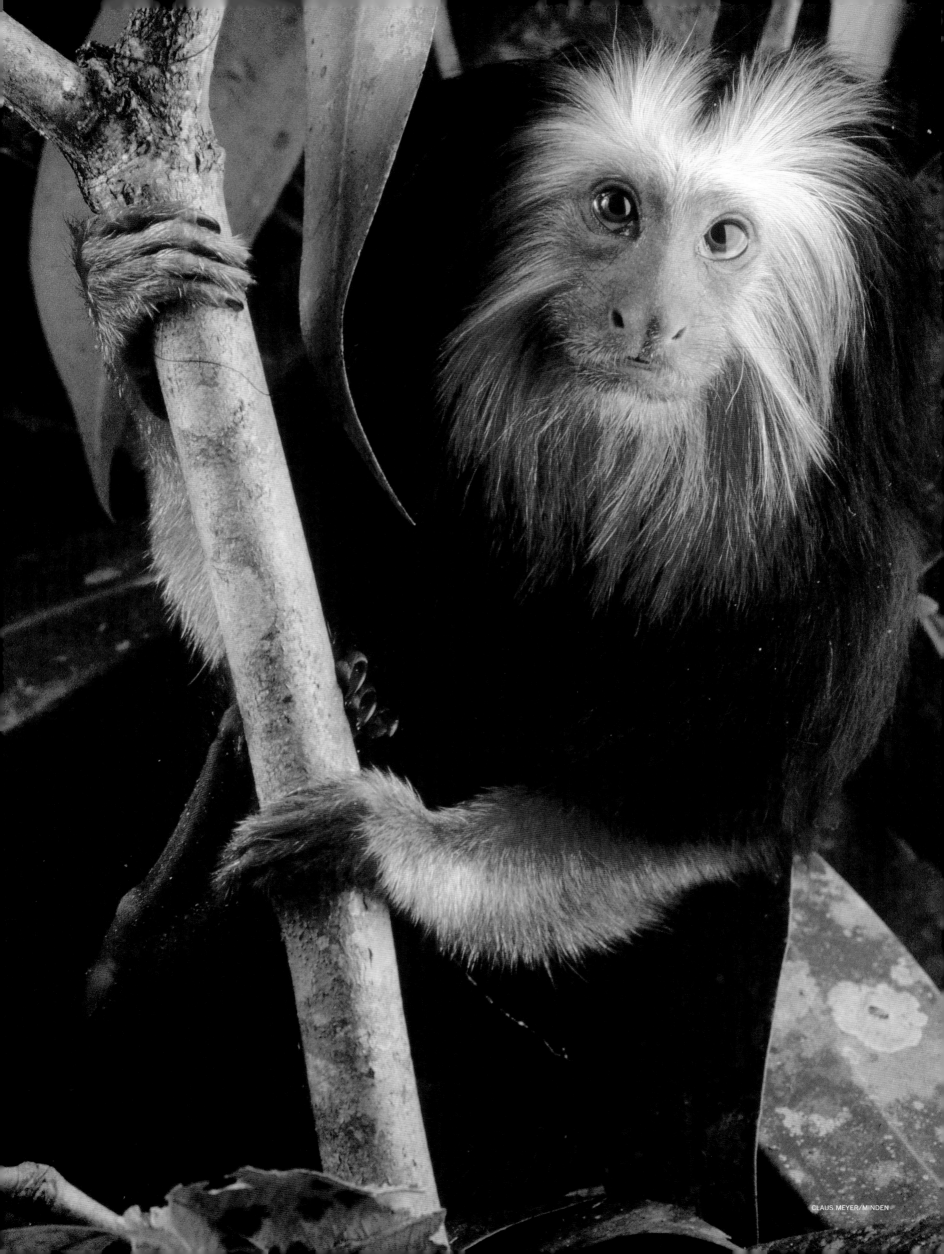

Two Cuties

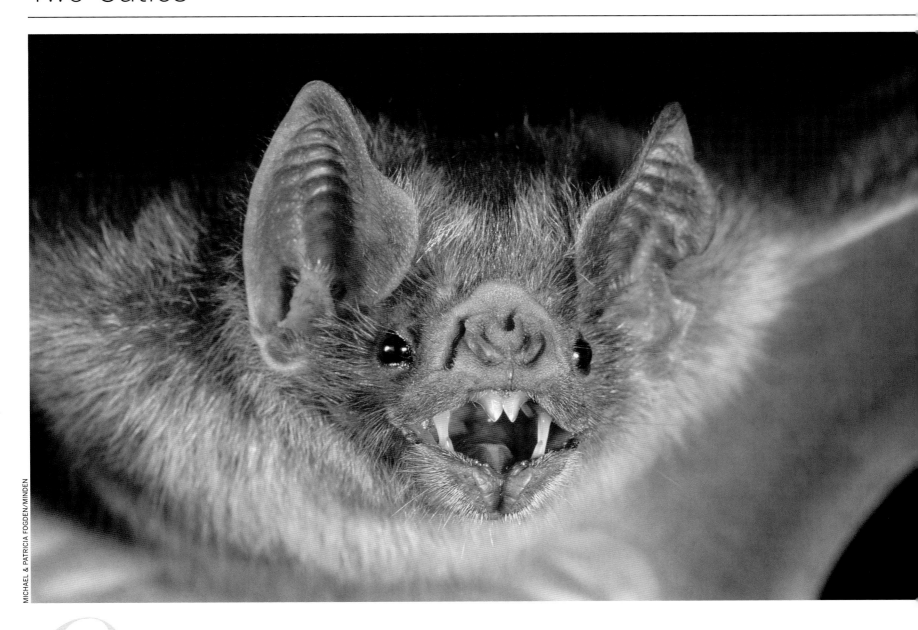

MICHAEL & PATRICIA FOGDEN/MINDEN

Opposite: Tamarins, such as this golden-headed citizen of Brazil named a lion tamarin, are squirrel-size monkeys that congregate in the rainforest in groups of from 10 to 40 members. They survive on insects, vegetation and items they can scrounge, including birds' eggs. The common vampire bat (above) has given rise to a million nightmares because of its name and its salient characteristic—it is one of only three of the multitudinous bat species, along with the hairy-legged vampire bat and the white-winged vampire bat, that feed solely on blood. Its digestive system has evolved to accommodate this liquid diet by secreting in the saliva a substance given, by us humans, the dramatic name "draculin." Yes, vampire bats hunt only at night. Yes, they feed mostly on the blood of mammals (including . . . *us!*). Yes, they figure out where to bite with infrared sensors and, after making a small incision with the teeth that are so alarmingly on display in this photograph, proceed to lap up the blood. Yes, a female can consume half her weight in blood in a single feeding. But, no—sorry, very sorry—they are not undead human beings. They are neither Count Dracula nor Edward Cullen nor any of the citizens of Bon Temps in the *True Blood* series. They are small flying mammals that have found their way in the rainforests of Mexico, Brazil, Chile and Argentina. And they are entirely unaware of any literary celebrity and box-office clout.

Truly Cool Cats

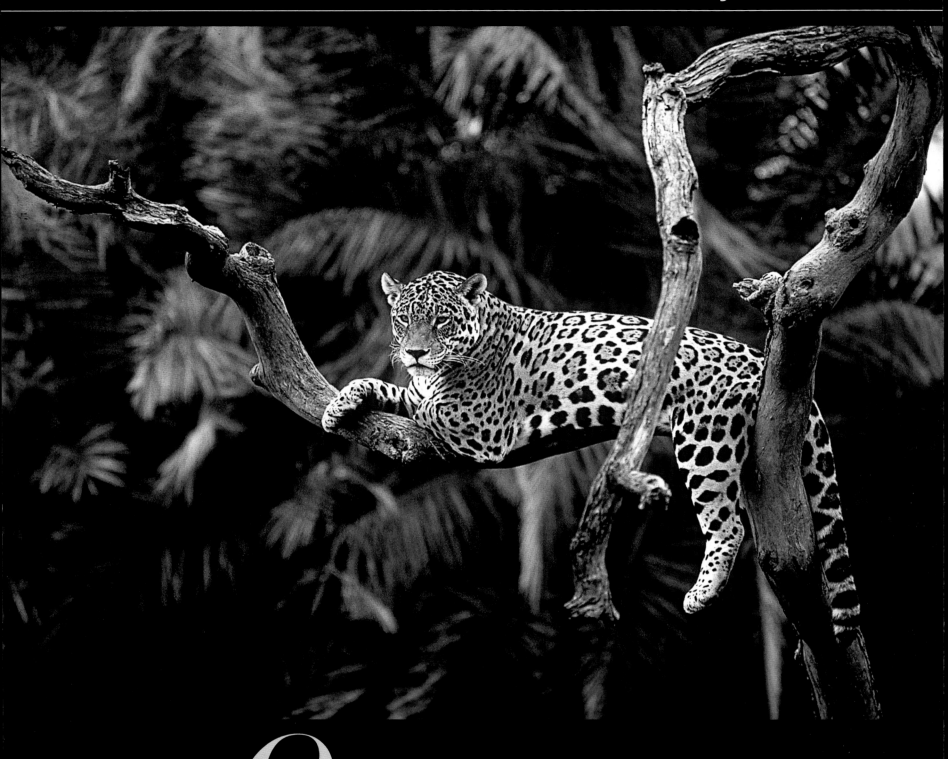

O Obviously we are looking on these pages upon two comparitively closely related animals. They are, resting in a Brazilian tree, the jaguar, and, peering up another tree, the ocelot. The jaguar is the larger—the third biggest feline on earth after the tiger and lion— and the most powerful cat in the entire Western Hemisphere. In normal instances it can grow to more than 200 pounds and a length of six feet, and is an all-star predator, stalking animals up to three times its size, killing its victims with a bite to the head that is one of the most powerful chomps on earth. The good news for us is that, as opposed to other species in the genus *Panthera*, the jaguar attacks human beings very rarely. As for the ocelot: It is also a mammal, also a

carnivore, also of the Felidae family but of the genus *Leopardus*—viz., more of a leopard than a panther. The distinction is subtle. Its range approximates that of the jaguar, as does its fashionable fur coat, but it more closely resembles a large house cat, growing to barely a yard in length and, at most, 30 or 35 pounds. It is territorial like the jaguar and nocturnal, and is a fierce battler, but picks on prey smaller than itself: rodents, reptiles such as lizards and turtles, amphibians such as frogs, the occasional bird or fish. A final tribute to be paid to both the jaguar and the ocelot: It is debatable whether the animal kingdom has produced two more beautiful species, when measured by the human aesthetic, than these fabulous felines.

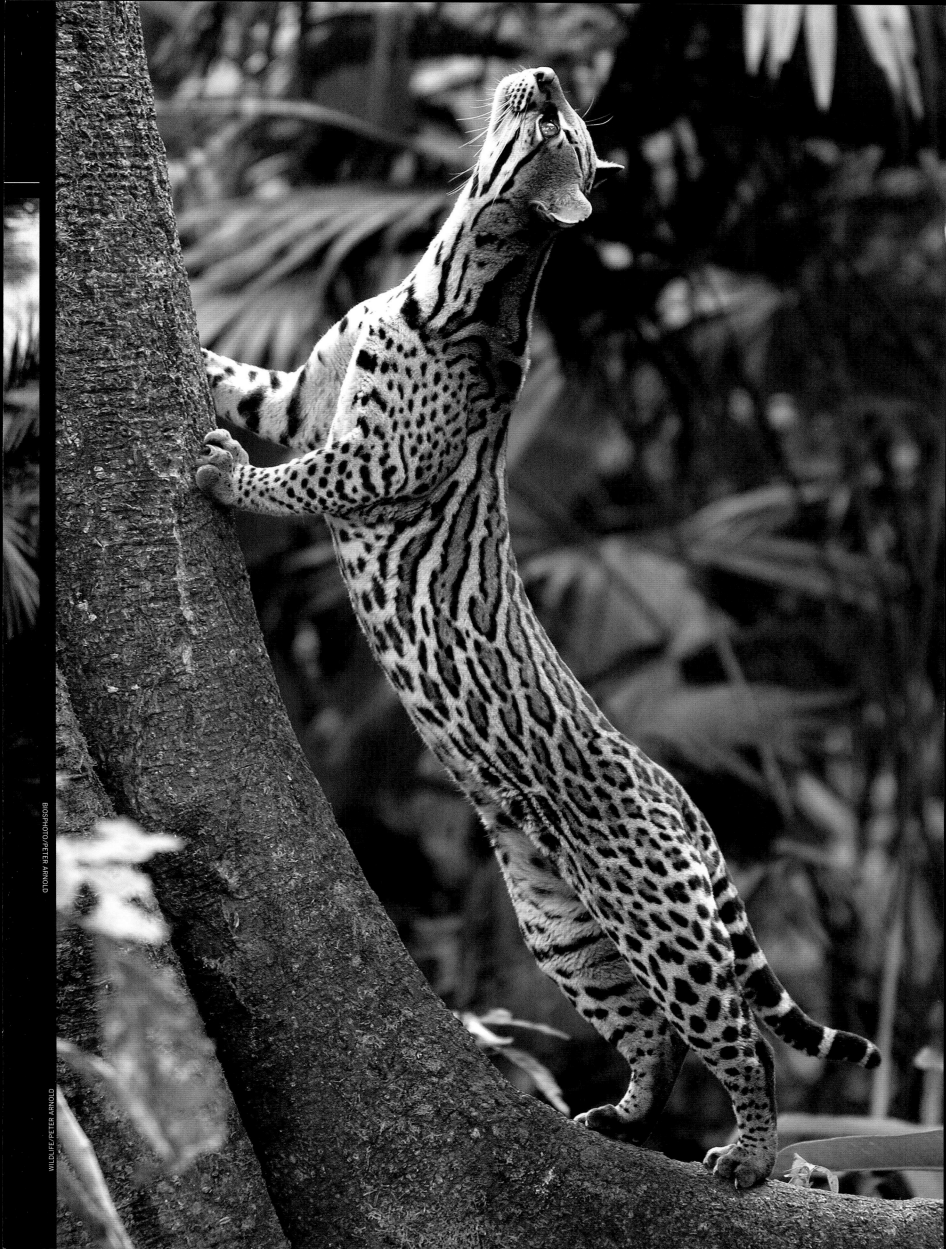

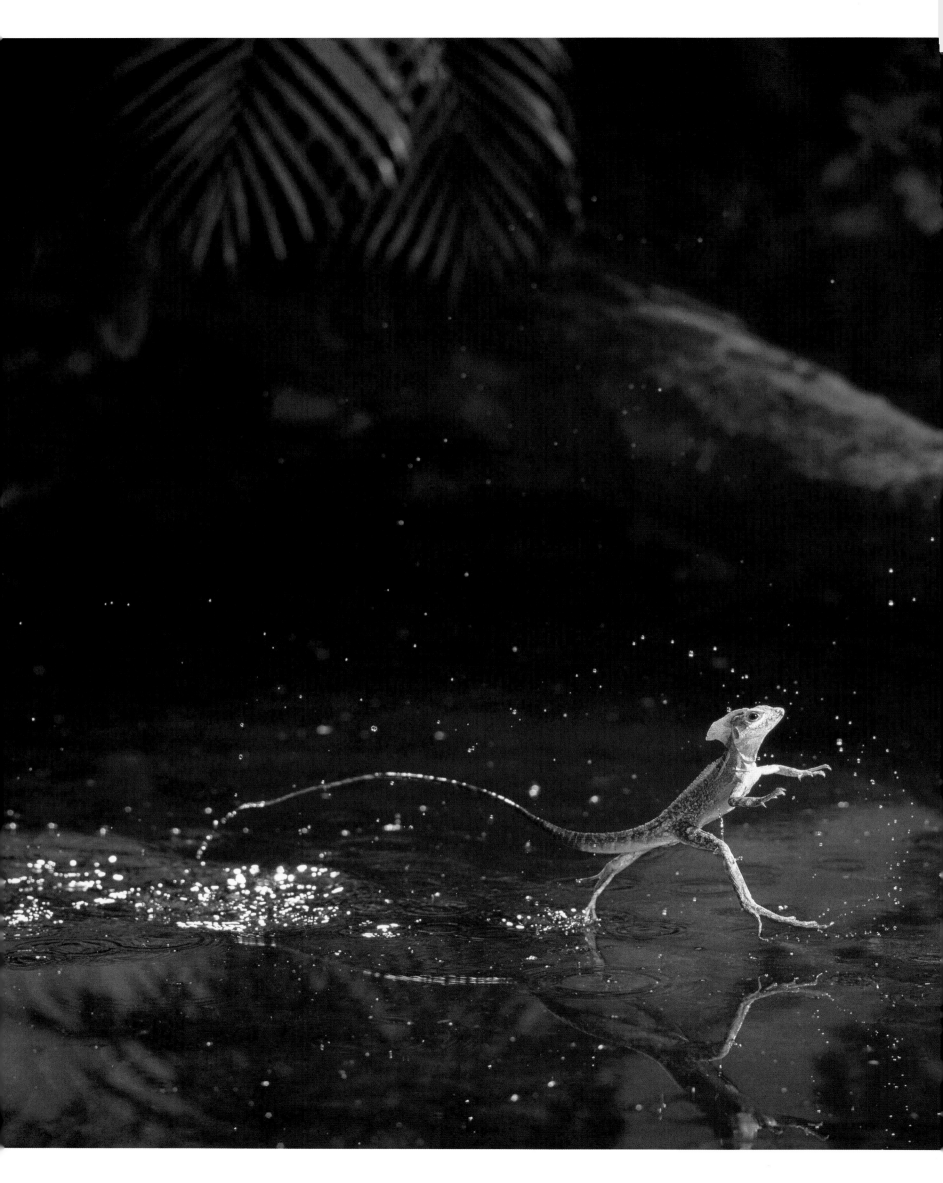

STEPHEN DALTON/MINDEN

Animals of Considerable
Repute, Deserved and Not

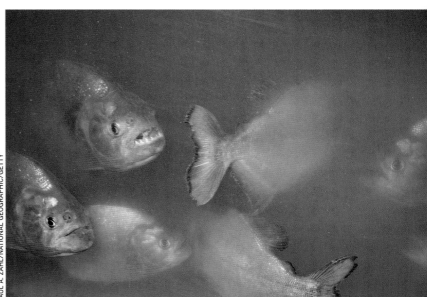

PAUL A. ZAHL/NATIONAL GEOGRAPHIC/GETTY

*a*Above: Agreeably displaying his legendary, specialized teeth for the camera is a piranha, the omnivorous fish that is native to South American rivers, notably the Amazon and its tributaries. Few animals have such a fearsome reputation if we assess it pound for pound, inch for inch. Consider: An ordinary piranha grows to less than a foot in length. But the rap on piranhas—Teddy Roosevelt wrote in 1914: ". . . the most ferocious fish in the world . . . They will snap a finger off a hand incautiously trailed in the water; they mutilate swimmers"—is entirely undeserved and based mostly on myth. They do have formidable dental work and are carnivores as well as herbivores, but, like most fish, they are generally fearful, and feed only when they need to, not for the fun of it. You would be hard pressed, for instance, to find a piranha chasing after a basilisk lizard (left) as it scampers across the surface of the river. This singular animal, which can grow to two and a half feet long (its tail accounting for three-fourths of the total), is known as the Jesus Christ lizard for its ability to walk—rather, run—on water when threatened. It has large hind feet with fringes on its toes, and in a sprint, with its back erect and its arms by its sides like an Olympian with perfect technique, moving at speeds exceeding five miles per hour, can skip across the surface like a flat stone for up to 100 feet. In the rainforest there is a daily show that makes *Avatar,* even in 3-D, seem like very ordinary fare.

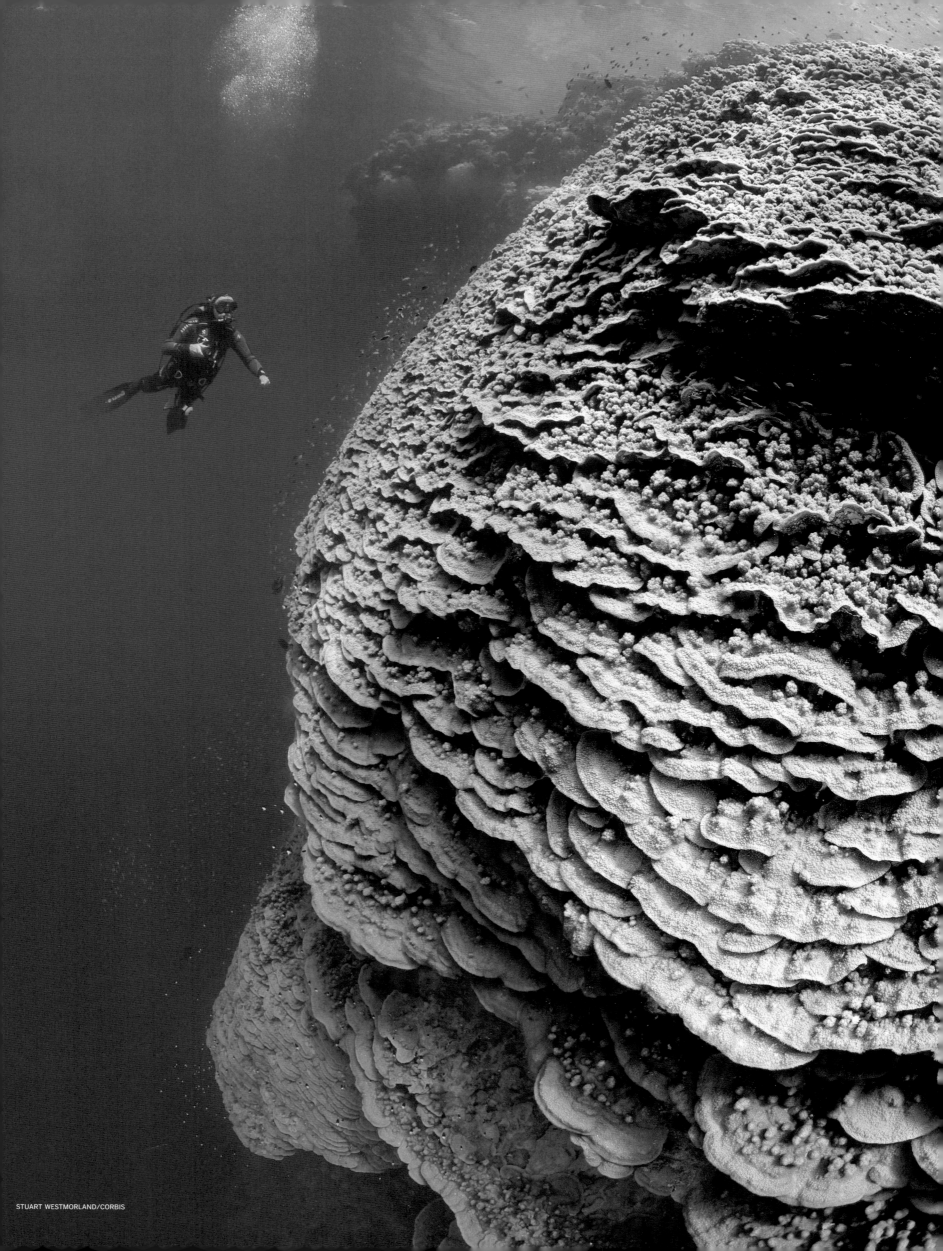

Living, Breathing Coral

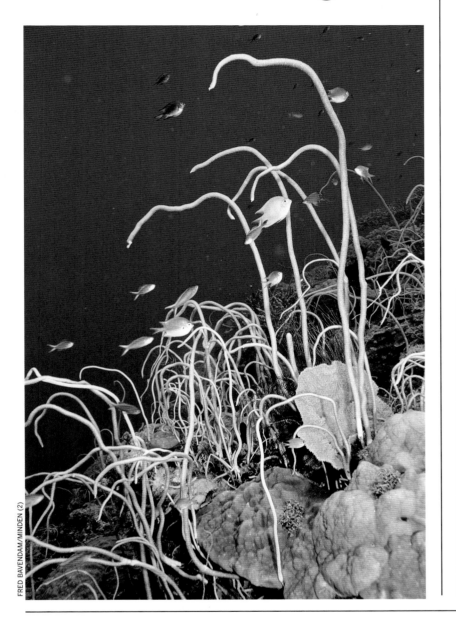

FRED BAVENDAM/MINDEN (2)

This one is difficult to wrap your mind around: On these pages you are looking at animals, and we're not just talking about the fish, who are playing only a supporting role here. We're talking about the coral. That's right: These are neither brilliant rocks nor flourishing plants but smaller relations of jellyfish and sea anemones, crowned with colorful tentacles, existing in colonies that have become fixed by remnant algae, sponges and other decayed creatures. White coral indicates polyps that have died; the pretty pastels that are a

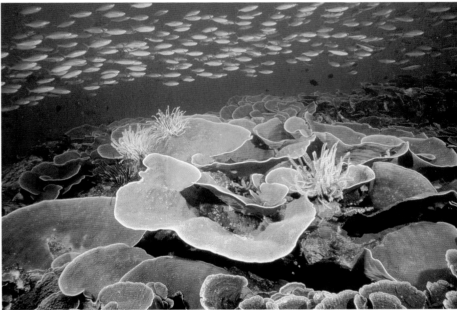

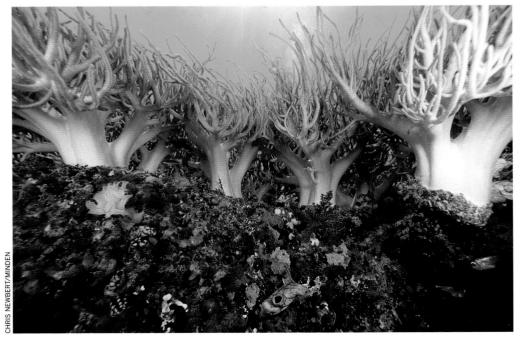

CHRIS NEWBERT/MINDEN

coral reef's hallmark show vibrant life. These reefs, found worldwide, usually in shallow waters in the tropics and subtropics, host an extraordinary diversity of wildlife, with more than 4,000 species of fish, just as many or more species of mollusks, and hundreds and hundreds of subtly or greatly different kinds of coral. Opposite: A diver is dwarfed by a large, pristine lettuce coral head at the Daedalus Reef Marine Preserve in the seas off Egypt; the lettuce is a stony coral with a hard skeleton of calcium carbonate made of minerals that the animal draws from the ocean water. Above, left: A sea fan stands on a deep reef slope about 90 feet beneath the surface in Kimbe Bay, Papua New Guinea. This is a soft coral, and is usually erect; in colonies it can act in a whiplike manner resembling that of, yes, a fan. Above: A school of fusilier stream over a vast field of disc coral (also called mushroom coral and short tentacle plate coral), on a reef off Indonesia. Left: In the same waters, another cluster of soft coral on a reef. The soft corals do not produce calcium carbonate skeletons, and therefore do not help to build a reef. They feed on what passes by, grabbing nutrients from plankton and brine shrimp.

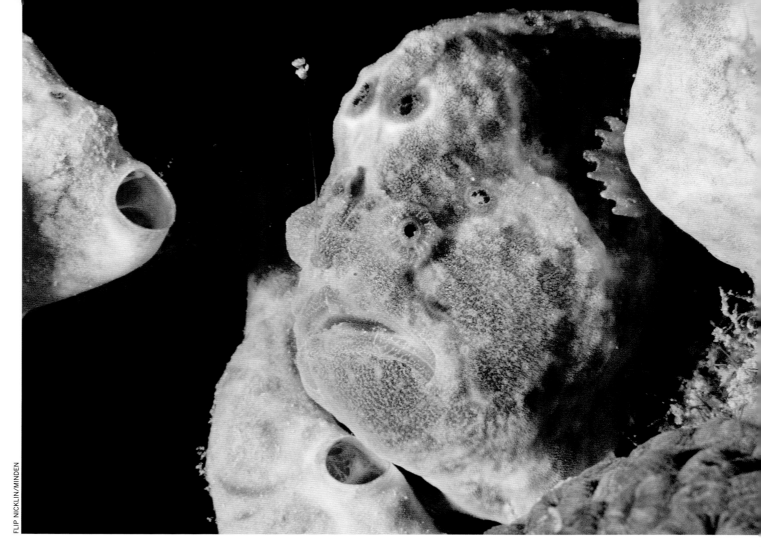

FLIP NICKLIN/MINDEN

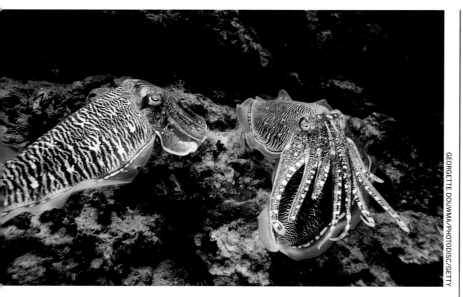

GEORGETTE DOUWMA/PHOTODISC/GETTY

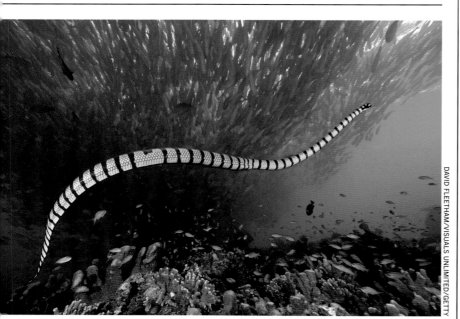

DAVID FLEETHAM/VISUALS UNLIMITED/GETTY

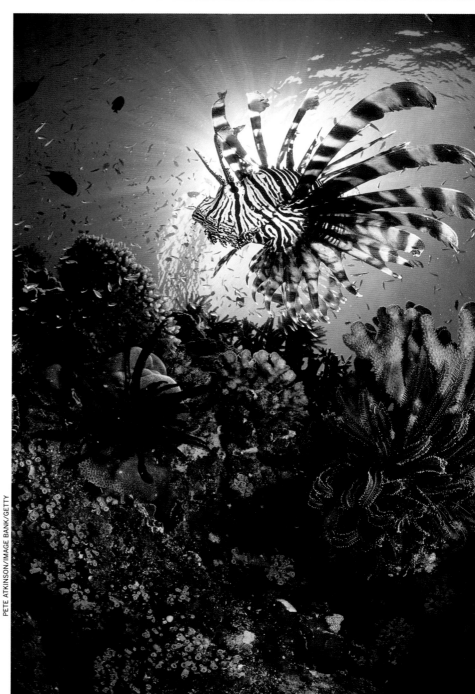

PETE ATKINSON/IMAGE BANK/GETTY

Some Are Clowning Around, Some Are Not

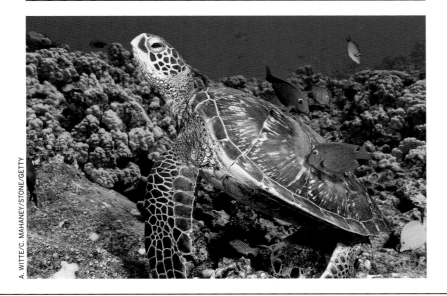

Coral reefs, including the astonishing 100,000-square-mile Great Barrier Reef of northeastern Australia—which is actually a series of perhaps 3,000 interconnected reefs ranging in size from barely more than an acre to 25,000 acres—are home, as we have said, to not only a wide array of coral but of fish and other animals. The portfolio presented here is chosen for its diversity and relative strangeness. Opposite, clockwise from the top, we have, camouflaged to resemble coral off Bonaire in the Netherlands Antilles, the frogfish, which is found around the world in tropical and subtropical locales at depths shallower than those frequented by its even more bizarre cousins in the anglerfish family (please see page 133); off Queensland, Australia, a venomous lionfish, whose spines can cause a diver great discomfort, even death; a yellow-lipped sea krait, which is a sea snake that is also venomous and that can ordinarily grow to five feet in length, swimming among fish schools over a coral reef off Malaysia; and two cuttlefish, which are not actually fish but mollusks and, in fact, are among the world's most intelligent invertebrates, courting in the waters of Thailand's Andaman Sea. At left is a green turtle stopping in at a reef "cleaning station" (we will explain momentarily) and below is a clown anemone fish off Indonesia. These last two situations represent grade-A examples of "symbiosis" in the animal kingdom, in which one entirely unrelated species helps another. Cleaning stations work like car washes and are manned, so to speak, by small parasite- or algae-eating fish; when a turtle passes through, his shell, which of course he cannot reach, is rendered spick and span. And a clownfish, known to all our children as "Nemo" after the Disney hero, whose body is shielded by a thick layer of mucus, is known to hide amid the tentacles of the fish-eating anemone—yet another anchored animal that looks like a plant. When a hungry fish spots a cheerful clown, it bears down, but the little fellow darts under the anemone's tentacles and the chasing predator gets stung, then pulled into the anemone's hidden mouth. The anemone provides shelter, and in turn is provided with a food lure.

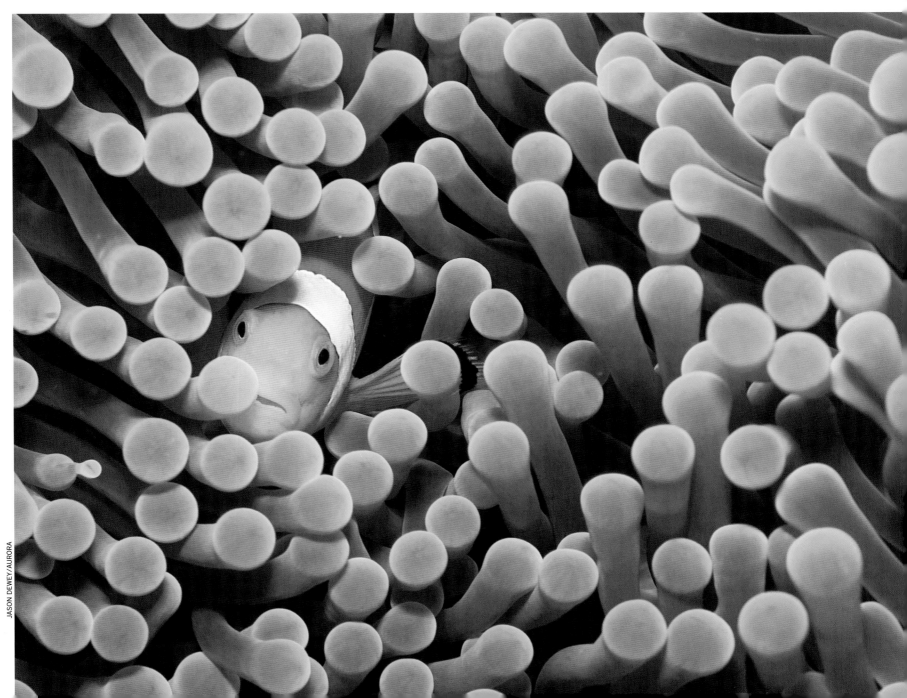

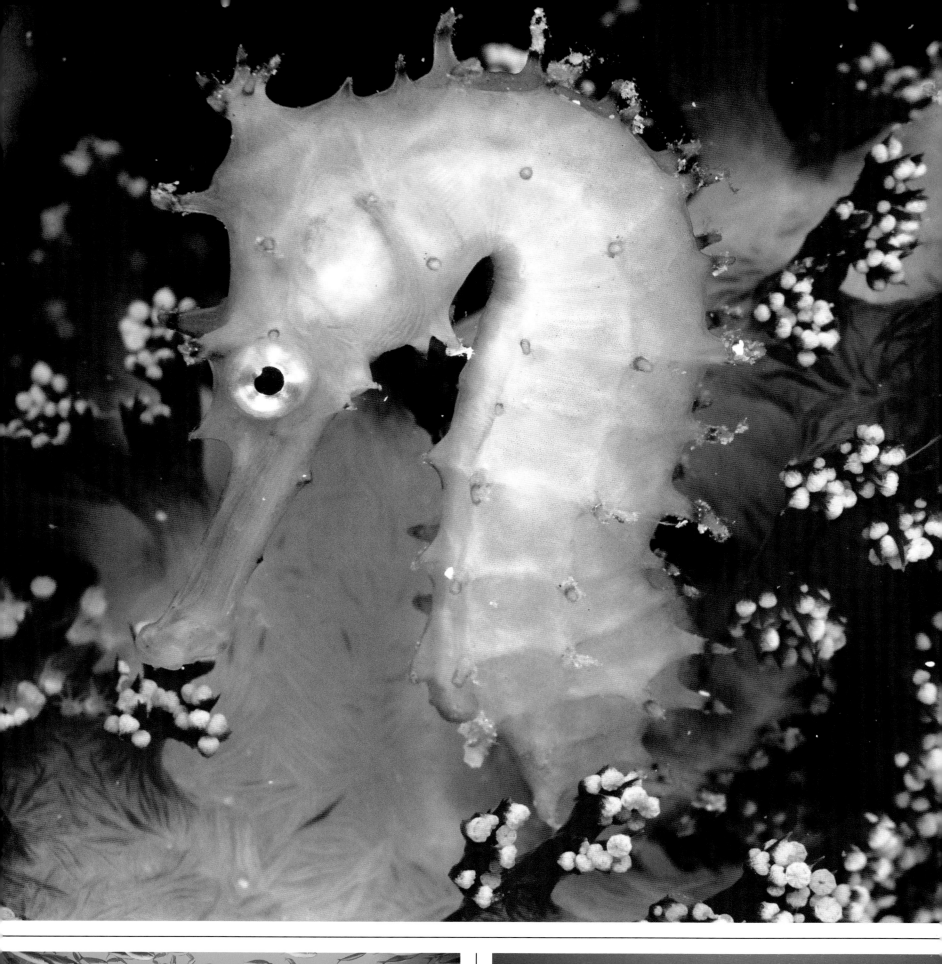

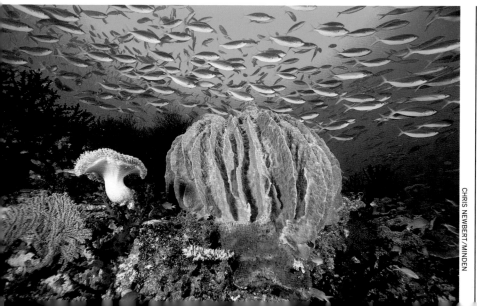

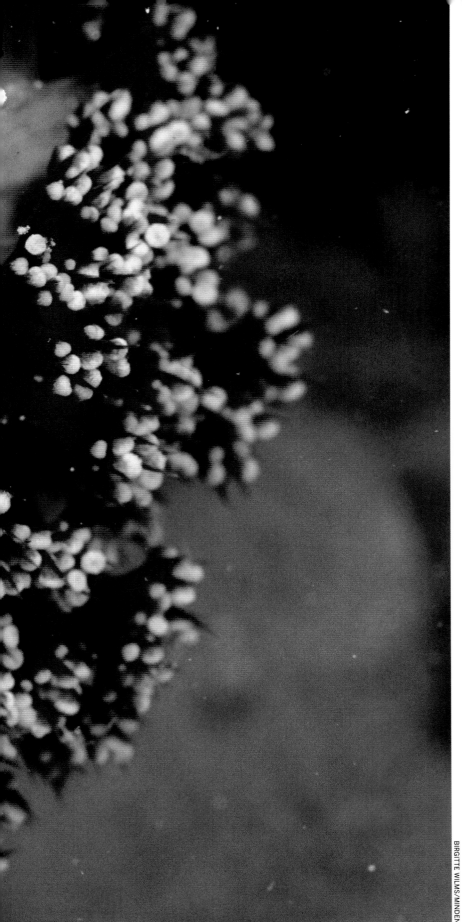

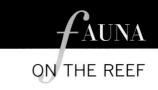

Proliferating, Persisting— and Imperiling

On these pages: two lovely creatures, one a benign beauty and one a true villain, plus three wonders of the animal kingdom that hardly look like animals. Any guesses? At left we have, clockwise from the top, an exquisite seahorse on the reef off Papua New Guinea and then three kinds of sponge, which today are happy as clams on the coral reef— an elephant ear sponge; a sponge in the midst of spawning; and a giant barrel sponge. Now, for centuries, most people—scientists most definitely included—were not at all sure just what sponges were. Many considered them plants, which isn't surprising if you judge them by their looks. In 1765 a linen merchant and amateur naturalist named John Ellis proved that because sponges could eject water, they must therefore be animals. He was right, and, in fact, the sponge, of which there are 15,000 different kinds, has been around some 500 million years, longer than any other living animal. And because sponges—the vast majority of which are incapable of moving about and so rely on water flowing through them for sustenance and oxygen—are, as scientists say, "morphologically conservative" (which means they don't change much), what we have now closely resembles what existed all those years ago. It has even been posited that the precursor to *all* animals closely resembles the sponge. On a given day, liquid equal to 20,000 times its volume may be filtered by the sponge; some sponges can retain 90 percent of the bacteria that pass through. Sponges, living in this sedentary way, have varying and some would say enviable life spans. One species, the living fossil sclerosponge, may reach 5,000 years of age, which would make it the oldest living creature on the planet. But can its habitat prove as endurable? Here's your villain: The undeniably handsome crown-of-thorns starfish (below). Able to grow to nearly two feet in diameter, it has been, since the 1960s, eating away at parts of Australia's Great Barrier Reef and other aquatic havens. The safe bet would seem to be that the durable sponge will outlast the starfish. But in nature, all bets are off.

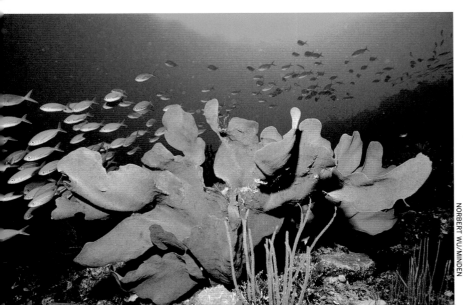

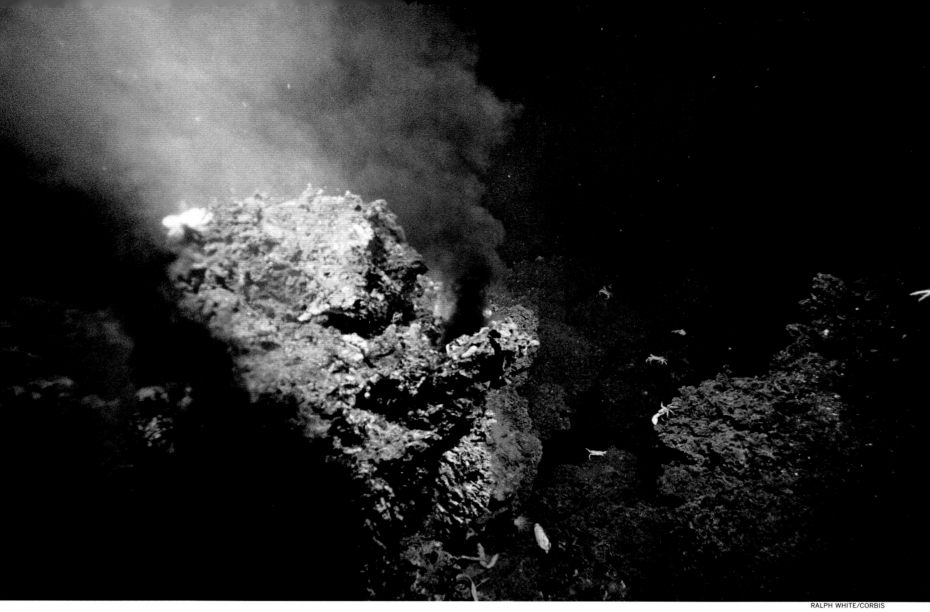

Please Allow Us to Vent

i

In 1977 the submersible *Alvin,* which can take three people nearly 15,000 feet below the sea, was engaged in one of its amazing ventures, this time to explore a volcanic rift in the Pacific Ocean. As so often happens in the business of science, a "routine" exploration opened the door to another universe, one bursting with entirely new forms of life in an ecosystem that itself was a novelty. Deep-sea vents, also known as hydrothermal vents or "black smokers," are essentially geysers on the ocean floor (above). Seawater slips beneath that floor, is heated by volcanic rock and thrust upward through cracks, where it collides with cold water, forming a toxic, superheated plume. In the land of the plumes, chimneylike structures composed of mineral deposits, primarily metal sulfides, arise. In this environment of extremely hot and bitterly cold temperatures, of powerful poisons and acute acidity—with a total absence of sunlight and intense underwater pressures that would crush most living creatures—an eerie world thrives, one apart from all others. There is no plant life, only animals and microscopic organisms, and no photosynthesis, which had previously been considered by biologists de rigueur for all living things. Vent life is sustained by a process called chemosynthesis, in which microbes combine vent chemicals with oxygen, and the 300 or so species that live around the vents represent a truly different kettle of fish, usually smaller and routinely ghastlier than their relations at lesser depths. Right: Giant tubeworms near the equatorial Pacific, which grow to eight feet and are kin to many smaller species of tubeworms inhabiting shallow waters around the world. Opposite, clockwise from top left (all from the same waters near hydrothermal vents in the Pacific): A vent shrimp; a "squat lobster," which isn't a lobster at all but a deep-sea crab; a vent octopus, which preys on small crustaceans that thrive near the smokers; and stalked barnacles, which are found in proliferation at vents around the world.

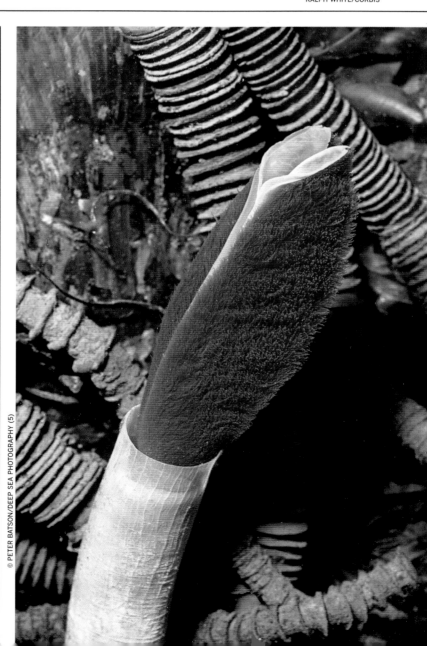

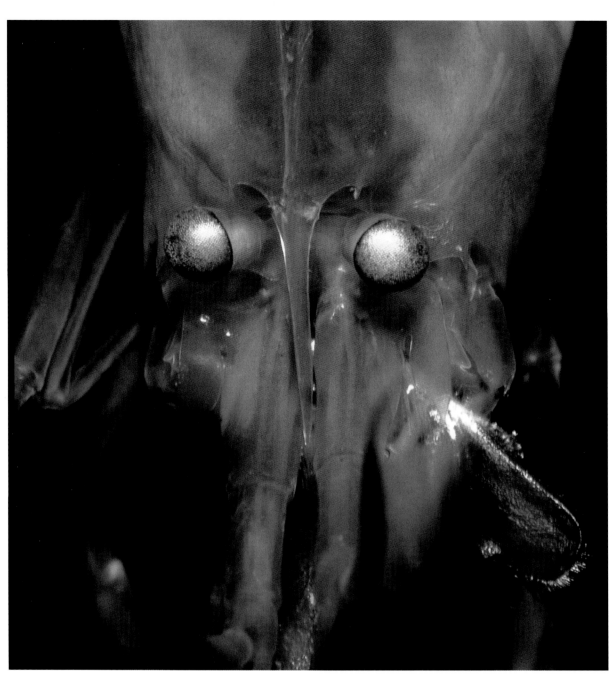

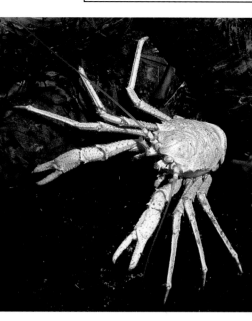

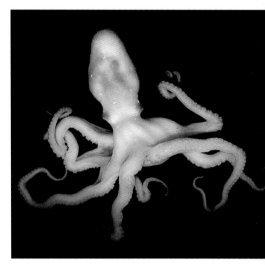

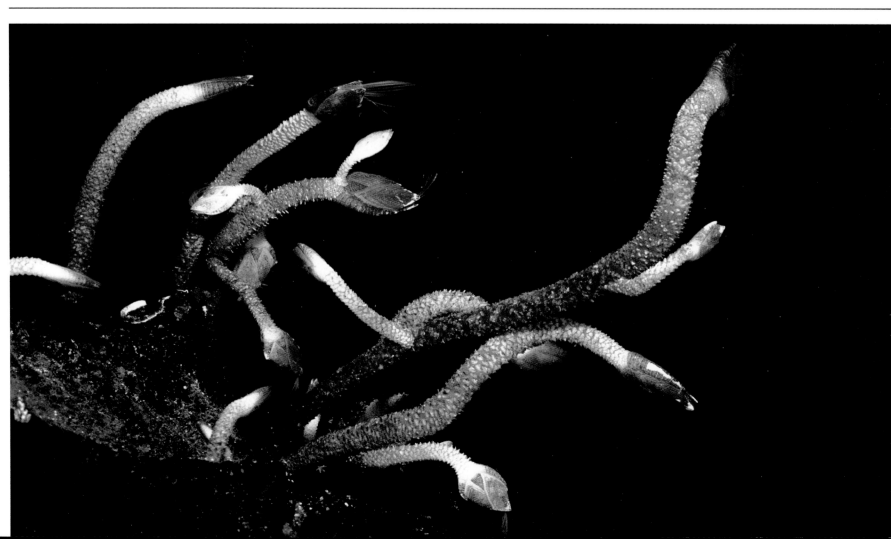

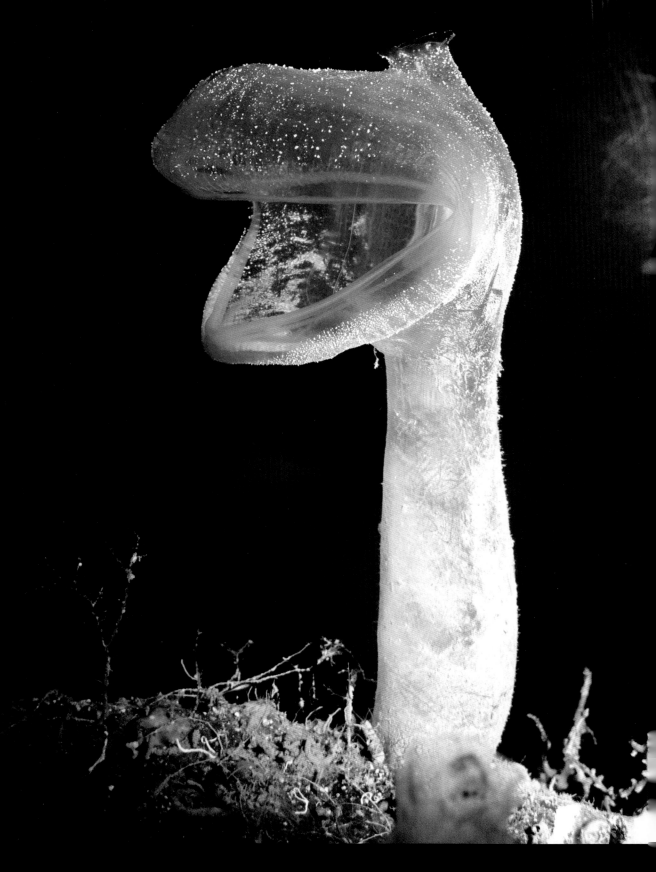

Spooky
Indeed

*t*he deep sea realm is not for the faint of heart, as it is home to a menagerie that would best any other the world over in dreadfulness of appearance—at least as measured by the human aesthetic. Above, we have a tunicate, a predatory filter feeder also known as a sea squirt or sea pork, in the watery depths off Monterey, California. Closely related to vertebrates (all animals with bones), they look prehistoric, and they are, dating to the early Cambrian period of about 540 million years ago. Also down deep off the California coast, in San Clemente Basin, is a slender hatchetfish (opposite, top left), a small fellow (an inch or two, usually) possessed of bioluminescent qualities, which allow him to throw off predators in the inky world in which he swims. Beside him is a glass squid photographed in the deep sea off New Zealand. This species has light organs on its eyes but is otherwise transparent, and possesses the ability to roll into a ball, like an aquatic hedgehog, in an attempt to elude its foes, which include goblin sharks and whales. At center is a four-eyed spookfish which just recently was discovered to be the only vertebrate ever found that uses mirrors, rather than lenses, to focus light in its eyes. Existing more than 3,000 feet down, where very little light penetrates, Spooky has found a way to make do with what's available. Bottom left: The rarely seen oarfish can be, in this species known as the king of herrings (photographed in the eastern Pacific), the longest bony fish alive, growing to more than 55 feet in length—from the end zone to darn near the 20 yard line on a football field. To the right of him is a fanfin anglerfish, whose glow (caused by light-producing bacteria) is a fatal attraction for inquisitive fellows in the dark, dark depths.

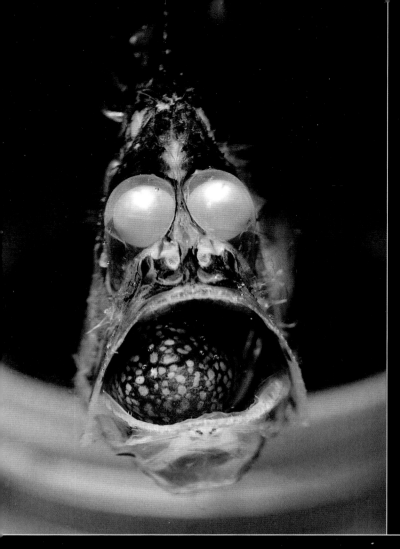

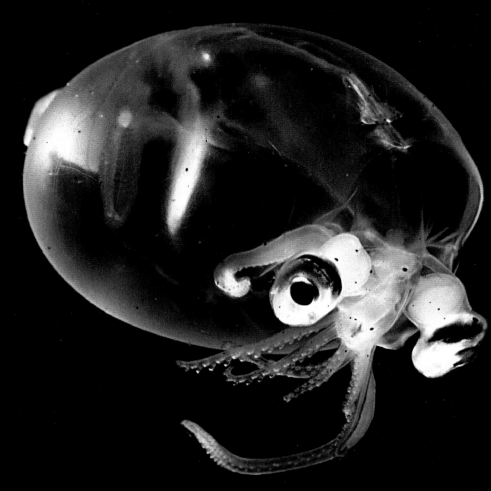

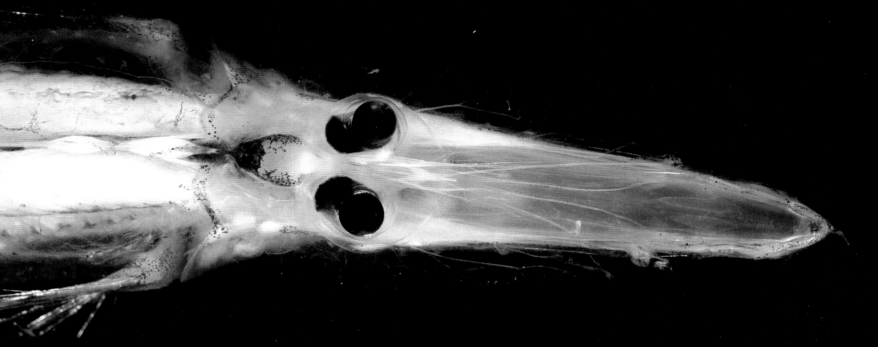

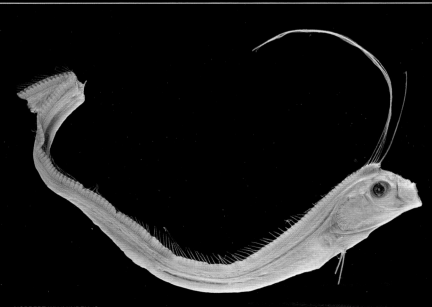

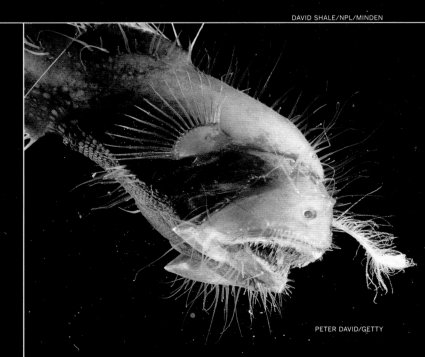

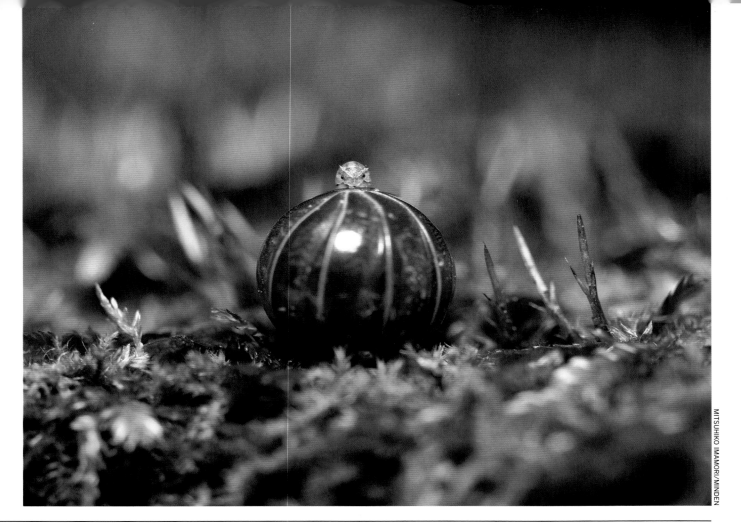

Roly-polies

As happened to us in our book's survey of the world's amazing plant life, we arrive at a point in our pages where we've dealt with the biggest and smallest, the toughest and most toxic—the species that exist on the fringes—and yet find there are so many more we want to investigate. And so here begins a miscellaneous menagerie simply too wondrous to ignore. First, on these two pages, we have a crustacean, a fish, a bird and an amphibian who are alternately trying to look tough, scary, sexy or just plain happy (at least hopeful). To explain: The woodlice species above is a common pill bug, although the defense methodology of this half-inch-long isopod is anything but common. When threatened, it rolls up into an almost perfectly round ball—hence its nickname, the "roly-poly"—with its exterior shell presenting to any predator the look of a mini-armadillo (hence its scientific family name, *Armadillidiidae*, bestowed way back in 1833). At right is one of the world's many extraordinary species of puffer fish, the guineafowl puffer, puffed up off Tower Island, one of the Galápagos. Feeding on coral, seaweed and whatever floats by, it grows to just over a foot in length, but its length is not its distinguishing characteristic. With encouragement, it inflates. This, however, isn't its strongest weapon of defense; its toxicity is: All puffer fish are highly toxic, possessing a poison that can cause death. The manly great frigatebird just below the guineafowl, also photographed on the Galápagos, is distending its gular sac during mating season to impress the chicks. And finally: The fellow opposite is an axolotl, often called a Mexican walking fish, which is not a fish at all but a salamander that keeps an especially cheerful countenance even considering the fact that, where once there were millions like him in the lakes in and around Mexico City, today there are precious few. The animal is facing extinction within a decade if preservation efforts fail.

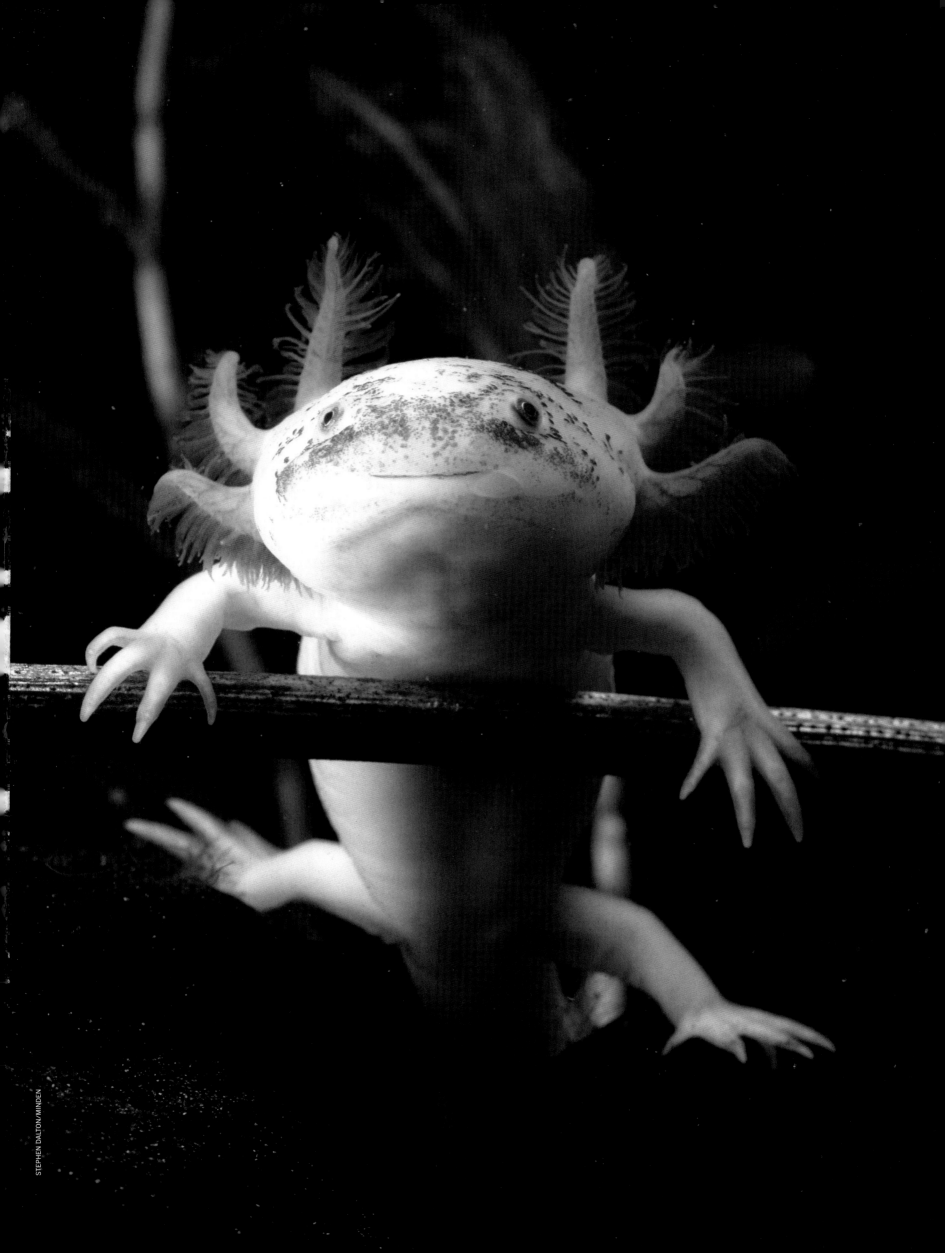

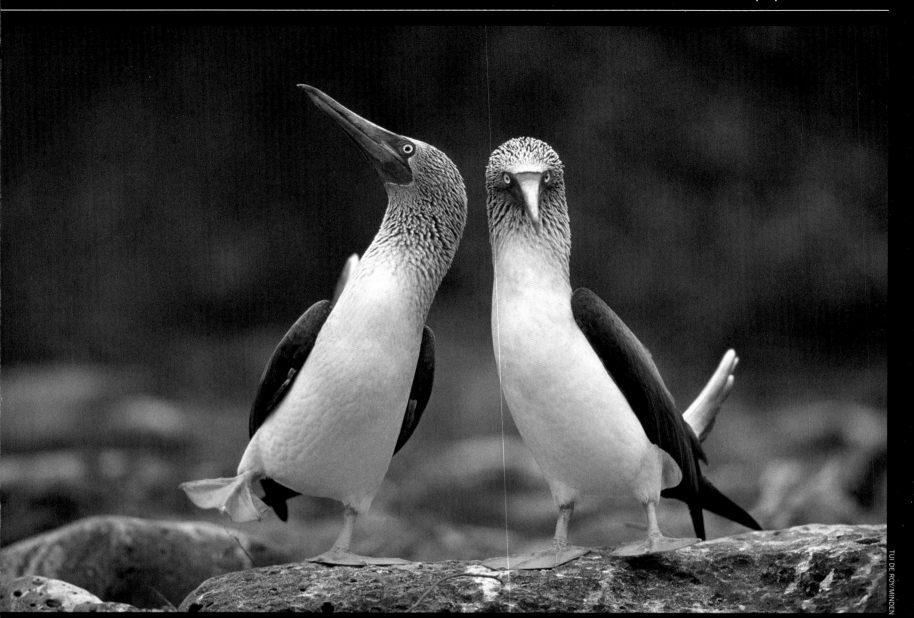

TUI DE ROY/MINDEN

*U*nquestionably, the life of animals can be tough, what with all these food-chain and habitat-loss questions. But sometimes we look upon our frolicking friends and think: *Would that that were me!* Above are two blue-footed boobies on Española Island in the Galápagos. The descriptive name of this seabird, which diets exclusively on fish and can grow to nearly three feet long, comes from the Spanish word *bobo,* which means, approximately, clown. It was bestowed because early observers thought the booby looked like a drunken sailor on land, but in fact the performance has a purpose. The monogamous male of the species dances around and shows off his singularly colorful peds every nine months or so to his mate, then his life partner parades around a bit herself, and not long after, two or three new booby eggs are delivered. Following an incubation period of about six weeks, one or two new chicks peep out. The booby is a romantic bird, and the pinkish Amazon river dolphin, two of which are seen cavorting at right, is a legendarily romantic freshwater mammal. South American folklore holds that at night, the male transforms into a seductive human swain who conquers females on terra firma, then reverts to aquatic form at dawn. Maybe these creatures, an endangered species and the largest river dolphin in the world, are indeed capable of such a feat: Their brains are nearly half again as big as ours. That's using your noggin.

KEVIN SCHAFER/MINDEN

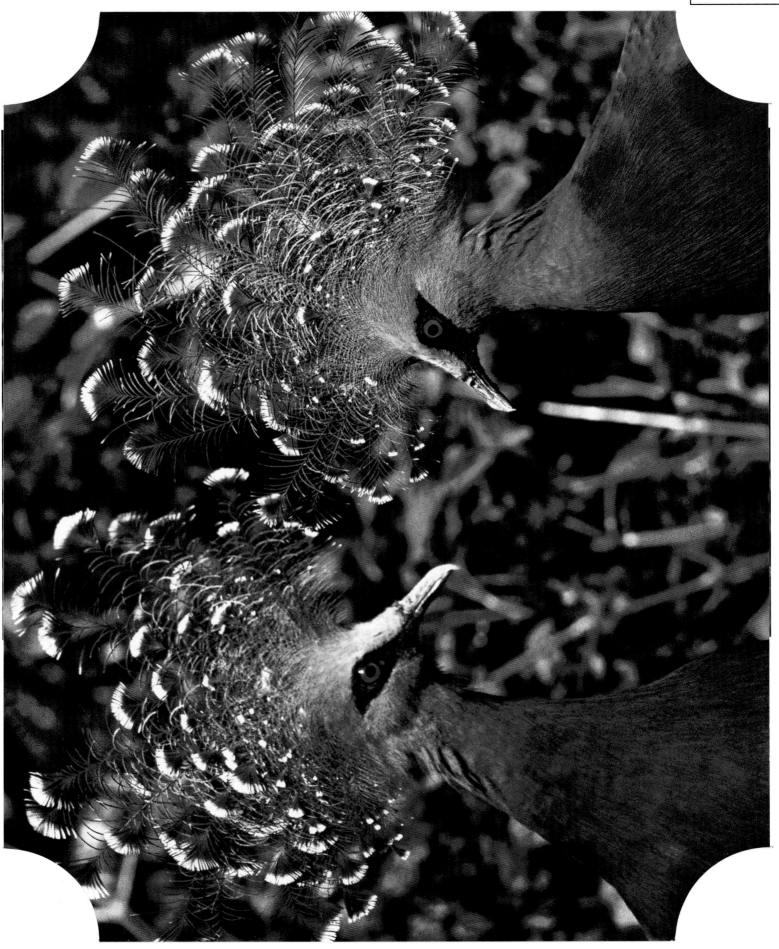

*n*Not terribly far from the boobies in the South Pacific are the large, beautiful crested goura pigeons of New Guinea. They were captured on film (and on holiday) in 1966 by LIFE's storied Larry Burrows, one of the greatest war photographers ever. In 1962 began Burrows's nine years (his last on earth) in a beauti-ful land filled with an awful violence: Vietnam. He chronicled the war from the front lines, taking occasional head-clearing week-ends in India, New Guinea and elsewhere. He was killed in 1971 when the helicopter in which he was traveling was shot down over Laos.

Ready for Their Close-ups

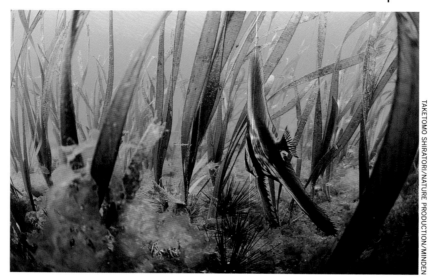

TAKETOMO SHIRATORI/NATURE PRODUCTION/MINDEN

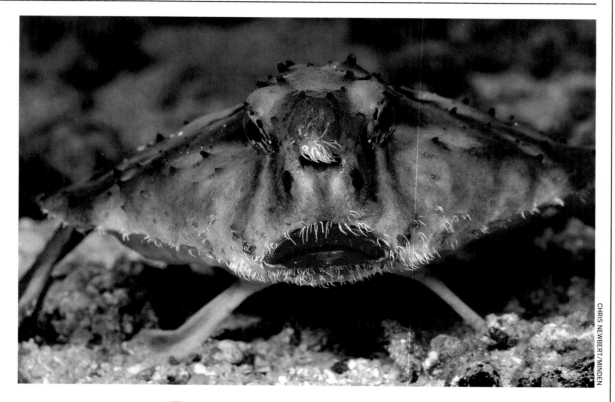

CHRIS NEWBERT/MINDEN

C an you find the Batavian batfish off Bali in the photo at top, left? Look hard. Yes, that's him, in the right half of the picture, pulling off one of the animal kingdom's most deft camouflage performances amidst the sea grass—a star turn that makes a chameleon look like a piker. Can you spot the rosy-lipped batfish 100 feet down off Costa Rica in the photograph immediately above? Well, that's a bit easier. The batfish bears scant resemblance to Michael Phelps in more ways than one; he's a less than proficient swimmer, and often strolls the ocean floor on his pectoral fins. Top row, center, is a pangolin, or scaly anteater or aardvark, on the hoof in Namibia. This is the planet's only mammal with big scales of keratin covering its skin. The short-beaked echidna, known for good reason as the spiny anteater, is seen at far right prowling in Queensland, Australia—it is the most widespread native mammal on that continent. The spines, which are modified hairs growing to two inches in length, are also made of keratin, a hard, fibrous protein found as well in various species of reptiles and amphibians. The echidna, like the pill bug we met on page 134, makes itself into a ball when threatened, and that's one ball you don't want to play with. Right: A star-nosed mole pushes through the shrubbery in Ohio. This animal, also a mammal, is a good swimmer and an expert burrower—and, basically, as blind as a bat (which in fact aren't blind, although they do rely on a complex sonar system rather than eyesight in navigation). Probably by way of compensation, the mole has developed a world-class snout, with 22 appendages featuring 25,000 sensory organs. The critters on this page have clearly found ways to cope.

GARY MESZAROS/PHOTO RESEARCHERS

i

In the introduction to our book we contrasted the narwhal with the unicorn by way of arriving at the conclusion that "truth," in the natural world, can be every bit as strange as fiction. Now we pair this whale with another bizarre ocean-going customer, the hammerhead, which is similarly close to being beyond belief. And yet we must believe, for these creatures certainly do exist. The scalloped hammerhead shark swimming at right in Kahe'ohe Bay, Hawaii, is a member of one of nine hammerhead species known for, well, the hammer that is its head. Interestingly, though their unusual appearance might imply a relic from eons ago, hammerheads are among the most recent of the shark family to evolve; the lateral head lobes, with the wide placement of the nostrils and eyes on the ends of the lobes, are seen as an advanced feature, perhaps improving visual and scent abilities. It is also hypothesized that the altogether remarkable head is an asset when maneuvering—diving, twisting, turning—in the sea. Also famous for its fantastical physiognomy is, as mentioned, the narwhal (below, two of them catching a breath in the Admiralty Inlet of Lancaster Sound off Nunavut, Canada). These are Arctic mammals primarily known for the long (up to nine feet) spiral tusks that are sported by the male of the species. In times past, the narwhal's tusk proved a problem for the animal, as it was coveted by hunters who then offered it on the blackest of black markets as, yes, a unicorn's.

Real or Unreal?

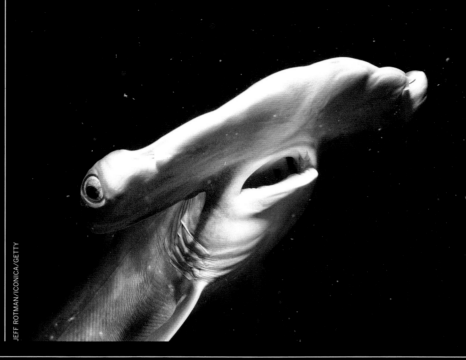

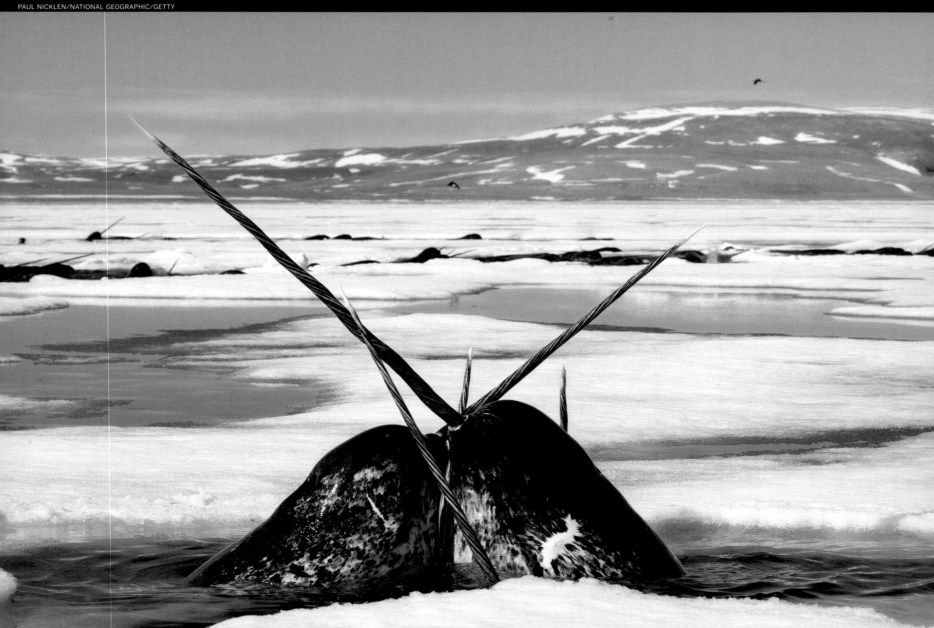

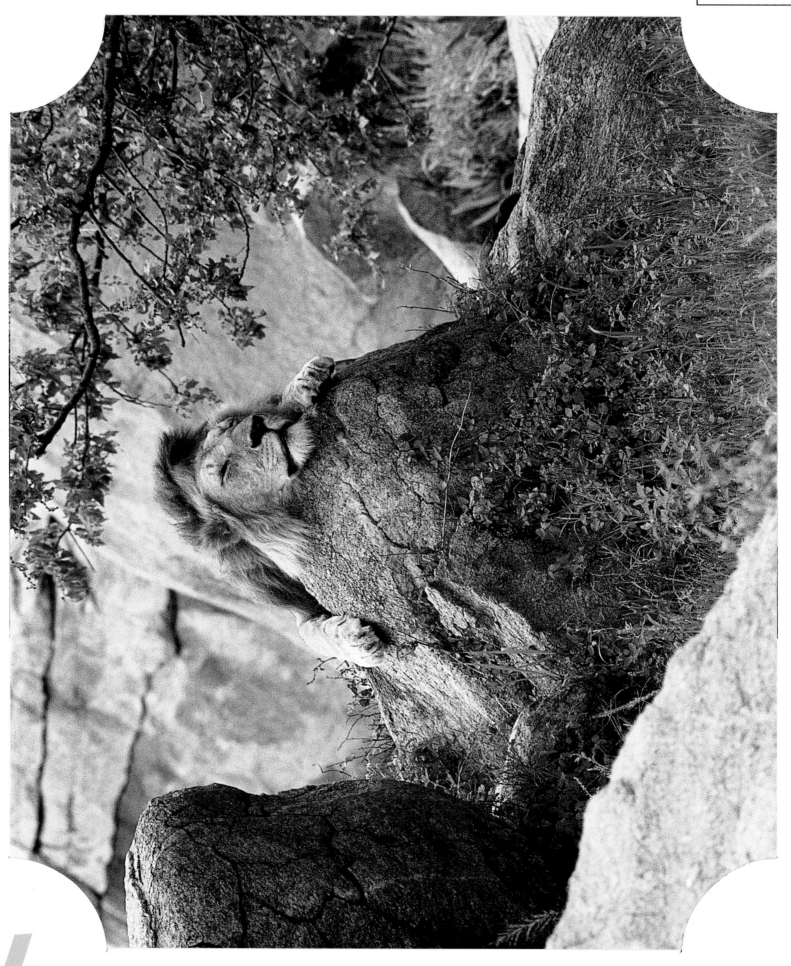

The so-called King of Beasts has not appeared pictorially in our pages yet because he isn't the biggest beast or even the biggest cat; he stands second in the latter category to the tiger. But we cannot close our book without including a portrait of this most regal and iconic of animals, who was rendered in both drowsy and active poses by LIFE's John Dominis in a celebrated, award-winning 1967 photo essay, "The Great Cats of Africa." Dominis shot other cool cats in his distinguished career—his up-close-and-personal take on Sinatra is legendary—but none cooler than the lion.

More Wizards of Oz

*e*arlier in our pages we learned of the underground orchid, the red kangaroo, and other floral and faunal marvels that make their home all but exclusively in Australia. Here are two more similarly storied denizens of Oz, the koala (left, hanging out in Queensland) and the platypus (below, aswim in New South Wales). These two animals have confounded mankind since first they were discovered, with the former thought to be a bear and the latter thought to be an enigma of unsolvable proportions: a duck? a fish? a duck-fish? none of the above? In the case of the platypus, the last question leads to the correct answer. Found only in Australia and Tasmania, this is a mammal, but one apart from all others. Beginning at the front, there is that snout, which looks like a duck's bill although it is really soft, leathery skin. The legs of the platypus extend outward like a lizard's, and the feet are webbed, which is invaluable because the platypus spends much of its time underwater searching for worms, shrimp and insects. Below the surface it closes its eyes and relies on receptors in its snout to detect the vibrations of movements emitted by the muscles in its prey. The platypus may dive as many as 80 times an hour, although it can stay down for 10 minutes by remaining inactive. As with all mammals, the mother feeds her young (usually two) with her milk, but she has no teats. Instead, the milk is secreted through tiny pores in her belly, coating the fur so that the young can suck it up. These young, by the way, were hatched from eggs, yet another resemblance to reptiles. And while we're on the subject of resemblance: The koala, as said, was long mistaken for a bear (its scientific name, *Phascolarctos,* combines Greek terms for "pouched" and "bear"). A koala indeed looks to be the plu-perfect real-world approximation of a child's Teddy, but it, too, is a docile mammal most closely related to the wombat, yet another wizard of Oz. The koala has formidable claws for climbing into trees, where it munches leaves and then, with a slow metabolism that reflects all other elements of its engaging personality, sleeps away most of the day.

The koala isn't a bear, but the giant panda is, although he behaves unlike other bears. He has a carnivore's digestive tract but dines on bamboo, from which he extracts precious few nutrients. So he metabolizes slowly, moves slowly and sleeps a lot—quite like a koala. And he is, similarly, an icon; China, to which the animal is native, uses the panda regularly in diplomacy. This youngster, named Chi Chi, was photographed in 1958 by LIFE's Michael Rougier in Frankfurt, Germany. At the time, the U.S. had a strict trade embargo with China, but in recent years pandering with the panda has been standard practice at U.S. zoos.

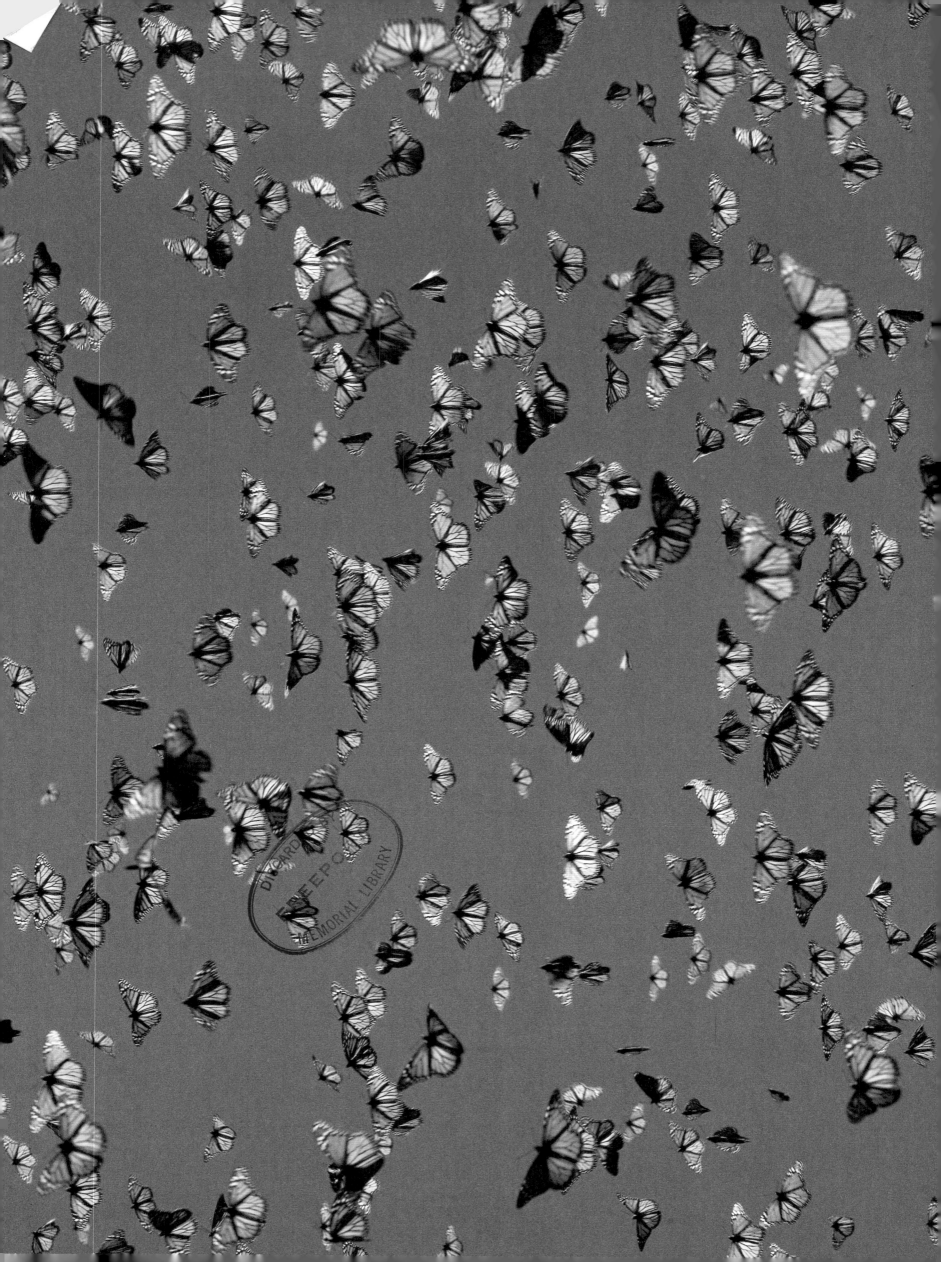